RESISTANCE ART in SOUTH AFRICA

The first documentation of the visual art
of the new culture of resistance
emerging in South Africa – the work of
over a hundred artists and cultural
workers seen in the context of the
troubled society in which they live.
Here are their paintings, sculpture,
graffiti, T-shirts, murals and posters –
the drawings on the wall.

Sue Williamson is herself well known
as an artist and activist, and has lectured
on resistance art in South Africa,
Sweden and the United States. Her
series of portraits on South African
women in the struggle, included in this
book, has been exhibited in many
parts of the world.

Roy Clucas, one of the country's top
graphic designers, has designed this
book.

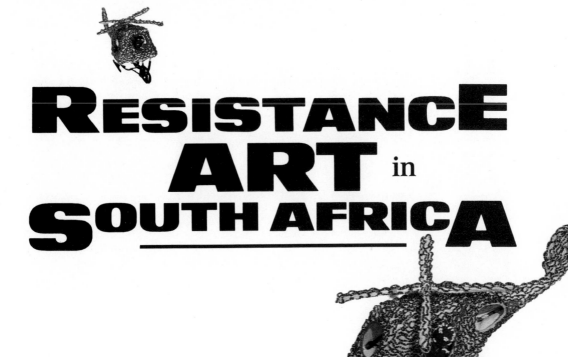

RESISTANCE ART in SOUTH AFRICA

Sue Williamson

St. Martin's Press

New York

First published in the United States of
America in 1990

Printed in the Republic of South Africa

ISBN 0–312–04142–X

Library of Congress Cataloging-in-
Publication Data:
Williamson, Sue.
 Resistance art in South Africa /
Sue Williamson
 p. cm.
 ISBN 0–312–04142–X
 1. Dissident art — South Africa.
 2. Art, Black — South Africa.
 3. Art, Modern — 20th century —
South Africa. I. Title.
N7392.W55 1989
704'.03968'009048 — dc20 89–28797
 CIP

Jacket/cover front: *Boss* by Norman
Catherine

Jacket/cover back: *Mother Africa* by
Mmakgabo Helen Sebidi

Title page: *Helicopter* by Gabigabi Nzama

C O N T E N T S

TO HELEN JOSEPH

AND ALL WHO HAVE

THE COURAGE

TO PURSUE

A VISION OF FREEDOM,

NO MATTER

WHAT

F O R E W O R D

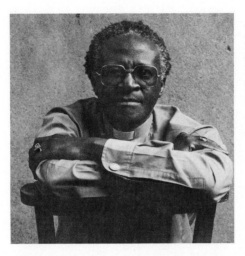

There can be no doubt in my own mind that the arts play a crucial role in the life of a people. Long ago, for instance, the San believed that their cave wall-paintings had a mystical influence on their livelihood and helped to ensure their continued survival. Painting was not just something peripheral to their existence, which they could do or not do as the whim took them. No, it was a matter of life and death. It was not entertainment, nor were they being merely creative; they were exercising that dominion over their environment which God wanted us human beings to have. Equally the ritual dance before the San set out on the hunt was not entertainment, it was a deadly serious affair.

Nor can anyone doubt that protest theatre is a powerful instrument in a people's struggle for liberation. Enacted on the stage for the audience to see are the experiences of their daily lives: the shame, the attacks on their dignity, the failures, the traumas, the triumphs, the joys and laughter. That catharsis is a vital thing. People come to the forceful realisation that they are not entirely the impotent playthings of powerful forces. Somehow the dénouement of the play does say something about good and evil: that there is a nemesis in the scheme of things and – ultimately –

even if not in a straightforward way, evil will bite the dust. And so they come away having seen *Woza Albert* or *Sizwe Banzi is Dead* or *You Can't Stop the Revolution* and they feel better inside themselves, knowing deep down that it will be okay one day.

Evil may be rampant now but people do have some control on events – even if only on the stage.

And it is important that people know that in being creative they become more than just consumers. They can transcend their often horrendous circumstances and bring something new into being. To that extent they are participating in the divine nature, for God is supremely Creator and Artist and He wants us to be co-creators too.

When people can assert their humanity and be creative in the way that

this anthology catalogues, it is wonderful. It speaks of a proud defiance of the hostile forces that would demean and dehumanise them. Graffiti, T-shirts shouting their slogans, banners, paintings, murals, sculptures – all say there is something in human beings which refuses to be manipulated, which proclaims for all to hear and see that human beings are creatures of the spirit too. They are made for something better than that which they are experiencing. They can dream dreams, they can work like anything to try to realise the apparently unrealisable – to reach out for the stars – to try to bring utopia to earth.

It will be a time when justice will reign, when people will matter more than possessions, when there will be peace and laughter and joy and compassion and caring and humanity. People will be treated as subjects, not objects, and all will share in making decisions that affect their lives.

The Bible says, 'Where there is no vision the people perish.' This anthology says, 'We too have dreams, we too have visions.'

Thank you, Sue, for conceiving this project and bringing it to birth. It deserves accolades.

† Desmond Cape Town

A jagged faultline cuts through recent South African history. It is a year, 1976, the year the children of Soweto decided to resist their oppression. Peaceful protest was met with police gunfire, and soon Soweto was aflame. The furious sparks set the rest of the country alight; hundreds died, thousands fled. In the space of a few months, things in South Africa had been changed forever.

The flames melted the oppressive ice which had frozen South Africans, black and white, into apathy for so long. Slowly the glacier began to move. It was a time for counting the cost, for accepting responsibility, for asking the question, 'What could I have done, what can I do now, to work for freedom?' New organisations mushroomed in opposition to the state, new possibilities for action came into focus.

I was one of those jolted out of lethargy by Soweto, and this book concerns the way the artists of my generation responded to the truths made clear by the events of 1976, the issues we addressed, and the work that followed. It is also about the growth of the ideas that art is not necessarily an elitist activity, and that popular cultural resistance has a vital role to play in the life of the community and the struggle for freedom.

Before 1976, a trip round South African art galleries would have given very little clue to the socio-political problems of the country. Strangely divorced from reality, landscapes, experiments in abstraction, figure studies, and vignettes of township life

hung on the walls. The work most admired was that which appeared in the international art magazines.

The poet Breyten Breytenbach wrote of this time: 'The white artist . . . cannot dare look into himself. He doesn't wish to be bothered with his responsibilities as a member of the "chosen" and dominating group. He

▲ DIKOBE MARTINS
BIKO AND SOLIDARITY – ONE NATION
CONTÉ ON PAPER
71 × 51 CM
UNIVERSITY OF NATAL

withdraws and longs for the tranquillity of a little intellectual house on the plain, by a transparent river.

'His culture is used to shield him from any experience, or even an approximation of the reality of injustices. The artist who closes his eyes to everyday injustice and inhumanity will without fail see less with his writing and painting eyes too. His work

will become barren.'

The desperate attempts at head-burying described by Breytenbach affected black artists too – although for different reasons. Dependent on sales through art galleries to a white market, black artists tended to produce carefully non-confrontational work – scenes of a jostling township life or traditional rural vistas. Popular, too, were religious or mythological themes. Gathering the courage to challenge the state through their work would take time for black artists .

In 1984, self-exiled artist Thamsanqa Mnyele, living in Botswana (and killed in a cross-border raid by South African soldiers in 1985), could still write: 'I have often been asked why, in South Africa, when . . . whole communities suffer dismemberment through forced removals, when the majority of the people are declared foreigners in the country of their birth, when people are crudely and ruthlessly suppressed through rushed pieces of legislation, detentions, the massacre of workers and students; when therefore whole communities resist this genocide through organising themselves into civic organisations, trade unions, women's and student organisations, there has been disturbingly little visual arts output in the country or abroad which is organically related to these community efforts. Nor has there been a groundedly political voice from this quarter, let alone a broad art movement with an obvious national commitment. Such is the extent of the concern.'

Two conferences in particular helped

to focus the attention of artists on the task at hand. The first was hosted by the University of Cape Town in July 1979, and was titled The State of Art in South Africa. Much of the first day was spent debating why no black visual artists (there was one black poet) were presenting papers at the conference. Said sculptor Gavin Younge: ' I know that black artists were invited. What I have heard is there is the feeling that nothing important would change as a result of the conference. Someone must be laughing somewhere to hear that black artists want to remain separate from white artists.' On the final day of the conference, the artists present pledged to no longer allow their work to be sent overseas to represent South Africa until all state-funded art institutions were open to black as well as white students. By visual artists, at least, the apartheid regime would no longer be given a cultural cloak of respectability .

Three years later, in July 1982, black artists were far more in evidence at a conference that formed part of an art festival in Gaborone, Botswana (held outside the Republic so that exiles could attend). The title of this conference was Art Towards Social Development and Change in South Africa, and the historic theme was culture and resistance. The festival hoped to 'serve as an indication of the current direction of committed art in South Africa' and had as its aim 'encouraging cultural workers to be part and parcel of the communities from which they come'.

The debate had been opened up. In the years to come, there would be a growing realisation amongst anti-apartheid forces that cultural resistance was a tool of immense power. If the media can be used to brainwash the white electorate and dominate the mass of oppressed people in South

Africa, then it can, in a different form, be used to fight that domination.

In a sense, the new direction was but a development of the old principle governing traditional African art, which is that art must have a function in the community: a song is composed to be sung especially while walking; a sculpture serves as a chair; a house is decorated to enhance the village. The new twist was this: that the 'function' could be one of bringing about change.

The extent to which the new thinking took hold can be judged by a letter in the largely black-read newspaper, The New Nation of

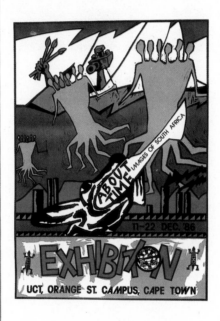

▲ POSTER FOR THE CAPE TOWN
ART EXHIBITION
BANNED IN DECEMBER 1987

3 September 1987. Reader Basil Dube of Thlabane gives his views:

'Art cannot exist without society. There can be no line separating the artist from his community. The progressive effect of art on society gives rise to cultural growth. The artist in South Africa must seek new forms of changing his society for the better. The black artist particularly should dispute whatever obstacles he may face. He must avoid clenched fist protest and

make an effective contribution. He must call on other cultural disciples and discuss the role of art in a broader sense.'

Murals, banners, posters, T-shirts – visual expressions of resistance – have become an important part of the work of progressive organisations and trade unions in the mass democratic movement, along with other forms of cultural activity like plays, dramatic sketches, songs and poems.

There were posters and banners everywhere, an African jazz band played and 5 000 people – more than three-quarters of them black – turned up to mourn at the funeral of white Johannesburg activist David Webster, gunned down outside his home on 1 May l989. It was a clear demonstration of the non-racial solidarity taking shape behind the crumbling edifice of apartheid.

'At the mass rallies and funerals, during our assemblies and on our marches, we've been stirred, sometimes profoundly moved, heartened and inspired by the popular culture of resistance,' said writer Menán du Plessis in a 1986 speech.

'It is not the morally self-conscious art of liberal protest, nor is it the defiant art of outrage, it is the diverse, complex, extraordinarily rich art of resistance. It is rooted directly in the context of struggle. It seems inconceivable that any of these living forms of art could be isolated from their directly political context and placed up on a stage, behind footlights, or mounted on the walls of a picture gallery.'

But, in fact, reparations to more formal black art are now being attempted. In November 1988, the Johannesburg Art Gallery mounted as its major exhibition a rich and comprehensive show of black art called The Neglected Tradition. Unbelievably,

it was the first time ever a large-scale retrospective show of work by black artists had been held in one of the country's leading art galleries. The title itself was an admission of just how pervasive the marginalisation and denial of black art by the white establishment had been.

Although there had been many fine black artists in earlier years, it was the energy and power of the art of the new generation which was forcing the stuffy upper echelons of the art world to take notice.

Art education facilities for black children have been almost non-existent. Under the hated Bantu Education Act of 1953, black schoolchildren learned only those subjects which would prepare them for lowly jobs in the labour market. Art certainly did not feature in the curriculum.

On the other hand, in Africa it is the community itself that has always served as teacher, and the absorption of art skills has never depended on what has been taught in the classroom. The passing on of traditional skills has largely fallen away in the black urban ghettos, but the sculptors of Venda,

artists like Nelson Mukhuba and Noria Mabasa, whose remarkable work has become so sought after in recent years, all learned their craft as children, starting out by carving such functional items as porridge stirrers or making clay

NORMAN CATHERINE
HOUSE ARREST 1986
OIL ON WOOD
46 × 43 CM

pots.

And even in the dreary townships with the unending rows of matchbox houses, that tradition of beautifying the community is not lost, just submerged under the ugliness of the imposed environment and deadened by the

harshness of day-to-day living. The Peace Parks and the street-decorating projects which swept the townships in late 1985 were a resurgence of that tradition, and a proud statement to the government – which had introduced a state of emergency – that the spirit of the people would never be quelled.

The restrictions may continue. Peace Parks can be demolished by the state, entire cultural festivals can be banned as happened in December 1986, on the eve of the opening of the Cape Town Arts Festival with its theme Towards a People's Culture, but the struggle for freedom cannot be stopped.

'To reach out and grasp this vision is our task and our joy,' said Mnyele. 'Our people have taken to the streets in the greatest possible expression of hope and anger, of conscious understanding and unflinching commitment. This calls for what all progressive art should be – realist, incisive and honest. We must restore dignity to the visual arts. The writing is on the wall.'

Sue Williamson
Cape Town
August 1989

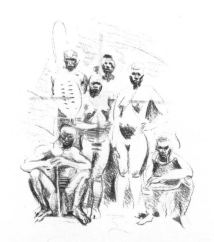

ROOTS
OF THE
CONFLICT

PAUL GRENDON

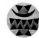

The first white men to settle on the southern tip of Africa arrived in what was to be Cape Town in 1652, as employees of the trading Dutch East India Company. Here, the settlers were met by the Khoi, whom they named Hottentots. Attempts by the Dutch to turn the pastoralist Khoi into labourers were resisted.

Six years later, the settlers imported the first large batch of slaves – from the Dutch East Indies and East Africa – thus preventing the development of a white labouring class, and encouraging whites to believe that dark-skinned people were inherently inferior.

In 1806 Britain took over permanent rule of the colony and in 1834, as throughout the British Empire, slaves were emancipated. The most serious consequence of this in the eyes of the Dutch-speaking farmers – the Boers – was that within four years the slaves they so looked down on would enjoy legal equality with their former owners.

The racial intolerance which would deeply divide South Africa was already so ingrained that the Boers decided to leave the Cape and push north and east. Thus began the Great Trek.

Paul Grendon's twelve-metre long painting depicts the whole sweep of South African history, from the arrival of the first ships, through the Great Trek, to the exploitation of the land and the mineral resources of the region by capitalist interests.

The title of his painting, *Ons vir Jou, Suid Afrika* (We Are for You, South Africa), is the climactic last line of *Die Stem*, the official national anthem, usually sung by the *volk* with swelling voices and the deep emotion of patriotism.

'I've always wanted to do a painting subverting the national anthem and showing the real effects of the arrival of the various colonising forces,' says Grendon, a graduate student at the University of Cape Town. 'Like the Mexican and other muralists, I am interested in making large-scale paintings that can be used in public places with imagery that is totally accessible to everyone.'

▼ ONS VIR JOU, SUID AFRIKA 1985 OIL ON MASONITE 240 × 1200 CM

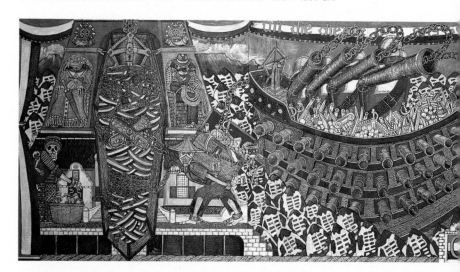

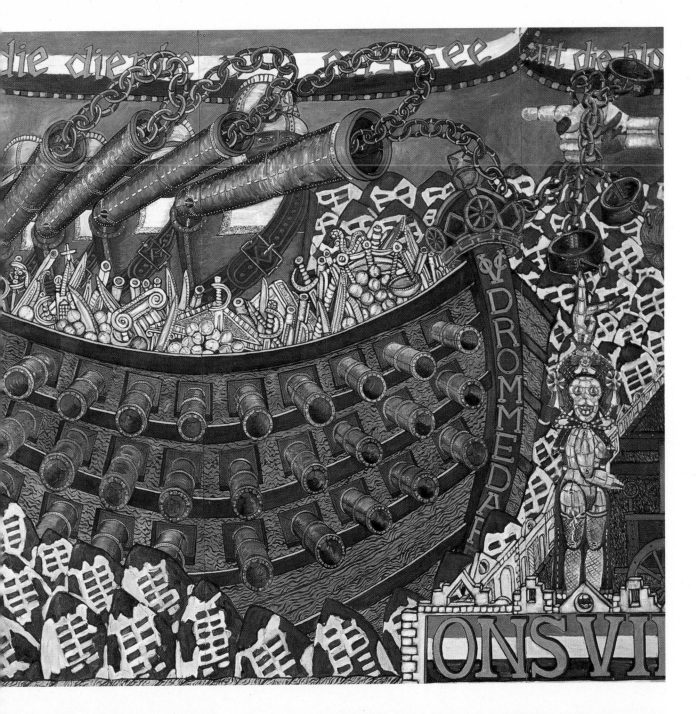

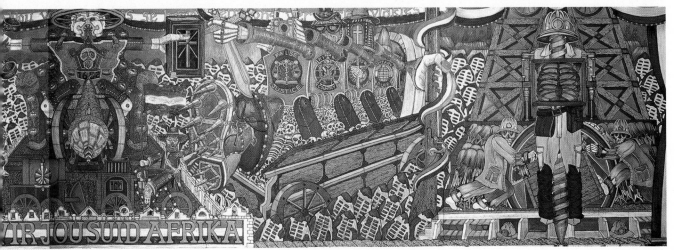

AZARIA MBATHA

Missionaries from Britain and Europe arrived at the Cape in great numbers during the nineteenth century, and started moving out and settling among indigenous communities. In missionary thinking, converting the heathen was inseparable from 'civilising' them – or encouraging them to adopt a way of life similar to that of nineteenth-century Victorians. Their teaching inevitably involved an attack on existing customs and institutions.

it. European, you came as a soldier and a missionary. You completely changed my world. Preacher, with your raised finger you showed me the way to salvation, but with your hand you tore my wives away from my side.'

About the past: 'The past is part of one's identity. Naturally we cannot live in the past, but we must live with it. We need to be reminded by and about our past, which we as Africans were compelled to forget.

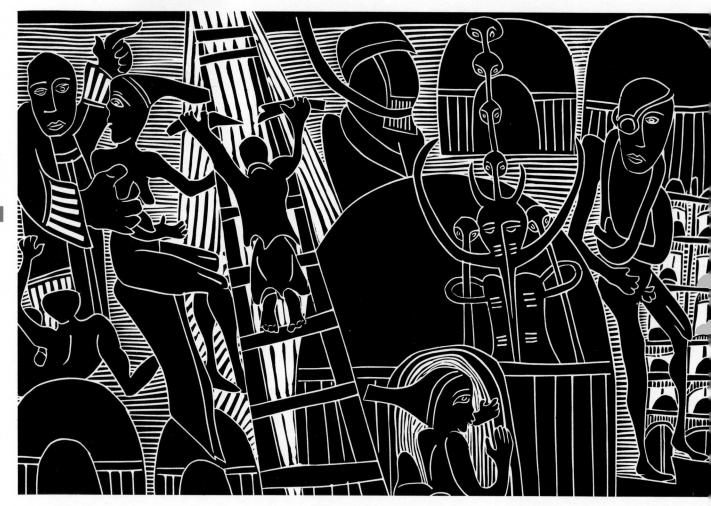

Azaria Mbatha was born in Zululand in 1941, and graduated from the Rorke's Drift Art Centre in 1964. Today he lives and works in Sweden.

About his print *The Ladder*, Mbatha writes: 'The African says, I was naked and wounded and hungry and blind. But I lived under a social order which made me feel secure and you destroyed

'Africans once were proud of their traditions, and some have begun again to study their origins. They understand that they were cheated. It was European civilisation which brought the end of African civilisation and replaced it with its own. I cannot find the words to describe what a terrible crime this is.'

▲ THE LADDER 1968 LINOCUT 40 × 57 CM

14

THE BATTLE 1987 OIL ON HARDBOARD 62 × 70 CM

JOSEPH MANANA

By 1838 the Voortrekkers – as the Boers taking part in the Great Trek were known – had reached Natal and were struggling with the Zulus, under their powerful chief Dingane, for possession of the rich grazing lands south of the Tugela River.

On 15 December, the Boers built a laager in a strong position alongside a river, and on the following day were attacked by Zulu impis, which, armed only with spears, were no match for the devastating Boer cannons. The victory was complete. So many Zulus flung themselves into the river that the water ran red with blood.

Joseph Manana, who was born in Natal in 1963, learned about the Battle of Blood River as a boy. His painting *The Battle* is a graphic depiction of the historic event in which his people fought so bravely. The fact that the Boer soldiers are in modern-day khaki uniforms is not significant. It is as Manana saw them in his imagination.

The scene in Manana's second painting takes place some forty years later, and shows King Cetshwayo carrying elephant tusks, with which he tried to appease the British. This attempt at reconciliation was to fail.

UNTITLED 1987 OIL ON HARDBOARD 54 × 72 CM

JULES VAN DE VIJVER

Vijver, legendary for his technical brilliance and inspirational teaching. He comments: 'After having worked in the Rorke's Drift–Isandhlwana area from 1976 to 1978, I started a series of silkscreen prints in which historical references and the South African landscape were used as a metaphor for the present. The major work of this period

being – like the African National Congress in the early 1960s – King Cetshwayo had been insisting on the need for peace. White aggression on the border led to the war, which resulted in the end of the autonomous Zulu nation and the personal loss of power and degradation of the Zulu king. History sometimes seems like a spiral. Dates are

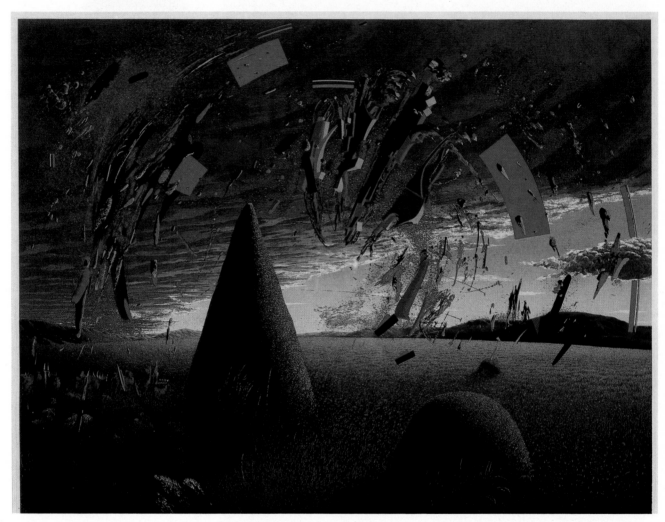

ISANDHLWANA 1879–1979 NO III – THE BATTLEFIELD 1980 SCREENPRINT 69 × 89 CM SOUTH AFRICAN NATIONAL GALLERY

Rorke's Drift was the scene of another famous battle, this time between the British and the Zulus in 1879. Today, the spot is marked by an art centre. It is perhaps not surprising that a number of the artists who have passed through the centre have taken as a theme for work the battles of Rorke's Drift and Isandhlwana.

One was Dutch-born Jules van de

was *Isandhlwana 1879–1979*, a series of three large multi-coloured silkscreen prints. They "commemorate" the Zulu War in the course of which, at the Battle of Isandhlwana, Lord Chelmsford's army was defeated by the impis of King Cetshwayo.

'This was the last instance in which a black South African nation was able to resist white colonial power: the tragedy

arbitrary names for points in time. *The Battlefield* shows the struggle between tribe and emerging industrial might. It is a picture of violence and silence.'

JOHN MUAFANGEJO

The Battle of Rorke's Drift followed hard on the heels of the Battle of Isandhlwana. Two Zulu *amabutho* – regiments of young men of the same

was the linocut, printed almost always in black 'because it doesn't tire the eyes'. Reviewing his London exhibition in 1983, the critic Edward Lucie-Smith wrote that it represented 'consistently the best of all the modern African masters of this medium – Muafangejo is a printmaker of world class.'

Muafangejo was a Kuanyama of the Ovambo people who straddle the war-torn border between Angola and Namibia. A deeply religious man, the con-

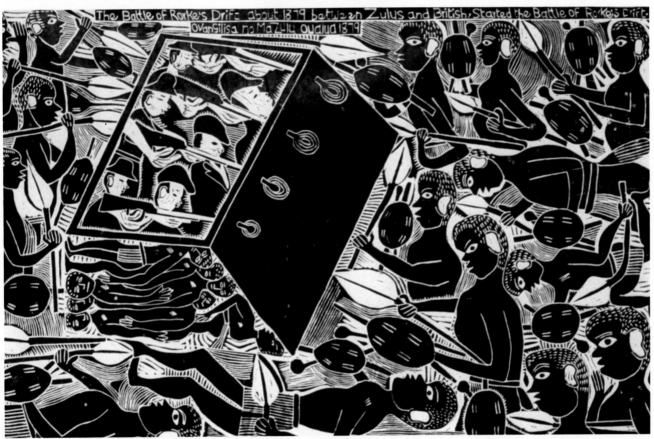

age – disappointed at not having been involved at Isandhlwana, crossed into Natal and attacked the border post of Rorke's Drift. The British defenders, firing from behind a hastily built wall and the mission hospital building, succeeded in staving off the attackers who, satisfied that they had seen some action, withdrew in the morning. Unaware of the events at Isandhlwana, the defenders believed they had saved Natal from a massive invasion.

John Ndevasia Muafangejo's linocut *The Battle of Rorke's Drift* is one of the few he did on an historical subject, but like almost all of his work, is filled with action. The composition is strong, the lines crisply incised, and the massed figures cram the space.

Muafangejo was a graduate of the art centre at Rorke's Drift and lived and worked in his native Namibia until his untimely death at the age of 43 in November 1987. His chosen medium

flicts between church and state, the violence which beset his land, the racial prejudices of society and his own desire for reconciliation are all reflected in his prints. Denying that his work was political, Muafangejo once replied, 'It is the world which is political.'

▲ THE BATTLE OF RORKE'S DRIFT 1981
LINOCUT ON PAPER
41 × 70 CM
TATHAM ART GALLERY

ANDRÉ VAN ZIJL

'The house I first knew was surrounded by trees and Africans, pythons, locusts, leopards; and I didn't know that it would all change. Such is the longing of youth.'

André van Zijl was born in 1951 in what is now Zimbabwe, the son of a farmer; and the nostalgia for the rich, magical surroundings of his childhood is also a nostalgia for his lost innocence. Not only would the bush itself change, but maturity would reveal new truths. In the Africa he perceived as perfect then, the rot had already set in.

Since his first exhibition in 1972, the main body of Van Zijl's work has dealt with these twin themes: the natural paradise in which man and nature existed in harmony, and the desecration of this paradise by the sometimes well-meaning but ultimately greedy and arrogant settlers who came bearing the flags of far-off countries to claim it for their own.

'One is trying to work within the parameters of a soiled Eden,' says Van Zijl. 'My work is commentary, it is critical, but I couldn't support such observation of abuse and exploitation if I wasn't convinced that the artist has a role in fostering the idea of a communication that goes beyond words, and is in fact an affirmation of life.'

Van Zijl's communication with his public has in many instances taken the form of witty, densely packed pictures filled with sharply barbed visual puns that destroy the sacred cows of Afrikanerdom and British colonialism alike.

That venerated architectural detail, the Cape Dutch gable, appears on top of a shaky little boat of settlers, forcing it to tilt dangerously. Pontificating politicians address the bare veld. To build up his evocative pictures, Van Zijl combines images taken from old photographs, sketches drawn from his own forays into the bush, brilliant splashes of African patterning, and references to art historical material, reworking it all to give new perspectives. His draughtsmanship is fluid and sure.

The Long Summer could have been lifted directly from one of those old sepia photographs found in family albums. The scene is a spacious verandah. It is the high noon of the Empire, the supremely self-confident years before the outbreak of the Anglo-Boer War. A group of colonials pose — elegant, smug, insular. In the background, a black servant, certainly one of many, hovers with a tea tray. On the lawn stand the hunters next to their kill. The natural denizens of Africa, the black man and the buffalo, have been relegated to the subservient roles assigned forcibly to them by the white intruder.

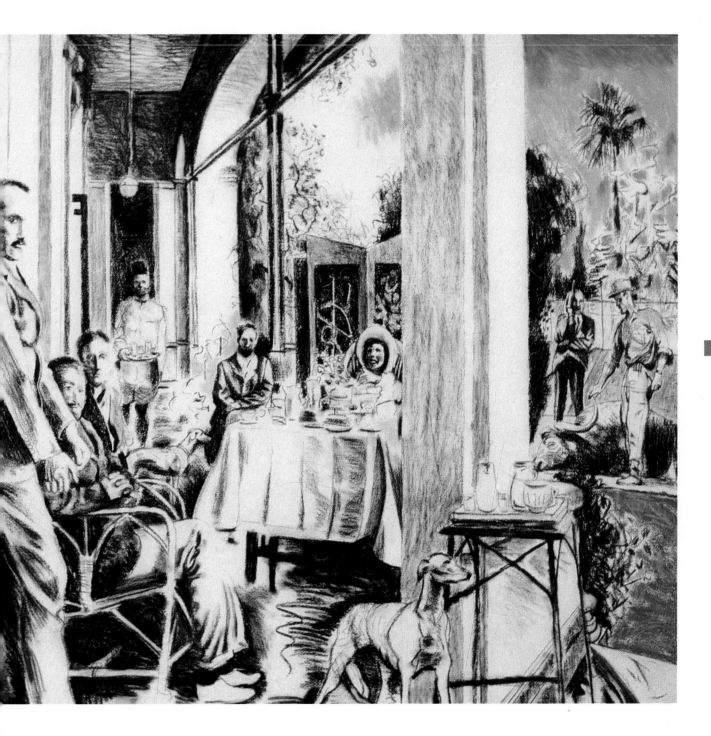

19

THE LONG SUMMER 1988
MIXED MEDIA ON PAPER
150 × 200 CM

PENNY SIOPIS

In 1652 South Africa was a country waiting to be discovered and civilised. The indigenous San people were irrelevant and deserved to be exterminated. Bantu tribes had pushed down from other parts of Africa, so had no real claim to the land. On top of that blacks were lazy/stubborn/treacherous, and categorised by the Bible as hewers of wood and drawers of water. The Boers, on the other hand, were God's chosen people and hardworking/far-sighted/

them, and we copied them for our history projects.'

Her *Patience on a Monument – 'A History Painting'* takes a critical look at history as recorded from a dominant white patriarchal point of view. Traditionally, history paintings, often authorised by the state, are heroic in character, and allegedly objective accounts of what

Siopis's work before. It's an Anton van Wouw bronze cast in 1907, a museum favourite with a secure niche in South African art history. 'For me, in the popular imagination it refers to the tradition of the noble savage – which, given the history of racism in South Africa, is significant,' says Siopis.

The background of the painting is a vast vista, sweeping backwards and fading into time and space. Closer inspection reveals that the landscape is composed of myriads of those school history textbook and other illustrations (photocopied, stuck down and painted over) of adventurers, missionaries, Boers, black warriors, slaves, British redcoats, Voortrekkers, traders and others – a record of South Africa's past

brave. The British were sometimes well meaning but tied to England's apron strings. As for women, they hardly rated a mention.

This is the view of South Africa's history absorbed by generations of the country's schoolchildren – black and white – from state-sanctioned textbooks.

'We were brought up on those stereotyped images of colonised and colonisers,' says Penny Siopis. 'Our textbook stories were illustrated by

really happened.

In Siopis's painting, a monumental black female figure – 'anti-heroic, an inversion of Liberty leading the people' – sits casually on a pile of natural waste and the debris left behind by 'civilisation' – including fruit peelings, a stretched canvas, a dead bird, objets d'art, a skull, models of a pregnant womb and a broken heart, a little handbag, ornamental fittings, an open book, and two views of a bust of a black man.

This bust has made its appearance in

from a specific and prejudiced point of view. It is all behind the seated woman, who is engaged in the very ordinary domestic activity of peeling a lemon.

The terrain of sexual politics and its part in the landscape of oppression and discrimination is one that Siopis has explored with considerable energy.

By using the tradition of Western painting with illusionism as its dominant mode, then subverting or deconstructing it, Siopis focuses our attention on the prejudicial ways the 'other' –

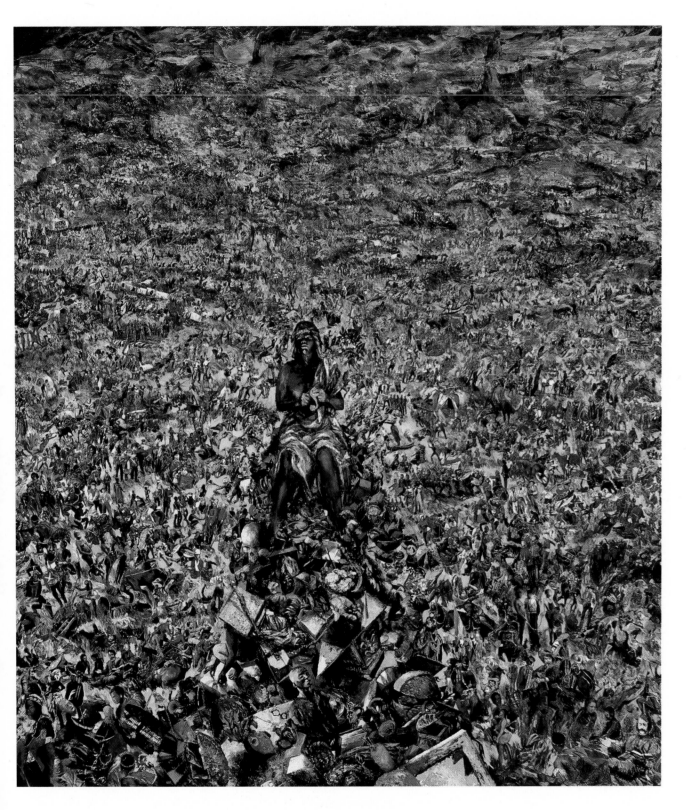

PATIENCE ON A MONUMENT – 'A HISTORY PAINTING' 1988
OIL PAINT AND COLLAGE
200 × 180 CM
WILLIAM HUMPHRIES ART GALLERY, KIMBERLEY

blacks, females, exotics, etc. – have so frequently been (mis)represented in that tradition.

Her work is theatrical, baroque, glowing with deep, rich florid colour that deliberately 'plays' with high art conventions. Many of her pieces are set in an artificial, interior world. Harsh daylight is shut out, everything is artfully arranged to create a certain effect, and each object and piece of flesh has its own place and significance. Empty frames, statues, lavishly draped curtains emphasise the artifice of the setting.

In *Dora and the Other Woman*, the stories of two very different women are intertwined against just such a background.

Dora was a young woman from the Viennese bourgeoisie at the turn of the century, sent by her father to Sigmund Freud for treatment for 'hysterical unsociability' when a suicide note from her was discovered. In fact, her psychological problems were related to her social milieu – she had little, if any, scope for independent activity, and believed (Freud agreed) that she was being used as a pawn in a game between her father and the husband (Herr K) of her father's mistress – 'give me your wife, you can have my daughter'.

'I am interested in the way certain feminist re-readings of Dora's case see Dora (in particular) and hysteria (in general) as a sign of woman's resistance to patriarchal domination or her protest against the "colonisation" of her body,' says Siopis.

For Siopis, the cases of Dora and Saartje Baartman, the 'other woman' in the painting, embody, quite literally, politics: the degrading treatment they received was because of their sex and, in Saartje's case, her race as well.

Saartje was otherwise known as the 'Hottentot Venus'. Her distinctive anatomy caught the eye of the brother of her employer, a Dutch farmer near Cape Town, who suggested to Saartje a trip to England and Europe to exhibit herself. A share in the profits was promised.

On arrival in London in 1810, Saartje immediately went on exhibition, causing a sensation, and after a long tour of the English provinces, travelled to Paris where an animal trainer put her on show for fifteen months.

Saartje did not return to Cape Town a wealthy woman but was to die of an inflammatory ailment in 1815, after

AN 1817 LITHOGRAPH OF SAARTJE BAARTMAN, 'THE HOTTENTOT VENUS', ILLUSTRATING AN ACCOUNT BY GEORGES CUVIER OF HER AUTOPSY IN PARIS

which her sexual organs were dissected and can still be seen in the Musée de l'Homme in Paris.

Why was Saartje such a spectacle? On the racist ladder of human progress, 'Bushmen' and 'Hottentots' were on the lowest rung just above the apes. Contemporary commentators emphasised their simian appearances – 'the women even more repulsive than the men' – and their brutal habits. These allegedly scientific observations were made, of course, in order that the white European male might preen himself on

account of his own supposed superiority.

There was another reason for Saartje's popularity: her enormously protruding buttocks and a flap of skin known as the 'Hottentot apron' covering her genitalia won her fame as a sexual object. Thus her combination of supposed bestiality and pronounced sexuality proved an irresistible fascination for the crowds who came to stare and poke.

In *Dora and the Other Woman*, nineteenth-century representations of Saartje are pinned to the drapery which half conceals Dora's body. These show Saartje being looked at from all angles, often with the aid of a magnifying glass or telescope. It was mostly through optical means that these Europeans had access to the exotic 'other'. Looking may be seen as a way of possessing with the eyes.

Siopis's deep interest is in the way prejudice operates in those historical images and texts which appear objective, harmless or 'natural'. For her, Patience, Dora and Saartje epitomise those kinds of (mis)representations of cultural identity, gender and race.

'I work within the tradition of Western painting in ways which attempt to turn its own values against itself, to show that it is not only the representation of politics that is an issue, but the politics of representation as well,' says Siopis.

▶ DORA AND THE OTHER WOMAN 1988 OIL PASTEL ON PAPER 153 × 120 CM

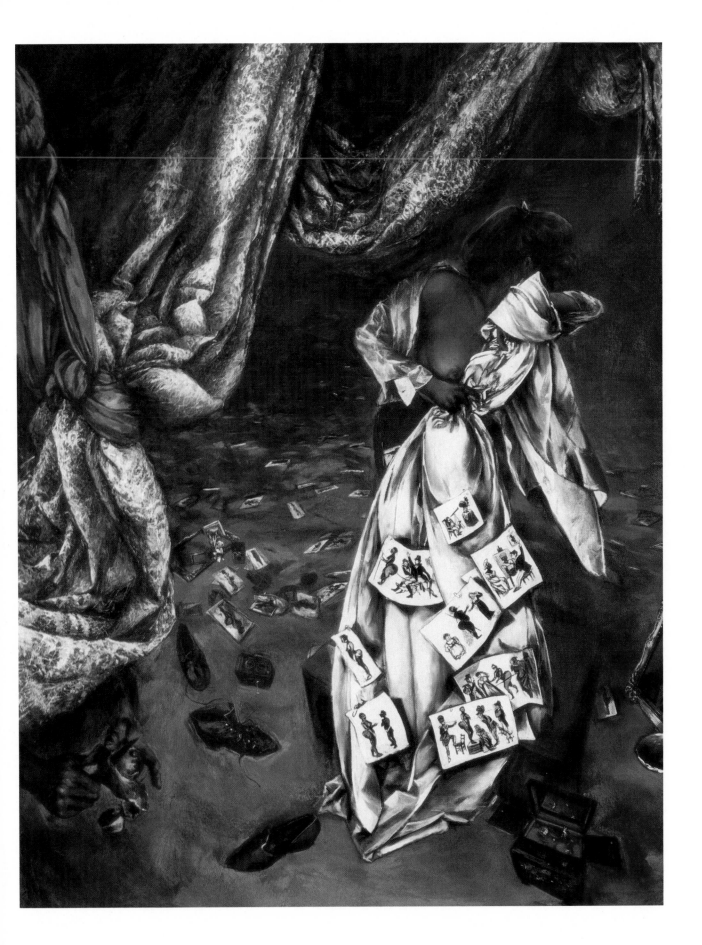

The few tiny groups of San who still exist today in the Kalahari Desert in Botswana are avidly studied by anthropologists, and have been the subject of a number of documentary films. But to the Dutch farmers of the eighteenth century the nomadic San, or Bushmen as they called them, were vermin to be tracked down and ruthlessly exterminated.

In South Africa, all that remain of the

PIPPA SKOTNES

structures and objects left behind by the plundered and the plunderers — constitute much of Skotnes's artistic vocabulary. Traditional etching techniques, sensitive crosshatching and aquatinting on copperplate produce tones down into the deepest velvety blacks. The prints have an air of melancholy and a strange, heightened reality.

A 1986 series of etchings entitled *Adventures in a Southern Wonderland*

THE RETURN II 1987 ETCHING 44 × 64 CM JOHANNESBURG ART GALLERY

San are their beautiful and elegant rock paintings, executed in the colours of the earth, and to be found in shallow caves right across the country. It is known that painting was central to the life of the San people, that the images often referred to the state achieved in the trance dance when man would be imbued with the strengths and skills of the animals he hunted, but the precise interpretation of these images is often elusive.

'Style and the Recovery of Meaning in Southern San Rock Paintings' is the title of a thesis for a Master's degree in archaeology being worked on by printmaker Pippa Skotnes. Any weekend, one might find Skotnes crouched under a low overhang of rock somewhere, tracing, with infinite care, a section of faded rock painting onto a little square of paper. One such complete tracing covers a wall of Skotnes's studio, an extraordinary meshing of starry forms and floating dreamlike figures.

Images from the past – the marks,

chronicled the exploits of Bloodlust, Prejudice and Greed in a paradise abundant with wild life and the San people.

Kolmanskop is a deserted mining town in Namibia, the once fine buildings half buried in sand. In a series of three etchings entitled *The Return*, crippled and bound figures drawn from the faded friezes of San paintings attempt to repossess what once was theirs.

▲ THE RETURN III 1988
ETCHING
45 × 60 CM

THE RETURN I 1987 ETCHING 45 × 60 CM

PAUL EMSLEY

In Paul Emsley's conté chalk triptych *The Visit*, the entire cycle of the white man's term in southern Africa – which Emsley sees as transitory – is played out from the moment of his emergence from the sea to his final departure. 'In a sense,' says Emsley, 'I feel we've never been assimilated, Africanised, and never will be. After all these generations, in spite of ourselves, we are still European.

'There is a way of looking at things which is very European – the skies in Europe are dark, the light more subtle. Forms are clearly defined by that light and by the shadows it creates.

'When Matisse came to Morocco he found the light dazzling, flattening out the shadows. It made him look at things quite differently, and coming back to Africa from Europe, I found that too.'

Some years ago, Emsley was known for his highly colourful expressionistic paintings, but growing dissatisfied with what he saw as an artistic cul-de-sac, he restricted himself to drawing from nature, studying trees, insects and clouds and carefully applying the lessons of the old masters in defining form through the meticulous use of light, shadow, and reflected light. This has led to a new body of work in which Emsley has emerged as a master draughtsman.

His triptych *The Visit* is a highly dramatic piece with almost as many themes and sub-themes and incidents and cross-references as an epic movie. The title refers not only to the white man's sojourn in southern Africa but also to the religious term 'visitation' – the arrival of a personal message or a severe affliction sent by God, and moreover, to 'the brief and mysterious visit of each of us to this world'.

In the first panel, *Arrival*, the awkwardness of the figure as it attempts to leave the water and scramble up onto the shore gives a foretaste of the difficulties that lie ahead. This moment of entry has none of the grace of the Birth of Venus, arising smiling from the waves.

The central panel depicts the present. The dwarf from Velasquez's *Las Meninas* is a key figure. 'I believe that the artist used her as a metaphor for the darker side of reality, those aspects of life we try to deny,' says Emsley. 'That darker side has manifested itself in a crucifixion, a Casspir [police vehicle], a refugee, a burning township, the indifference of a dozing dog, and a bride who represents my recent divorce.'

Departure is the final act, and like a Shakespearean tragedy, ends in death. Against an explosive sky, a helicopter hovers, ready to evacuate. Figures huddle round a body on a stretcher. Emsley has taken this body, the two ambulancemen and the policeman from photographs of Dr Verwoerd, the South African prime minister, after his assassination in 1966. The naked foot

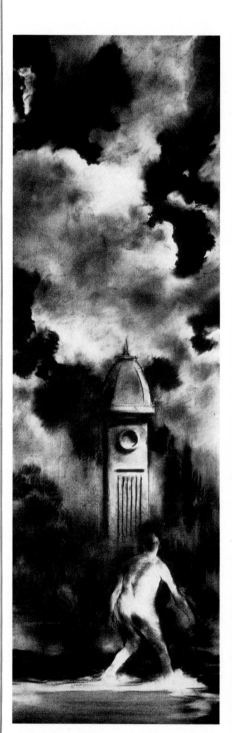

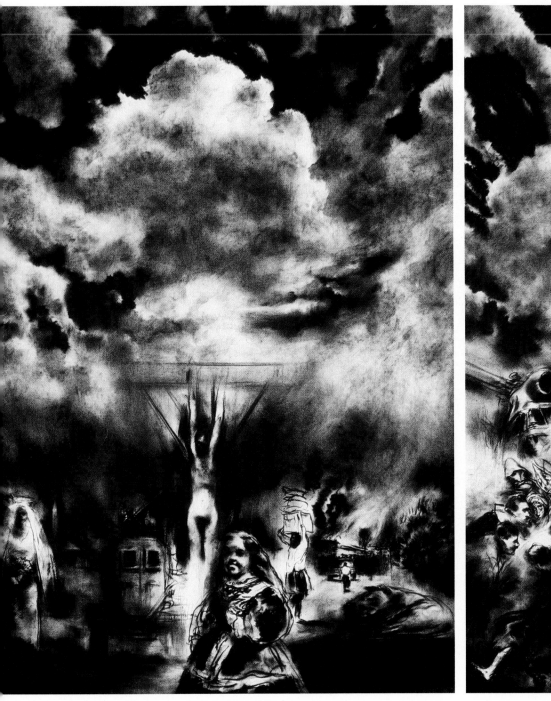

THE VISIT: ARRIVAL, THE LIFE AND THE TIME, DEPARTURE 1987
TRIPTYCH
CONTÉ AND CHALK ON PAPER
93 × 30 CM, 93 × 66 CM, 93 × 30 CM

refers to the process of dying, one foot in this world and one in death. The drama has played itself out.

In 1977 Emsley left South Africa to make a new life in England, but found he was unable to stay away. Preparing to come back, the news of the death of Steve Biko and the massacre of a group of missionaries at Elim in (then) Rho-

the unease of my thoughts combined to make one of the most intense and memorable moments of my life. Looking up at the sky, I felt the presence of the victims, and it did not take much for me to imagine that I could see the ghost of Biko encountering those of the Elim victims across Table Mountain.'

In *Untitled with Table Mountain*, the

desia shocked him deeply. 'These two tragedies seemed to signify the awful polarities of southern Africa.'

On his return, Emsley found himself walking along the beach at Blouberg-strand, with the famous view of Table Mountain across the bay. 'The huge atmosphere of Africa seemed very tangible at that time. The elation at being home, the beauty of the place and

figure with the mountain in its head is autobiographical. 'The figure is asexual to indicate the impotence I felt in the face of such enormous problems. Facing this figure is another — arms tight, fists clenched, phallus erect. Black anger, frustration and urgency. Behind lies Table Mountain, symbolic of the arrival of the white man at the bottom end of Africa.'

▲ UNTITLED WITH TABLE MOUNTAIN 1979
OIL ON CANVAS
127 × 158 CM
SOUTH AFRICAN NATIONAL GALLERY

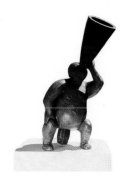

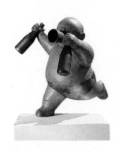

A MUTANT SOCIETY

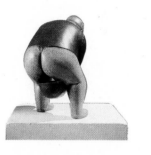

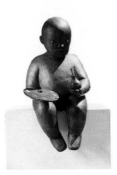

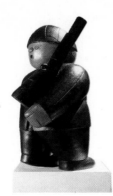

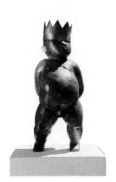

BRETT MURRAY – PAINTED RESIN SCULPTURES

WILLIAM KENTRIDGE

Pierre-Auguste Renoir's famous painting *The Boating Party* gives us a vision of a golden world, shimmering with light and intoxicating colour, in which relaxed diners laze on the verandah of a riverside inn.

'The great Impressionist and Post-Impressionist paintings give me such pleasure,' says artist William Kentridge, 'a sense of well-being in the world, a vision of a state of grace in an achieved paradise.'

terms of human misery. In bad years peasants starved in the countryside around Tiepolo's ceilings. But in paintings of the time the effect is not of history distorted but of a benevolent world. However, it is one thing to be grateful for those lies and quite another to perpetuate them.'

In a recent interview with the Johannesburg *Weekly Mail*, Chris Hani, chief-of-staff of Umkhonto we Sizwe, the military wing of the African National

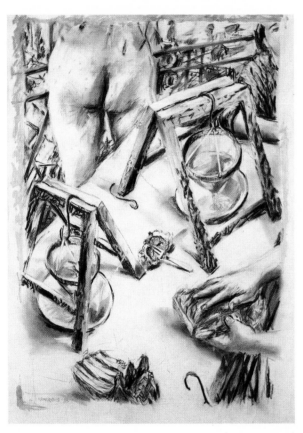

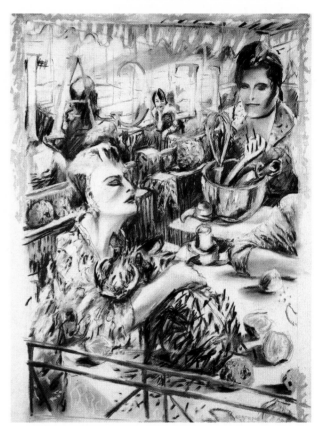

He based his mixed-media triptych *The Boating Party* (1985) on Renoir's painting. But the idyllic scene has changed to one of horror. The diners still seem to be languid, at ease, but a warthog which appears in the first panel is cut up and appears as a jelly in the third, and behind the back of the elegant woman a burning tyre falls.

'The state of grace is inadmissible to me,' says Kentridge. 'I know this is contradictory. The world has not changed that much between then and now in

THE BOATING PARTY 1985
TRIPTYCH
CHARCOAL AND PASTEL
ON PAPER
150 × 78 CM EACH

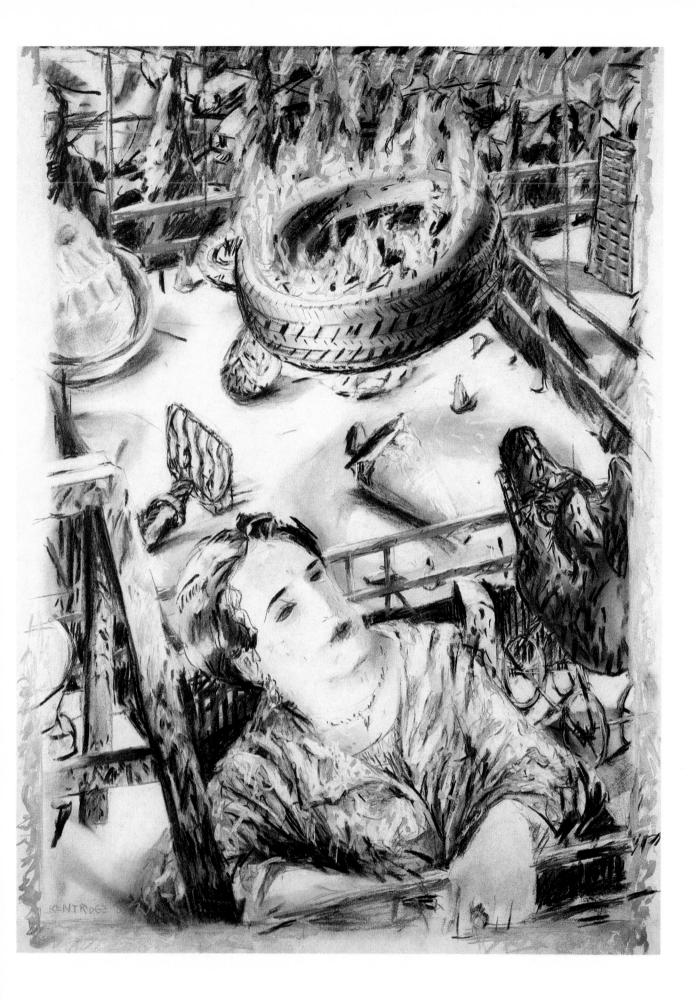

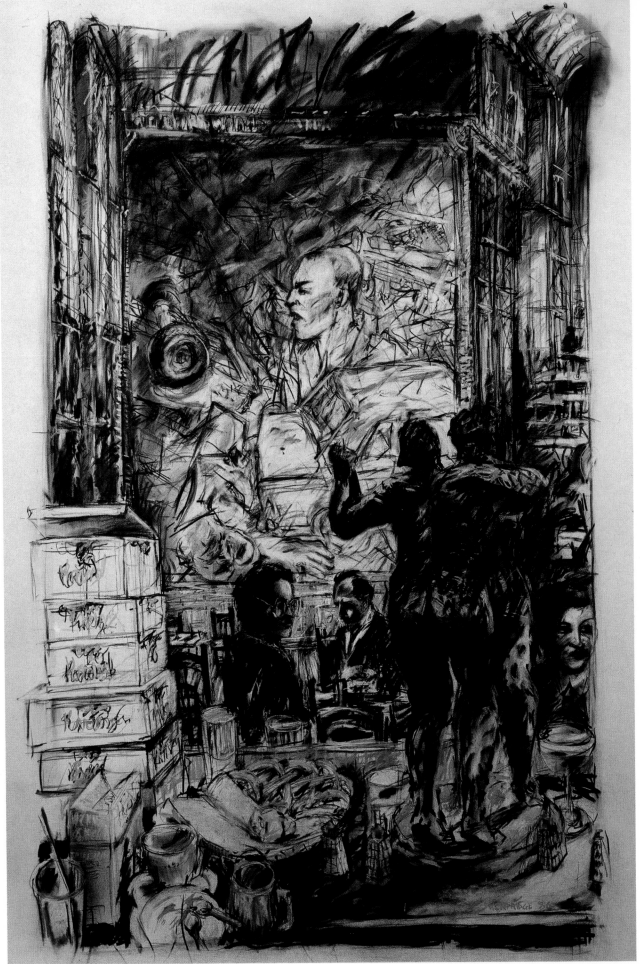

BREAKFAST IN THE ANTECHAMBER 1985 CHARCOAL AND PASTEL 120 × 100 CM

Congress, had this to say about white South Africans: 'Their life is good. They go to their cinemas, they go to their braaivleis [barbecues], they go to their five-star hotels. That's why they are supporting the system. It guarantees a happy life for them, a sweet life. Part of our campaign is to prevent that sweet

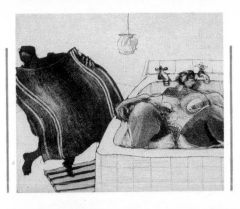

burg's centennial year.

Kentridge puts forward as his symbol for the city's hundredth year a bloated businessman grown rich on the gold that brought Johannesburg into instant being in 1886. The celebrations were, in fact, cancelled after an outcry from concerned citizens who felt that the city

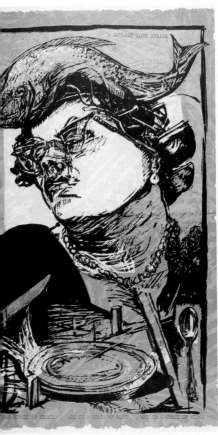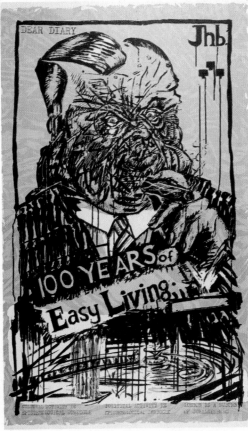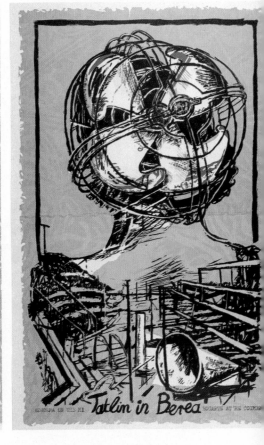

life.'

Hani could have been talking about the diners in Kentridge's *Breakfast in the Antechamber* (1986), seemingly unaffected as yet by the kind of war-movie background to their meal.

'I suppose I'm interested in doing the opposite to a movie poster, which fragments its plot into a number of little scenes,' says Kentridge. 'I take a number of very different, contrasting images and put them together to make a coherent whole.'

Skirmishes on the home front were recorded in a 1981 series of small etchings called *Domestic Scenes*. In *Woman in*

Bath with Companion and Light, the towel held by the attending maid becomes a possible instrument of suffocation.

Kentridge's love of posters led to three striking silkscreens being made in 1988 – *Art in a State of Grace*, *Art in a State of Hope* and *Art in a State of Siege*. The first is about an art that sees no further than its own pleasant horizons; the second believes optimistically that art can help to bring about the success of the revolution; the third concedes the possibility of defeat. The imagery used in this poster draws on the planned celebrations for Johannes-

had nothing to be proud of. Kentridge's powerful image, with its overtones of George Grosz's comments on Nazi Germany, reinforces that view.

▲ WOMAN IN BATH WITH COMPANION
▲ AND LIGHT 1981
 ETCHING 20 × 30 CM

◄ ART IN A STATE OF GRACE 1988
 SILKSCREEN
 160 × 100 CM

▲ ART IN A STATE OF SIEGE 1988
 SILKSCREEN
 160 × 100 CM

► ART IN A STATE OF HOPE 1988
 SILKSCREEN
 160 × 100 CM

DEBORAH BELL

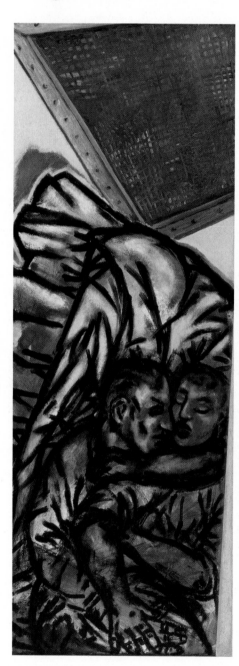

The subjects of Deborah Bell's paintings react blindly and instinctively in their strange claustrophobic settings. The heavy clothes ('drapery is flayed flesh for me – in clothing the figures, I'm showing their inner turmoil'), the tilted, enclosing perspectives of the interiors give a sense of players inextricably enmeshed in a turgid dead-end situation in which they are without

much the current South African iconography of hyenas, spotted dogs and crocodiles. Once you start seeing these images crop up frequently in student work, you know they have become clichés.'

Side Show is one of Bell's most recent paintings, a work in which the materials used for constructing the props – 'the thingness of things' as Bell puts it –

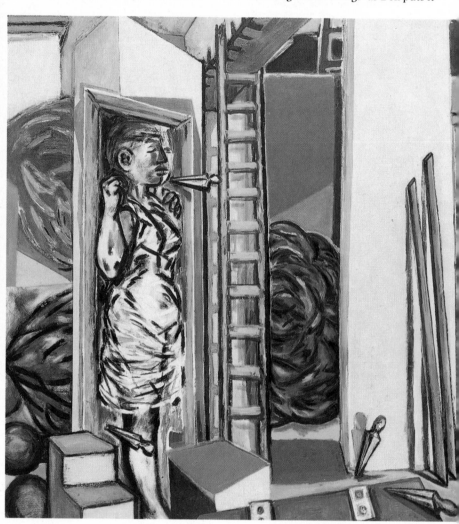

▲ SIDE SHOW 1988 TRIPTYCH OIL ON CANVAS 180 × 65 CM, 155 × 155 CM, 180 × 65 CM

The closed world lovers create for themselves is sometimes born out of desperation and fear of what lies outside, rather than a need to share sweet secrets. Their embrace can become a struggle for life, a metaphor for much broader social and psychological issues.

true will, programmed to behave in certain patterns. In this world, violence and isolation are endemic.

'The claustrophobia that I feel impelled to induce, painting the characters into tighter and tighter corners, is on one level the claustrophobia I feel in this country,' says Bell. It is her way of painting the situation. 'I dislike very

have almost as significant a role as the five seen and one unseen (except for the hand) players. Nails, mesh, woodgrain, hinges, bolts, strange ballooning swathes of fabric – all are rendered fairly crudely, the inanimate objects pressing down and obstructing the players with a malevolent life of their own.

The female target for the knife-

thrower is also an artist's model and a painting enclosed in a frame. Her hands raised in supplication or defiance, she is totally dependent for her freedom on the intentions of the knife-thrower—artist. A ladder near her implies escape

but it is jammed tight underneath an overhanging truss. However, there is a glimpse of a ladder outside – which may lead somewhere. . . .

A Soldier's Embrace (1985) was the drawing Bell submitted for the Detain-

his job. I wanted to show that male sexuality and the desire for power and domination are all linked. The baton is a symbol of that. The background detail is from Piranesi's engraving of a mad-house. You can see those little rings

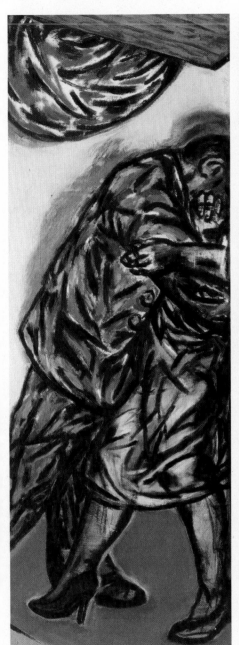

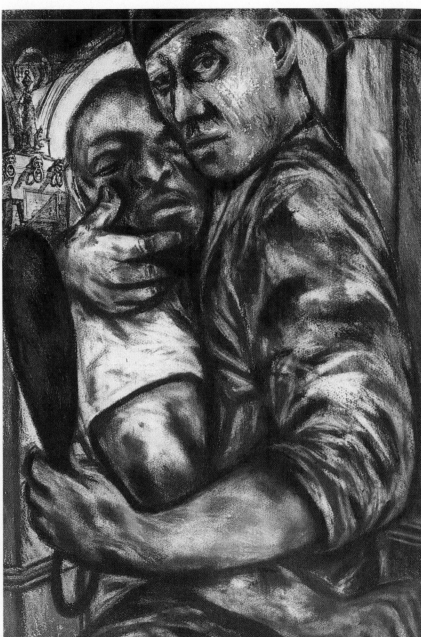

ees' Parents Support Committee show at the Market Gallery in Johannesburg in January 1988. 'It was from a photograph of Gideon Mendel's of a policeman grabbing a black demonstrator. It was a very sexual embrace for me. That policeman was getting pleasure out of

people would be tied to.

▲ SOLDIER'S EMBRACE NO. 2 1987
CHARCOAL AND PASTEL ON PAPER
700 × 490 CM

M MAKGABO MAPULA HELEN SEBIDI

▼ TEARS OF AFRICA 1988
CHARCOAL AND COLLAGE ON PAPER
200 × 800 CM

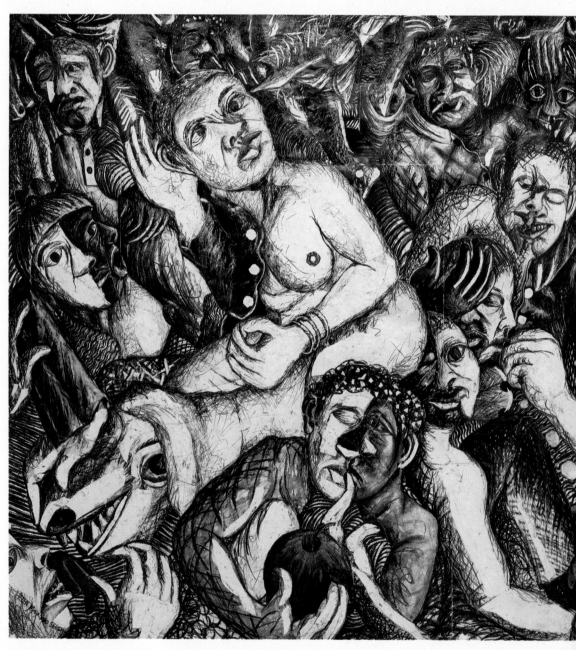

When traditional cultural patterns are callously destroyed, an entire society can lose all sense of direction.

'People don't know where they want to go. They're unhappy. It's quite heavy for a black woman. When she has to talk she is not allowed to. There is something blocking her. "It's on my shoulder, how can I move this load from my shoulder?" She is not free. When you are in the backyard you can't get out – it's a very big mess in Soweto.'

Mmakgabo Mapula Helen Sebidi's drawings are mass portraits of the disrupted society created by exploitative legislation which treats Africans as labour units.

Well-paid jobs are scarce. Men who are unable to bring home enough money to support their families lose authority. 'He has been kept as a woman under the white man's shoulder instead of trying to create his own work. If he says to his family, "I'm not having a job," they'll say, "Go into the street and look for a job."'

Sebidi's work is quite confrontational. 'When you go to the location you're getting squeezed houses,' she says, and every inch of her picture surfaces is covered with bodies. They're jammed up against the edges. They push and shove in the struggle to survive. There's no room to breathe here. No time to stop and relax a moment. One is reminded of the commuter trains which carry workers between Soweto and central Johannesburg, crammed so tight that people hang out of the open doors and a man can be stabbed in the back and his body won't fall down.

The animals in Sebidi's work are used as symbols of certain aspects of human nature or metaphorically. 'In the Garden of God animals were there first – the animals taught the people. In our culture, we don't say a thing

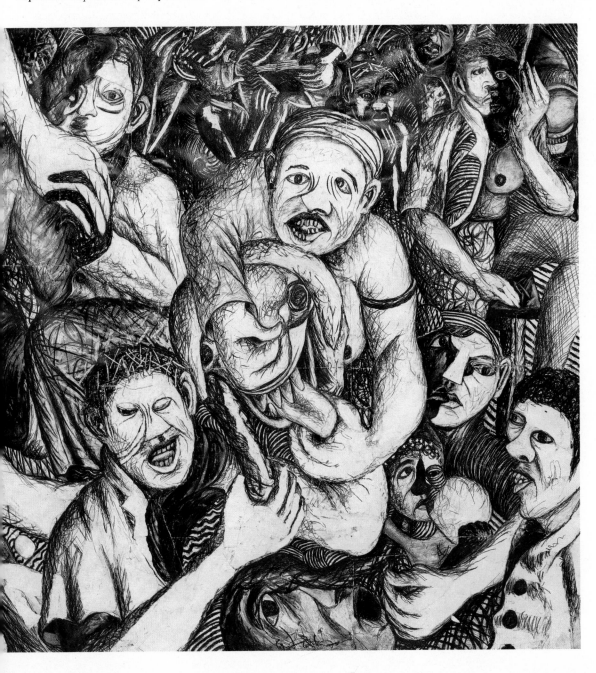

straight out – if you are having a hard life, we won't call your life bad, we will go around, we will say, "You are fighting with an animal, and if you catch his tongue then you will come right."'

The Standard Bank Young Artist for 1989, Sebidi has definitely come right in an artistic sense.

The story of how she became an artist in the first place is the stuff movies are made of, featuring spirits from the past, an influential and artistic grandmother, an inauspicious beginning to her working life, a sympathetic employer and various mentors along the way.

'When I came to Johannesburg, I didn't know anything about art. I started domestic work – but I was hitting my knees when I cleaned – I think the art was talking to me.

'Then I met a German woman and worked for her – she helped me. One day she did a painting of a woman and children. When I saw it I felt I must do painting, so I painted some traditional people on a piece of cardboard. After that I couldn't stop. I met Koenakeefe Mohl, from Soweto, and I studied two years with him.' This period came to an end when Sebidi went home to look after her grandmother Metato and stayed for eight years.

'She was a very big decorator. When people were painting their walls they wanted her to be there. She would say, "I'm not going to drop what I was gifted with," and that encouraged me. She was 108 when she died, but still very young.'

The family home is at Skilpadfontein – or, in Tswana, Marapyane, which means 'small bones'. When Sebidi's people moved to the area from present-day Pretoria in the early eighteenth century they found a lot of little bones in the ground. 'People had died there – no one knows how. I'm getting this name Marapyane inside my work – maybe those dead people have dropped something there. It's a very strong country. People say, "Can't you see how the tree moves? Hold yourself like that tree." If those people didn't have themselves I wouldn't have my art.'

In 1984 Sebidi returned to the city and started to take classes at the Johannesburg Art Foundation. An experimental workshop in collage held in October 1987 led Sebidi to much larger scale and a freer, more powerful way of handling her material.

Mother of Africa is about the woman who is left behind in the country while her husband goes to the city to work. 'The woman is carrying the cross. She still loves him even though he has dropped her. She works, she cooks, she does everything. How she is struggling. What was supposed to be gained has been destroyed.'

Dislocation and confusion is the theme of *Where is My Home? – The Mischief of the Township*. 'Where do people belong? Not in their traditional home, and not in the city either.'

On the importance of art in her life, Sebidi says, 'My work is showing me the way I should go. I am creating the best in my own way.'

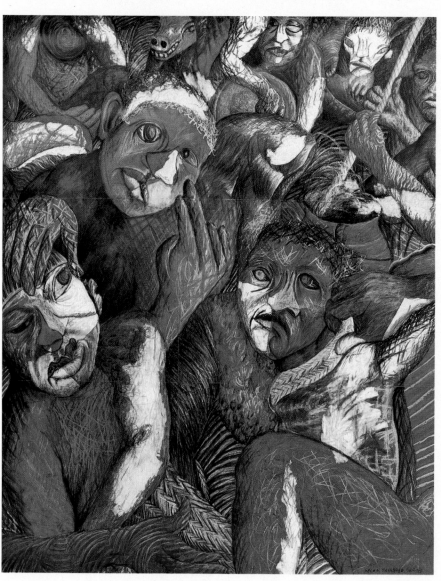

◄ MOTHER AFRICA 1988
PASTEL AND COLLAGE ON PAPER
162 × 128 CM
UNIVERSITY OF BOPHUTHATSWANA

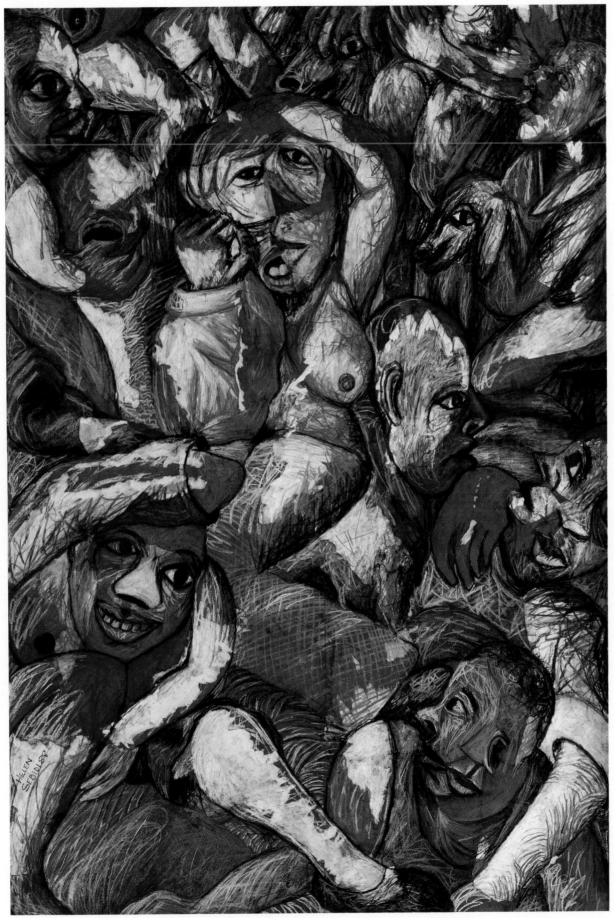

WHERE IS MY HOME? – THE MISCHIEF OF THE TOWNSHIP 1988 PASTEL AND COLLAGE ON PAPER 200 × 147 CM

THE WOMEN OF THE VALLEY

In the beautiful Valley of a Thousand Hills, where the rolling green hills are speckled with villages of the beehive-shaped Zulu huts, the pace of life is slow and easy. Crafts are practical: handsome baskets for storage, rush and grass sleeping- and eating-mats, pottery and beadwork. Traditionally, beadwork is worn by both men and women, but to make it is women's work, and the skill is passed down from mother to daughter.

In 1980, a small revolution in traditional beadwork took place. More and more of the colourful necklaces and bracelets were being made specifically for the tourist trade, but now Thembi Mchunu took cloth and stitched a 'doll' – very different in style and concept to anything which had been seen before – which she dressed in contemporary *amabinca* clothing decorated with beadwork. She took the doll to show to Jo Thorpe at the African Art Centre in Durban, an important outlet for black crafts. It was received with approbation. Other beadworkers followed her lead, and slowly a new art form was born. That first doll led to a whole series, some of them set in complex tableaux. Treatment became increasingly sophisticated, and most interestingly, a subtle and possibly unconscious form of social comment became apparent.

One is reminded of the women of

Chile, where a group of women in Santiago, many of them victims of political repression, started in 1975 to make 'arpilleras – embroideries of life and death' which chronicled their lives.

In a bead and cloth sculpture by Sizakele Mchunu, a distraught black mother rolls in grief on a mat next to the coffin of her dead baby. Bright scraps of coloured material decorating

THANDI AND SIZAKELE MCHUNU

the coffin represent the flowers which at black funerals are usually pulled out of bouquets and placed singly on the grave.

The sorrow which Sizakele portrays in her coffin sculpture is balanced by an engaging scene in which a mother leans over her newly born twins on a high hospital bed. A policeman stitched by Thandi Mchunu is dressed in a grey uniform with shiny buttons, a figure of authority.

Front. Although the leaders of both organisations repeatedly called for an end to the violence, politically linked incidents of murder, arson, rape and intimidation continued.

The violence spilled over into the rural areas, and the people of the valley noted an increase in the number of police helicopters criss-crossing the sky. 'The eyes of the government' the people call them. The most recent sculptures include carefully observed

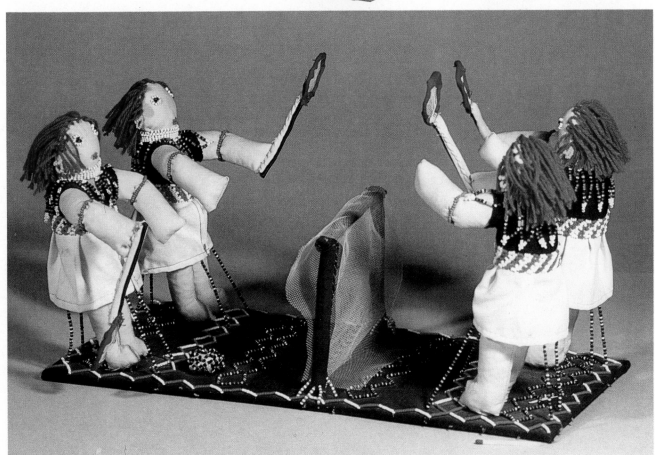

A diverting piece by Mavis Mchunu, somewhat reminiscent of the paintings of the British artist Beryl Cook, portrays her view of how white women spend their time: playing tennis.

In 1987 the violent political conflict in nearby Maritzburg's African townships escalated drastically, with violent clashes between Chief Mangosuthu Buthelezi's Inkatha followers and the supporters of the United Democratic

and colourfully beaded versions of the helicopters, and, for the first time, one of two young men carrying guns.

A subject may be repeated, but it will receive a fresh interpretation each time. Using the skills they learned as children, the women have broken the pattern of making beadwork purely for adornment, and worked creatively and sensitively to carry the truth about their daily lives to a larger audience.

JANE ALEXANDER

The horrific thing about being a part of a sick society is that there is no escape from the disease. Everyone is affected.

Coming into the eerie presence of Jane Alexander's compelling life-size sculptures, this truth becomes immediately apparent. The experience is not so much one of looking at art, as of being suddenly confronted with ghoulish aspects of one's own life.

These powerful figures seem more real than people on the street outside, in spite of the fact that in some places the flesh is repulsively crawling away from the bone, the skin is strangely blemished and horns are growing from the head.

placing *The Butcher Boys* and other pieces in settings taken from postcards and images in the media. Atmospheric, grainy, in black and white, the disturbing montages evoke memories of news photos taken subversively and in difficult circumstances; conversely, since we know these images have been manipulated, they raise questions about the validity of photographed documentation.

Through her work, Alexander seeks to identify the manner in which violence, aggression, cruelty and suffering are conveyed through and contained by the human figure. The alter ego of aggression is vulnerability. Those

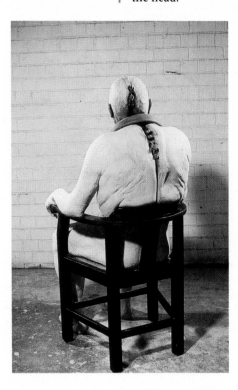

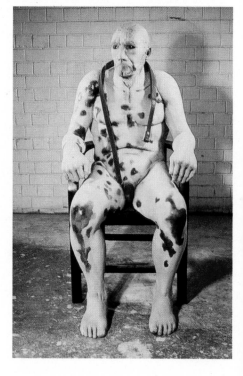

UNTITLED 1985–6
PLASTER, BONE,
OIL PAINT,
WOODEN CHAIR,
RUBBER STRAP
LIFE SIZE

'Part of the reason I make things realistic is I don't really want to have to explain my work,' says Alexander. 'What I wish to communicate is done so most readily, I think, through this type of realism. People can make their own interpretation, and if it's different to my idea it doesn't matter.'

The figures seemed to gain a documented reality through a series of photo-montages Alexander made,

who are secure and unthreatened do not need to bully, but when an entire society is insecure, all its members become both aggressors and victims.

Alexander is still a very young artist, the work shown here being part of the submission for her Master of Arts degree. The subject of her dissertation is 'Aspects of Violence and Disquietude in Twentieth Century Three-Dimensional Human Figuration', in which Alexan-

der comments on the work of sculptors like Mark Prent and Edward Kienholz, artists who have had some influence on her own work.

In 1982, an untitled piece of two skeletal figures hanging from a wooden not been that sort of subject? Violence imposes itself easily. The public is drawn to violence. It intensifies reality, disrupts mundane daily existence and perhaps creates a sense of worth. People are fascinated by car accidents, for instance.'

Domestic Angel, a small, bound winged figure suspended by its heels, was made in 1984. 'It was really just a maquette. I had been working on some large winged figures, and I suppose the

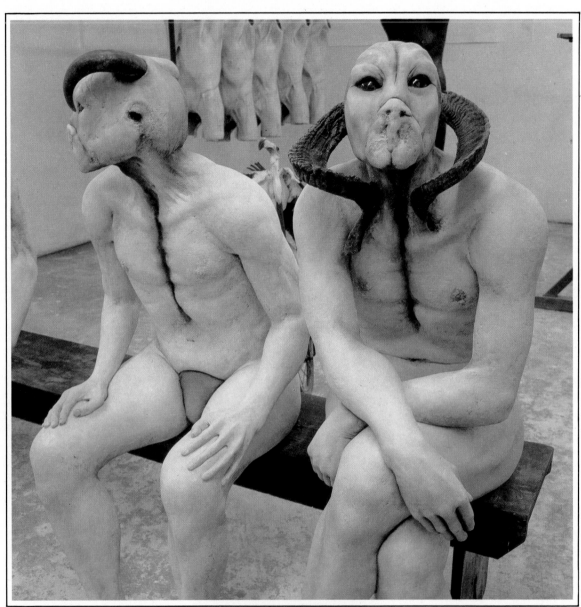

▶ BY THE END OF THE DAY YOU'RE GOING TO NEED US 1985 PHOTO COLLAGE 29 × 20 CM

▲ THE BUTCHER BOYS 1985–6 PLASTER, PAINT, BONE, HORNS, WOODEN BENCH LIFE SIZE

frame, carcasses with animal skulls and human bodies elongated as if emaciated by famine or stretched by the torture rack, won first prize on the National Fine Arts Student Exhibition. 'I wondered, would I have won it if it had title of this one refers to domestic workers, or something one might have in the home. . . .'

At this time, Alexander also did a series of gross crawling figures, sometimes with missing limbs. One of them was *Dog*. 'I discovered that the more

horrific my work, the more readily people looked at it. I began to wonder if people would respond to more restrained images. For me, the work that followed was far more difficult – *The Butcher Boys* were a radical departure from those earlier pieces – these new ones were living figures. Despite the exposed bones and so on, I was attempting to reveal aspects of violence through passive forms.'

A 1985 (untitled) figure of a man seated with his head between the knees on a slab, the flesh at the back of his head split to the bone, was seen by many to be a comment on death in detention, but in fact was based on the rather strange death of a man who worked in the building where Alexander lived at the time. His body was said to have been found in the furnace of the boiler of the building, although as a cripple it would have been impossible for him to climb up there.

'I have not compromised my work. Much as I might like to make a powerful statement about detention, I don't know any detainees. I don't want to try to pretend a suffering I haven't had some contact with, or undergone myself. My work is from my own experience.'

▼ DOG 1984–5
PLASTER, HAIR, BONE, CREOSOTE, OIL PAINT
HT: 62 CM

Alexander works with building plaster, which has the great advantage of being able to be moulded. 'I can smash a part I don't like and rework it.

'If I'm going to do a piece, I choose people of physical appropriateness, then I cast them, cut up the casts and rework those. I make the basic structure of wire and bandage, and build up the plaster over that. I have a basic skull shape that I cast. Hands, feet, faces and heads are not cast but modelled.' Working fairly consistently, Alexander takes about three months to make two life-size figures.

Leaving university in 1987, Alexander could not find a job in Johannesburg, or support herself from her work, so she took a post teaching English in a school in remote Rehoboth, Namibia. Rehoboth is the home of the so-called Basters – people who are a mixture of Khoi and the early Dutch and English settlers. 'The people were tremendously kind and polite. The highlight of the year is the Rehoboth Show. The level of creativity did not seem to extend beyond crocheted tea-cups, springbok skin handbags and clothes-peg houses.'

With no facilities available, the only work Alexander was able to make

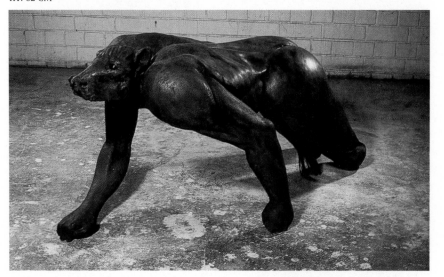

▲ DOMESTIC ANGEL 1984
SYNTHETIC CLAY, WINGS, OIL PAINT
HT: 34 CM

during this period were some small maquettes in clay – one of a hoofed human figure, head draped, ankles bound together, balancing on two sticks.

Commenting on socio-political art she says, 'What is the point of doing burning tyres? Isn't that just the artist saying, "I am aware of this!" Why are we not rather looking at the whole environment?'

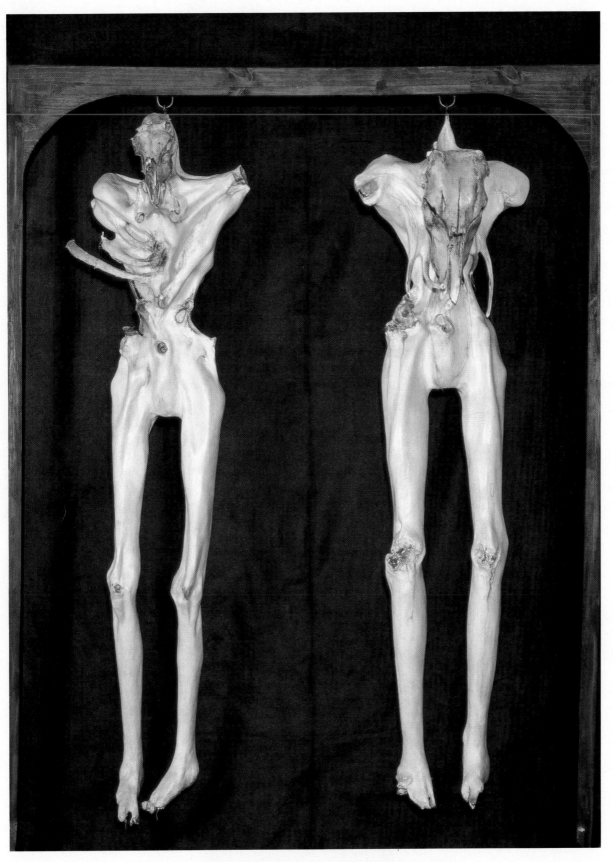

UNTITLED 1982 WAX, PAINT, BONE, PLASTER OF PARIS, WOOD, STEEL
HT: 225 CM UNIVERSITY OF THE WITWATERSRAND

PHUTUMA SEOKA

Driving through the dappled dusty bush on the road to the little Venda town of Giyani some ten years ago, one might have stopped at the roadside stall of Dr Phutuma Seoka and examined his wares: wooden skeletons and other somewhat elongated carved figures, some articulated.

In 1986, in a joint show with Norman Catherine in Basle, Switzerland, Dr Seoka's work was hailed by critics as being wholly in the 'international new ideas' bracket and in the mainstream of contemporary art, with the political flavour one would expect from an artist in South Africa. In 1988 his work was shown in Los Angeles, and a show is scheduled for Vienna in 1989.

Yet one can still take the road to Giyani and follow the sign and visit the artist and his son at their workshop.

Visitors are greeted courteously, and Dr Seoka

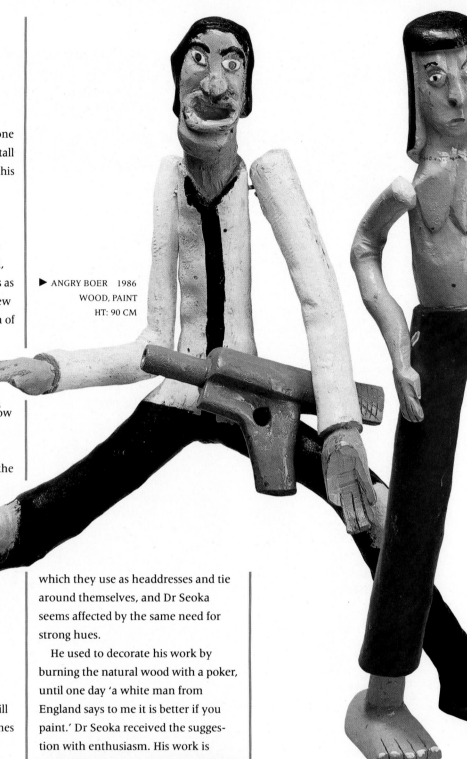

▶ ANGRY BOER 1986
WOOD, PAINT
HT: 90 CM

(once a practising herbalist) will explain to the interested how he comes to make his sculptures.

'I get them by the dreams. They show me. If I can see that man in my dream, I have to remember him. How can I put that man in the wood? Sometimes it's difficult. I look at the wood . . . I see the people standing there . . . then I know, I must cut it like that.'

The women in the Giyani area are famous for the brilliance of the cloths

which they use as headdresses and tie around themselves, and Dr Seoka seems affected by the same need for strong hues.

He used to decorate his work by burning the natural wood with a poker, until one day 'a white man from England says to me it is better if you paint.' Dr Seoka received the suggestion with enthusiasm. His work is

▲ CROSS MADAM 1986
WOOD, PAINT
HT: 101 CM

bright, ebullient, crude and vigorous –
with a well-developed satirical twist.
The Angry Boer and *The Cross Madam* are
archetypical South African figures:
sour-faced, aggressive, ever on the alert
for an unsatisfactory performance of
duty from their hapless black workers.

The piece *Page* v *Coetzee* depicts a

1984 boxing match between the white
South African Gerrie Coetzee and the
black American Greg Page. A sports
event in which white competes against
black can generate huge interest in the
townships, and that afternoon, when
Page knocked Coetzee out in the eighth
round the atmosphere in Guguletu,
Cape Town, and other townships was
definitely carnival. People danced in
the streets.

In Dr Seoka's lively and evoc-
ative piece, Coetzee is shown
slack-jawed, sagging at
the knees, while an agile
Page, possibly feeling the
great swell of black sup-
port behind him, moves
in for the kill.

A bust of State Presi-
dent P. W. Botha
has silver glasses

– blinkers, through which he cannot
see.

'I must make what I see in my
dreams,' says Dr Seoka.

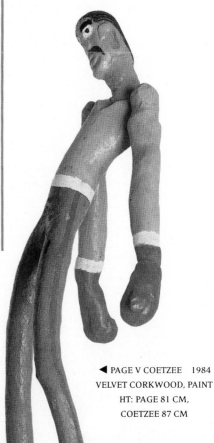

◄ PAGE V COETZEE 1984
VELVET CORKWOOD, PAINT
HT: PAGE 81 CM,
COETZEE 87 CM

▶ P.W. 1985
VELVET CORKWOOD, PAINT
HT: 58 CM

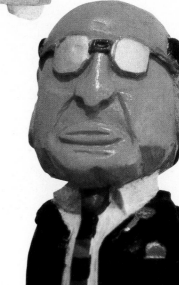

NELSON MUKHUBA

If any one artist were to embody the clash of first and third world cultures and values in his life experience and in his work, that artist might be Nelson Mukhuba. At times, seated in his village home in a chrome-and-red-velvet Ellerines chair, watching his generator-powered television set, proclaiming himself the greatest artist in the country and producing the work to substantiate that claim, it might have seemed that Mukhuba had managed to achieve the best of both worlds.

A traditional African doctor, he saw himself as a kind of God-king of his universe. The sources for his work ranged from powerful images drawn from his dreams and his spiritual life, to the Bible and to

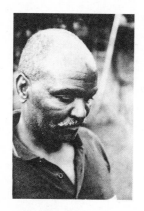

personalities observed on television programmes. Knowing nothing of Picasso, he was as open as the master in his approach to his work.

He was born in 1925 in Venda, and as a boy learned how to carve porridge spoons, bowls, and maize stampers. Going to the city to seek work, he was in turn stage electrician's 'boy', gardener, house

◀ DRUNK BOER 1984
WOOD, GLASS BOTTLES, METAL
HT: 223 CM UNIVERSITY OF SOUTH AFRICA

▲ VORSTER JACARANDA WOOD HT: 80 CM

painter – all menial jobs, but in later years as a migrant worker, he was to express no bitterness. It seems that the intense feelings of exploitation which were to cloud his last days were centred on the way in which he was treated by the white art world. In February 1987 the powerful creative forces inside Mukhuba were overtaken by the forces of destruction, and in February 1987 in a ritual purging, he killed first his wife and two of his daughters, then himself.

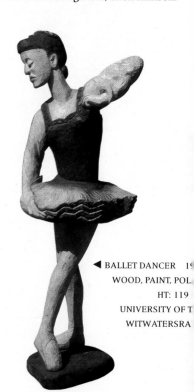

◀ BALLET DANCER 1
WOOD, PAINT, POL
HT: 119
UNIVERSITY OF T
WITWATERSRA

JOHANNES SEGOGELA

Once a welder, Segogela, who lives in Lebowa, now spends all his time carving. His work is sometimes marked with an appropriate biblical text – here, on the subject of retribution.

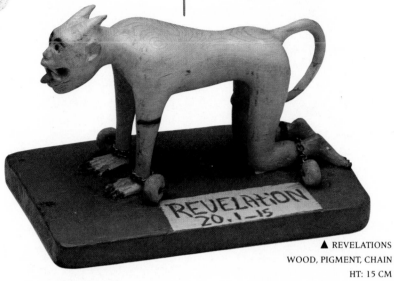

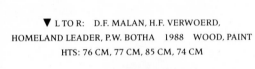

▲ REVELATIONS
WOOD, PIGMENT, CHAIN
HT: 15 CM
UNIVERSITY OF THE WITWATERSRAND

THIS PORTRAIT OF THE HIGHLY UNPOPULAR EX-TRANSKEIAN LEADER, CHIEF KAISER MATANZIMA, WAS PAINTED BY YOUNG CROSSROADS ARTIST, S. JOKIWE, IN 1983

JOHANNES MASWANGANYI

Maswanganyi lives in Venda, and learned carving from his father. He decided if he could portray famous people his work would be valued. He enjoys carving politicians, and his dyspeptic portraits tread a fine line between parody and satisfying his market.

▼ L TO R: D.F. MALAN, H.F. VERWOERD, HOMELAND LEADER, P.W. BOTHA 1988 WOOD, PAINT
HTS: 76 CM, 77 CM, 85 CM, 74 CM

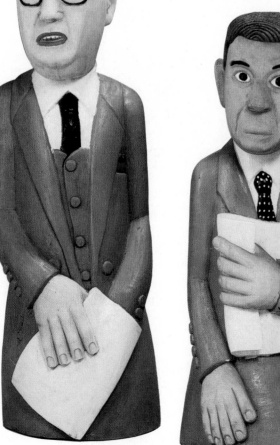

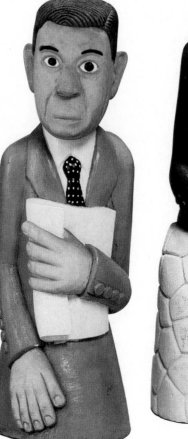

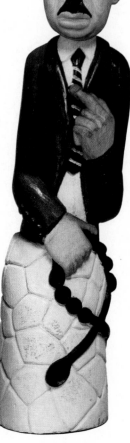

NORIA MABASA

Like her fellow Venda artist, Dr Seoka, Noria Mabasa dreamed her way into realising her creativity. Trained in the traditional methods of making pottery, her first attempts at figuration came in 1974, at the age of 36. 'I get sick, so I am sleeping. In my dream that old lady came to me and showed me what I must do and told me I must make just a little one.' That first small sculpture Mabasa modelled from clay was of a young girl hitting a drum. Others followed. 'Just small girls. My sculpture is not so much for men.

'I didn't want to sell them because I was shy. I put them nice in a big paper bag, and my cousin she came, she sell all those little ones. She brings back R20. I say, "You see!" Then I'm making sculptures every day.'

Mabasa lives in Tshino, in the troubled bantustan of Venda which received its 'independence' from the South African government in 1979. Before that, political authority had been vested in the traditional chiefs and headmen, who in turn were accountable to some degree to the people. The constitution given by the Nationalist

UNTITLED
CLAY, PAINT
HT: APPROX. 80 CM
▼

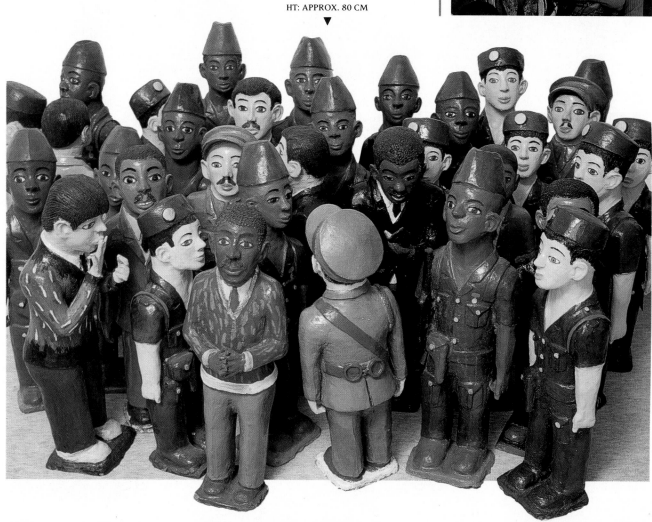

government to the fledgling state changed all that. Corruption and nepotism have become rife. The large and hitherto unseen tribe of bureaucrats, politicians, and the military which the new order brought to Venda, caught Mabasa's attention, and she first became known to the art world for her ironic and amusing painted clay figures of this new breed.

ing, Mabasa went down to the river and found the log she had dreamed about on the bank. Getting it home with some trouble, she began at once to work it, knowing already from her dream what the form was to be.

Mabasa's dreams were to lead her on from piece to piece. She is an intensely dedicated worker, and although physically slight, seems undaunted by mas-

sive pieces of wood, attacking them with sureness and vigour. She works at home, her studio one of a small complex of round thatched huts which surround a central courtyard of packed earth.

Carnage II is an extraordinary and powerful piece in which six people, a snake, a lamb, a lion and a crocodile surge forward locked in combat. The

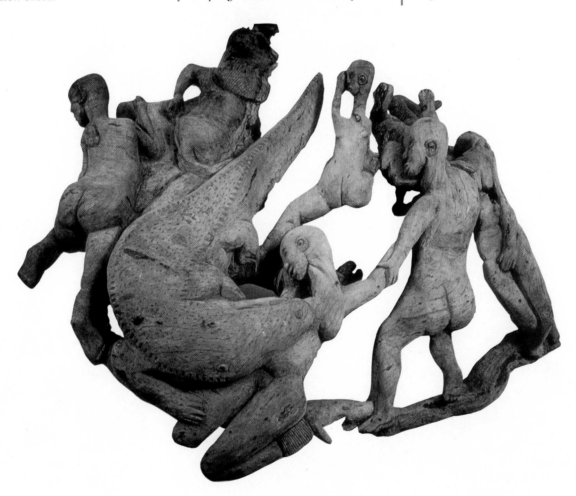

But it is through her wood sculpture that Mabasa has really come into her full power as an artist. Wood carving is traditionally men's work in Venda, but once again Mabasa's dreams showed her the way. 'In 1976, I am sleeping in the morning. I see the river Luvuba, I see the wood rolling in the river like this . . . a big wood. I asked someone, "Is it yours?" He said "no."' On awaken-

tensions are perfectly balanced, the strength of the loosely worked forms and the purity of line are breathtaking. With this seminal piece, the visionary Mabasa emerged as a major figure in South African art.

▲ CARNAGE II
WOOD
79 × 197 × 219 CM

ROBERT HODGINS

'South Africa is a pimple in a very acned surface – it's been a pretty bloody decade-and-a-half worldwide. In a weird sort of way it makes us part of the world – what the police and army do here is what they do in Uganda or South America. Maybe we're imitating terrorism like we used to imitate art.'

'The terrible crime of the Nationalist government is they've committed us to 300 years of counter-violence and counter-counter-violence. It's coming down with the speed of an avalanche. The best you can hope is that the boul-

▼ A MASSACRE AND THREE WITNESSES 1985
OIL AND ACRYLIC ON CANVAS AND BOARD
52 × 39 CM

▼ A BEAST SLOUCHES 1986
ACRYLIC ON CANVAS 122 × 173 CM
UNIVERSITY OF THE WITWATERSRAND

ders won't bury you.'

'Matisse lived through two world wars. Do you see that in his work? Maybe he was registering the Germans marching down the Champs Elysées even while he was painting his hundred-and-thirty-first goldfish.'

'You can work from sunlight on a girl's face or a blown-up corpse. The whole suffering world can become your breakfast. It's what happens to the painting after that starting point that matters. Of course, for the artist the violence of making a distorted line is as real as the violence of his time, or indeed the violence of human history.'

'Rauschenberg said if you see a picture and it doesn't somehow minutely alter your vision of life then either it's a bad picture or you're not looking properly.'

Robert Hodgins in full cry keeps the mind on the run. Verbally and visually

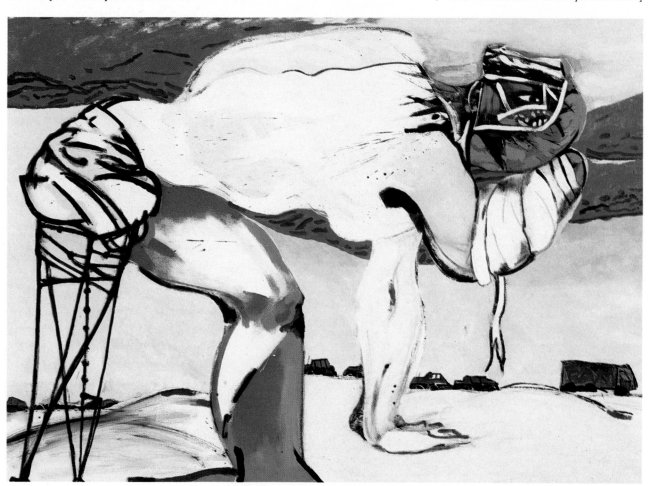

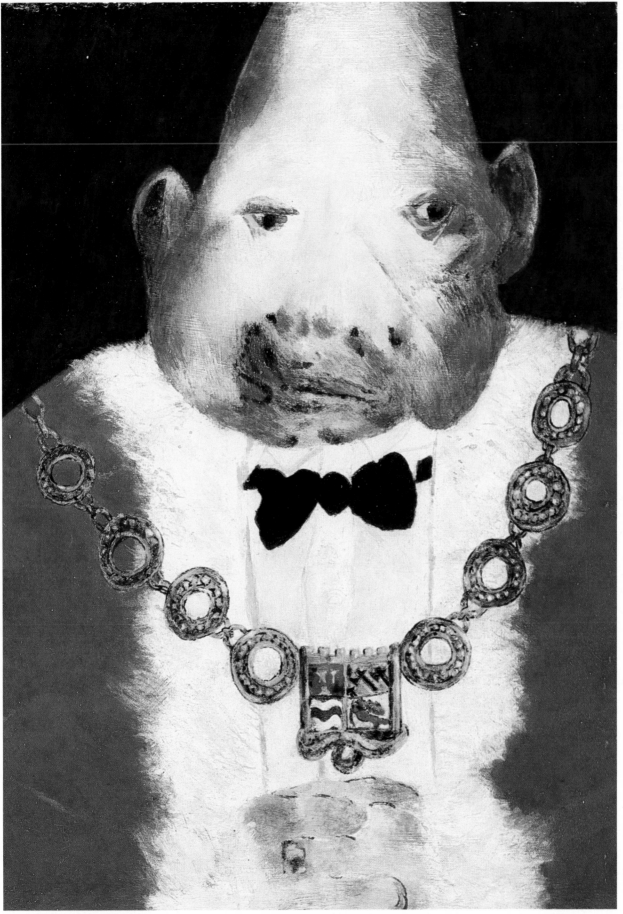

UBU – THE OFFICIAL PORTRAIT 1981 36 × 26 CM TEMPERA AND GESSO ON CHIPBOARD JOHANNESBURG ART GALLERY

articulate, in his late sixties he is one of the oldest of South African painters, although perhaps not the most elderly.

'I am so fascinated by Weimar Germany – that terrible feeling of underlying threat and some extraordinary work coming out. Interesting that it's always the left wing that produces it – never the right. The right is just as much in turmoil yet nothing comes out. They don't realise they are making history, whereas the left do.'

On the subject of his own work he says, 'If I had to describe what my paintings are about I would say, "Human beings are what human beings are."' Pleased grin. Human frailty in all its more unattractive manifestations – vanity, corruptibility, beastliness, greed – is indeed the starting point of much of Hodgins's work. Most of what happens after that has more to do with the intoxicating act of conveying paint to canvas with a loaded brush and with solving the problems of that particular work than with pushing a cautionary line. 'The great thing about painting is that the problems are enjoyable to solve. If the problem is difficult to solve, it's the wrong problem. You're fingernailing.' Fingernailing, explains Hodgins, is fussing about unnecessary detail instead of considering the painting as a whole, as in worrying about the fingernails on a hand.

Hodgins was born into a working-class family in England in 1920, and arrived by boat in South Africa on his eighteenth birthday. He was persuaded to make art his subject after an address by Archibald Sanderson RA 'who said if you teach art properly you will never have a bored child'.

'I think the artist is always an extremely lucky person even if he is not "successful" – he has a magic gate into a garden into which he can go all the time. If I had any political aspirations I would create a world where maximum

people had that available to them.'

If such a world existed, the subjects of Hodgins's paintings might be very different. *A Beast Slouches* is titled after the Yeats quotation, 'And what rough beast, its hour come round at last, slouches towards Bethlehem waiting to be born'. Hodgins's beast is a strange and damaged creature dragging itself through the mine dumps of Johannesburg – 'the kind of guy who only knows one way to organise his life – direct brutal action. Beats his kids, business rivals, socialised rugby. The ban-

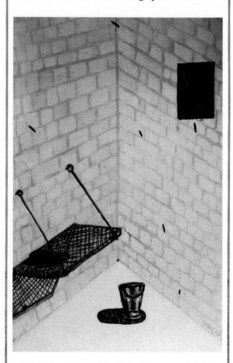

THE CELL 1985 OIL ON BOARD 42 × 27 CM

dages have something to do with those figures Bacon uses and that hand that has the faintest hint of being a bandaged penis is a reference to a mate in the army in North Africa who used to visit the army brothel in Alexandria, after which he had to wrap his penis in an antiseptic bandage as a medical precaution. As far from the intimate pleasures of sex as you can imagine – which is the point of it in my painting.'

A number of Hodgins's paintings have featured Ubu – 'the character in the Jarry play – also a science master I

hated. I have taken him out of the play and used him in all kinds of different situations – he is the tyrant who can be as awful as anyone but is still a figure of fun . . . like Nero, Idi Amin, Goering. I saw the possibilities of this evil man who is also a comic. Interesting that we have never had a laughable tyrant. Koornhof, perhaps.'

There are over 20 Ubu paintings, including *Ubu in Berlin, Ubu and Mr America, Ubu and the Black Politician, Ubu Interrogator I and II, General Ubu, Ubu and the Sad Old Men, Ubu Ubu Superstar, Ubu in the Last Judgement Steambaths* and *Ubu Screams*. In *Ubu the Official Portrait*, the pear-faced Ubu in the robes of the Lord Mayor faces us directly but looks at once downwards and sideways, shiftily avoiding our gaze. His nose seems to have flattened and slid down his face, and his mouth is a smudgy grimace. Flabby face reflecting internal rot, Ubu is the embodiment of a greedy and morally corrupt society.

On a small and simple painting of a cell exhibited on the Detainees' Parents Support Committee show: 'that little painting . . . it's a room where you don't know if it's five in the morning or five in the afternoon . . . it has the horror of a public lavatory – those white tiles . . . the only furniture is your slop bucket and your bed . . . we are all trapped.'

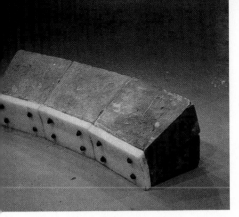

JEREMY WAFER

'When I go home to visit in Zululand, it's always incredibly hot and my family are sitting inside, hermetically protected, with the windows closed and the air conditioners going full blast. Every now and then someone will go outside to say a few words to the workers, then run back in. Outside, the air conditioners drip and hum. . . . Seemingly quite bland objects have a resonance for me. I try not to make deliberately threatening objects.'

Jeremy Wafer's drawing of an air conditioner is indeed somewhat bland, reminding us of those little pictures in the Yellow Pages, a volume which Wafer peruses with interest, studying illustrations of fridge motors and armature winders. It is perhaps the combination of charcoal and linseed oil on the handmade paper which gives a rougher, darker, cruder texture to the piece than any ordinary air conditioner would have, arousing memories of other metal objects, and tinging the drawing with hints of menace. For Wafer, the handmade paper has a feeling of gentleness offset by the hardness of the image imposed upon its surface.

Wafer's work has always had a somewhat enigmatic quality, though the concern for surfaces, structures and contrast is clear. He won the Standard Bank National Drawing Competition in 1987 with his *Power Station Triptych*, three drawings of construction details seemingly far too simple and farmyard-like to be connected with engineering in the eighties. 'I can get my ideas out quicker in drawings', says Wafer, 'but the drawings must have the kind of presence I want sculpture to have.'

Vastly appealing visually is his piece *Low Wax Wall* – 'the size of a lying-down man' – in which semi-circular sections of concrete and beeswax are bolted together. The mating of the hard greyness of the concrete and the soft smooth golden beeswax is unexpected and satisfying. 'It's a Zulu beehive-hut shape and it's about borders and barriers . . . hardness versus softness. It links vulnerability and threat.' And destinies.

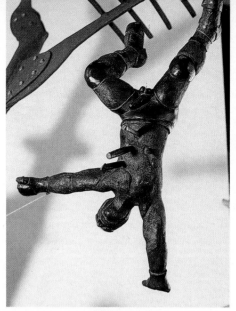

DAVID BROWN

From Homer through Conrad to Fellini, artists have drawn on the enclosed, claustrophobic quality of shipboard life to illuminate larger truths about society. In David Brown's *Voyage* series, five-metre-long ships of war, deeply rusted, plough their way forward on a voyage that can end only in cataclysmic disaster.

The crew, cast in bronze, are robust, brutish, strong, almost sub-human. These people know no way of life except hard physical labour and no way to impose their will except through blind force. Their victims, swinging by the heels, caged up or being keel-hauled, are lean and lithe. There is a feeling of *The Planet of the Apes* on the high seas as choreographed by Hieronymus Bosch. Yet even in the blinkered mindlessness of the crew, there is a tension, a driven tortured feeling as if somewhere, deep down, each person knows something has gone badly wrong.

'I try to make a universal statement, but the work grows out of the insanities here,' says Brown. 'I don't know if the work would be so raw if I wasn't South African.'

An early influence on Brown's work was the location of his first studio. 'It was in Canterbury Street in the old District Six. The police department was across the road. At the time of the riots they would all gear up. Then there were the meths drinkers with their

bashed Francis Bacon faces. They would sleep under my window. All that had quite a profound effect on what I was doing.'

Each ship takes Brown about three months to complete, working as he does entirely alone, cutting into the heavy steel, welding, chasing, tapping the bolts that hold parts of the ship together. 'I suppose I could have an assistant, but I enjoy the physical work,' he says. Only the figures, modelled in wax, are sent away to the foundry for casting.

Brown does not make preparatory drawings, but simply sketches out the area the piece is to occupy on the floor of his vast studio, and starts. The pieces grow organically, bit by bit. Brown's fascination for the varied surfaces and subtle colours of metal is clearly evident. The hull of Cor-ten steel is periodically drenched with water to develop an indestructible and rich skin of rust, which contrasts with the dull green patina of copper sheets on the decks, the rawness of curious stainless steel appendages on the rigging, and the cross-hatched bronze skin of the crew.

Another Brown piece, *Man and Machine*, stands, of all places, in the foyer of the Receiver of Revenue building in Cape Town. 'It was a commission from the architect,' says Brown. 'Initially, I just made a small maquette. He was quite horrified when he saw the finished piece. I did leave the genitals off, though.' For those who perceive the irony of Brown's work in such a setting, seeing it there bold and brawny amongst all the uniformed security men is the one enjoyable thing about going to visit the tax man.

VOYAGE I & III 1988
COR-TEN AND STAINLESS STEEL, BRONZE, COPPER, CAST IRON
HTS: 251 & 250 CM

CLIVE VAN DEN BERG

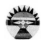

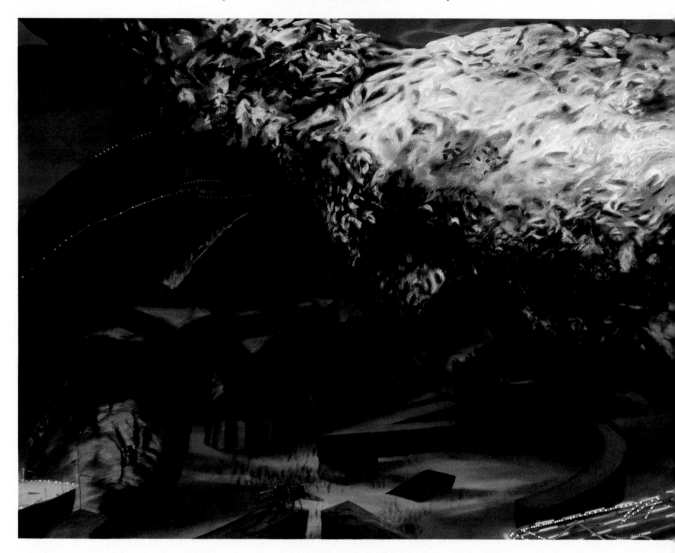

A FIELD OF LIGHTS 1987
OIL ON CANVAS
90 × 250 CM
SOUTH AFRICAN NATIONAL GALLERY

Regarded by the rest of South Africa as culturally backward, Durban is a brash, lush, steamy, semi-tropical, somewhat tawdry holiday city sprawled beside the Indian Ocean. Reminders of its past history and battles contrast with cheap come-ons for vacationers. The city seems perpetually on holiday, but undercurrents run deep, and flashfires

ing separated from the main landmass.

In *A Field of Lights* from Van den Berg's 1987 series *Invocations*, a strange and loathsome object, a decaying, bruised protuberance, has thrust itself or maybe is falling into a water's edge scene. 'I suppose in a strange way it functions as a kind of conscience,' says Van den Berg.

attract attention from above maybe, a cry for help.'

In an earlier work, the flayed, fleshy surface of the obscene protuberance belongs to the landmass itself, a strange bluff (one of Durban's landmarks is its Bluff) apparently about to topple into the sea. *Pool Above the Ocean* this piece is called, and never has that turquoise

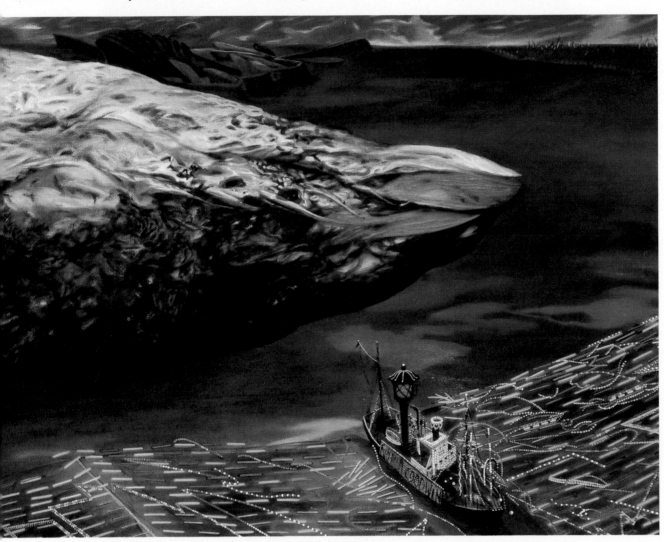

of racial discontent flare up frequently.

These contrasts, these anomalies, the absurdity of living in a place which tries to hide its racial tensions and present itself to the world as a pleasure city, are what informs the work of Clive van den Berg. His re-interpretations of the city are fraught with anxiety, inducing a deep sense of imbalance and unease. Constant in his imagery is an island be-

Yachts are flaming on the horizon, and, dwarfed by the huge intrusive presence, funfair lights twinkle vainly in the lower part of the picture. The colours are lurid, the image is a scene from a horror movie. A boat – surely, in spite of its gay trappings, the boat from *Apocalypse Now* – pushes its way through a field of lights, the sort used to illuminate airfields. 'An attempt to

jewel of the suburban garden seemed so precarious and out of place.

'One of the first things people did when they came to this country was to build gardens . . . crazy . . . in Africa,' says Van den Berg. 'Nadine Gordimer called ours a swimming pool and caravan culture. I have a sense of our civilisation being a very transient thing.'

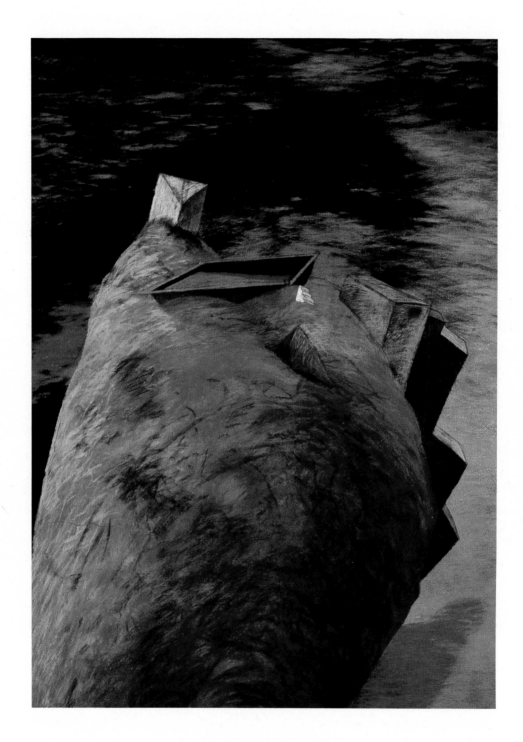

POOL ABOVE THE WATER 1985
PASTEL ON PAPER
175 × 117 CM
DURBAN ART MUSEUM

CHABANI MANGANYE

ing, some are screaming for help.'

Msinga, a rural area in KwaZulu, is a long way from Soweto but in many ways it is equally troubled. Like Soweto, and in fact for basically very similar reasons, it is notorious for what has become known in the white media as 'black-on-black' violence. You can't cram vast numbers of people into an area far too small to sustain them and not expect explosions.

people were crowded into the area, it rapidly became ravaged and over-grazed, making it almost impossible for people to scratch out a living. Tensions turned Msinga into the flashpoint of violence in KwaZulu, and the centre of the stolen gun trade in South Africa. Fighting between groups and individuals, often leading to deaths, has become commonplace.

In Manganye's painting, only the

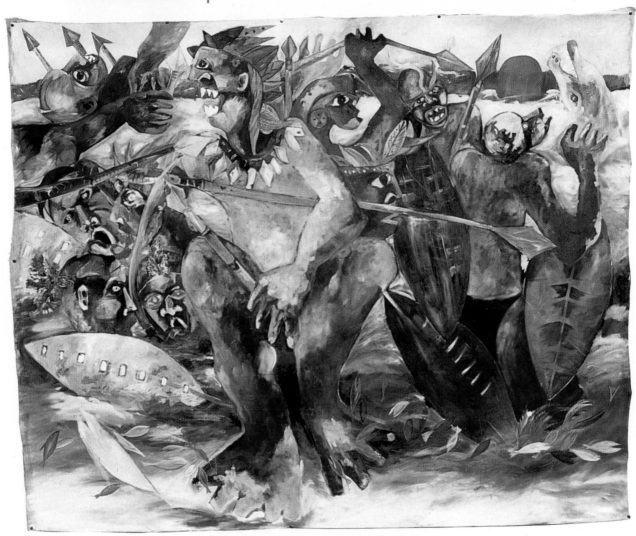

'This painting *The Battle* was not planned, but when I did it I had Msinga in my mind,' says Chabani Manganye, an artist who is also head of the Mofolo Art School in Soweto.

'When I look at it, I just see the death of warriors – some of them are drowning in the sea, some of them are shout-

At the heart of the Msinga troubles lies the government's resettlement programmes. In the past the area was used by black tenant farmers, but when white farmers moved in about 20 years ago, blacks were resettled in the scraggy, thornbush-covered hills across the Tugela River. As more and more

chief is in control – 'he is suspended, he is not in the sea and he's not out of the sea. All the other figures are falling down and drowning.'

▲ THE BATTLE 1988
OIL ON CANVAS
130 × 160 CM

DENISE PENFOLD

'It was the end of 1986 – the state of emergency. The tensions coming out at street level were very strong and the sense of things coming apart was for the first time in my experience quite exposed. *Decisive Descent* was one of a series of paintings that grew out of the feelings I had at that time.'

The harsh screeching of car brakes on the highway near Denise Penfold's home in Cape Town seemed particularly insistent then, and an earlier painting in this series was called *Car's on Fire and Falling*. Flame reds and acid yellows portray an out-of-control car leaving a freeway, its exposed passengers laid out like tiny corpses.

The Hanging Man with its bound, one-legged figure suspended upside down recalls the Tarot card. 'It depicts a moment of decision . . . a fear of falling,' says Penfold. '*Decisive Descent* came after that.'

The difficult, narrow format gives a sense of constriction. Penfold works by putting brush strokes on canvas, and allowing those strokes to dictate the forms that evolve. 'In *Decisive Descent* the forms are now falling . . . they didn't have a choice. The figures are still bound, but one has a limb missing . . . there's a sense of disintegration. . . .'

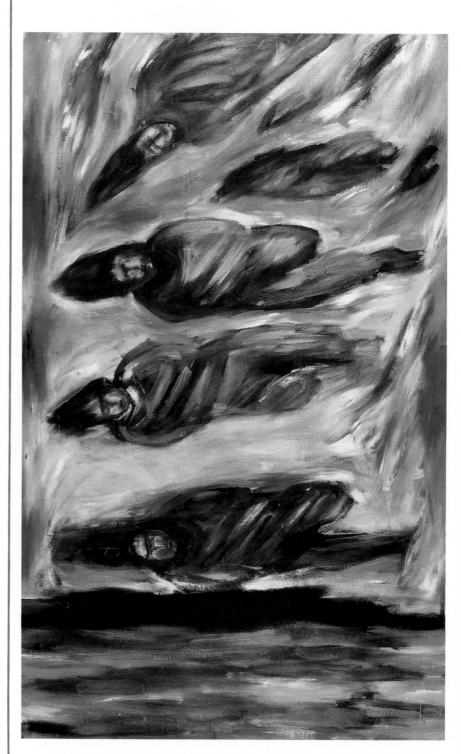

DECISIVE DESCENT 1986
OIL ON CANVAS
131 × 82 CM

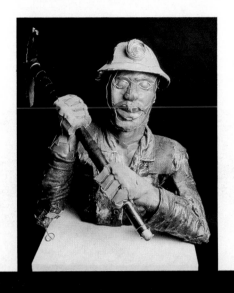

EXPLOITATION

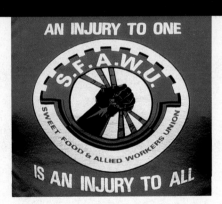

AN INJURY TO ONE

S.F.A.W.U.

SWEET FOOD & ALLIED WORKERS UNION

IS AN INJURY TO ALL

JOHANNES PHOKELA – LEATHER SCULPTURE

SAM NHLENGETHWA

'It would be worse than I had imagined,' a recent account by Mzimkulu Malunga, a miner for 18 months, read. 'There were still horrifying accidents underground – stretchers could be seen coming from the shaft almost daily, carrying seriously injured people. I was living in a single-sex tribally segregated compound. It was a very different life to any other in South Africa.' The starting pay, in 1986: R44.88

carry on. His spirited and touching depictions of urban black life – the confusion of the country woman in the city, the bus boycotters walking to work ('people don't boycott for fun, they are responsible for their families') – are drawn from his daily observations. 'I have a list of all the things I've seen in my life in my mind,' he says. 'I don't sketch. I know exactly what to do because I've seen it.'

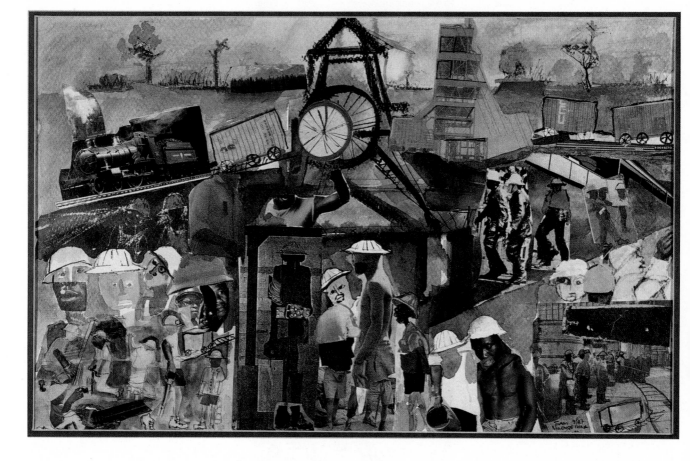

▲ SHAFT 1987
COLLAGE ON PAPER
29,5 × 47 CM

(about $20) a week.

In *Shaft*, Sam Nhlengethwa's vibrant collage of life underground, the workers are seen in subterranean toil. 'The way I feel about the people working on the mines is the way I feel about the rest of the people suffering in the whole country,' says Nhlengethwa.

Nhlengethwa is a television technician in Johannesburg, who will often arrive home from the studio on Friday evening, work through the night on his collages, sleep for an hour or two, then

BROKEN-DOWN INTERIOR OF A DISUSED MINERS' HOSTEL ON CROWN MINES, JOHANNESBURG

UCAS SEAGE

A bed of another kind, *Found Object*, 1981, by sculptor Lucas Seage, with its chains, broken glass and barbed wire, seems to come closer to the reality of the miners' lives than the colourful concrete bunks. In a 1981 interview

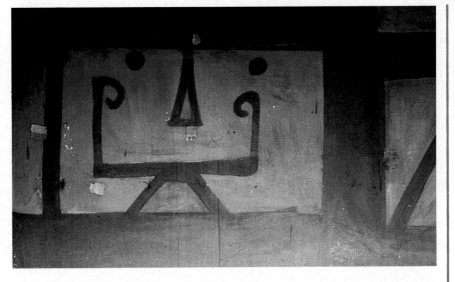

▲ FOUND OBJECT 1981
WOOD, PLASTIC, GLASS, ROPES, CHAIN,
BOOK, BLANKET, PADLOCK, NAILS
HT: 37 CM HAENGGI FOUNDATION

with David Koloane, Seage said: 'I try to crack the apartheid system, even if it is a tiny, tiny little crack I manage to make. My message is directed to the man in the street, hence I use symbols he can easily identify with – such as a reference book, a Bible, chains, a primus stove. I regard art as a weapon against injustice.'

UNKNOWN MINERS

Even under the most appalling conditions, the creative urge remains. The painting by miners of the stacked, narrow concrete shelves which constituted their entire living space bears witness to this. Artist Larry Scully was the photographer: 'It was on a Sunday morning in 1971 that I was taken by a friend to a disused hostel on Crown Mines, Johannesburg. On the walls of the half-broken-down buildings were what remained of a whole series of paintings in the concrete bunks. Each painting in each bunk was a personal expression by an individual gold miner. Some were abstract designs while others combined vivid primary colours with collages of beer labels. Each artist like a bird singing in a tree proclaiming his territory. This is my space!'

GAVIN YOUNGE

patronage', says Younge, 'but there is almost always a double agenda going.'

In 1979, Younge's abstract *To the Dark Rising* won the Afrox prize for metal sculpture. With it came a cash award of R2 000 towards the cost of work for a forthcoming prizewinners' exhibition.

Although the competition was open to all sculptors and was now in its fifth year, there had never been a black prizewinner. To work in metal is to use expensive materials and have access to sophisticated tools and equipment. Art-

black Afrox workers at their barracks in Langa and Guguletu, and talked to them about their wages and working conditions. Collecting their battered mugs, enamel plates and worn boots, Younge constructed three steel wheel-barrows and filled each with these well-used objects of the workers' daily lives. The top of each barrow was covered with a sheet of glass, as if the mugs, plates and boots were in a show-case, objects of great value to be venerated – or, possibly, of anthropological interest. The piece was called *Workmen's Compensation*.

At the same time, Younge declined the offer to have his work publicised in a glossy catalogue, suggesting to the PR people that the several thousand rands earmarked for the printing should instead go towards donations of equipment to community art centres.

'Afrox were furious. The catalogue was never made and the competition was never held again. I was trying to tell Afrox that their sponsorship of the arts was being made possible by the low wages they were paying their workers. My fight with them was that they did not consult [with the artists or the community], they simply hired a public relations firm.'

Younge is a film-maker as well as an artist, and his book *Art of the South African Townships* was published in 1988. He was exposed to labour politics when he moved to Durban to teach art at the University of Natal in the early 1970s. It was a heady time. The inertia of the 1960s was breaking up. Steve Biko, Strini Moodley and Saths Cooper were staging radical plays. Younge became part of the Wages Commission, a group of staff and students at the university conducting an inquiry into workers' wages, and handed out leaflets for the Benefit Society, a fledgling union (at that time trade unions *per se* were illegal), trying to teach workers to organ-

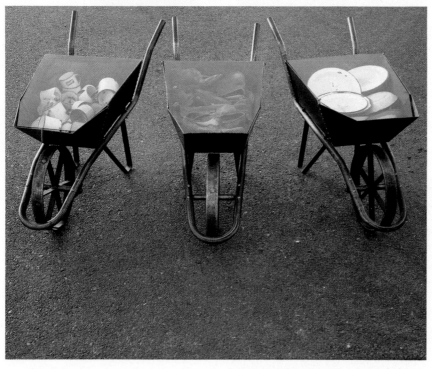

▲ WORKMEN'S COMPENSATION 1981 FABRICATED STEEL & MIXED MEDIA HTS: 67 CM

Patrons of the arts in South Africa are few and far between, but even those who do come bearing gifts may find the recipient strangely suspicious and un-grateful. The story of Afrox and sculptor Gavin Younge might act as a cautionary tale to those companies who seek to burnish their image by hiring a public relations firm to spend a few thousand suitably publicised rands on a prestige exhibition while back at the factory working conditions are less than ideal. 'Artists are dependent on

ists who do not have access to these are unable to enter the competition no matter how 'open' it might be. Younge knew Afrox (manufacturers of gases and welding equipment) had turned down a request from the Community Arts Project (Cape Town) for welding equipment. 'I decided to tell Afrox something,' he says.

Younge articulated his message in the piece he prepared for the Afrox exhibition, purposely couching it in an international art language. He visited the

ise. 'SASO [South African Students' Organisation] had been formed in 1968 – they were struggling with the roles of whites – were we fellow travellers, or what? It certainly made one look more closely at what one was doing.'

'The people shall share in the country's wealth' reads the third clause of the Freedom Charter, but Younge's 1986 *Koperberg* (Copper Mountain) series of six cast bronzes based on early mining rigs speaks of greed and exploitation. *Genrick's Gaol* with its windowless structure, closed portcullis and cut-off stairway recalls the bleak and inhuman conditions under which miners still work.

'The struggle is over the land – food, wealth, minerals, politics, and the way things shake down after that,' says Younge. '*Talion* [which stands outside

GENRICK'S GAOL 1986 CAST BRONZE HT: 64 CM
UNIVERSITY OF STELLENBOSCH

TALION MAQUETTE 1986 CAST BRONZE
HT 22 CM

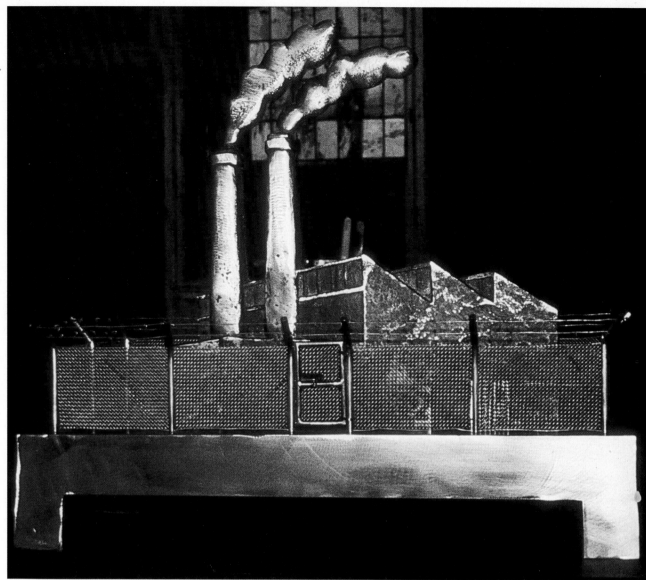

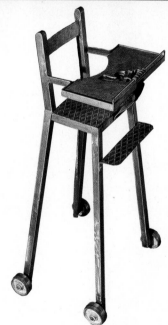

the Johannesburg Art Gallery] salutes a new order based on the principle that we [whites] cannot hope for more than we have given. It's a political statement in an abstract form. A heroic statue of a worker would have been inappropriate'.

A high chair for *Botha's Baby* has a recess in the feeding table for a gun. *With a Huff and a Puff . . . All Fall Down, I & II* were two low relief sculptures in cast iron. The pieces comment on the absurdity of a society which imagines that high security walls can keep out the winds of change.

Younge's work has always been characterised by an intelligent and careful scrutiny of issues and consider-

ation of the appropriateness of method and material . 'I believe that the term "political art" doesn't refer to the content of a piece, but rather to the organisation of its content,' he says. 'As an artist, I have been struggling with ideas which are much more clearly defined in other spheres of society. The art world is intolerant of debate over issues of accountability. I'm making choices on the basis of having thought about things.'

◄ BOTHA'S BABY 1981 CAST IRON AND
WELDED STEEL HT: 127 CM
SOUTH AFRICAN NATIONAL GALLERY

KENDELL GEERS

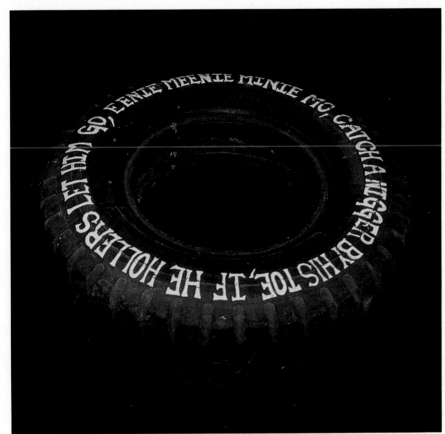

Eeny meeny miny mo
Catch a nigger by his toe
If he hollers let him go
Eeny meeny miny mo

This version of the old rhyme dates back to the abolition of slavery in the United States. New perceptions of racially offensive language have made it unrepeatable in most circles, 'but I still hear kids using it,' says Kendell Geers. 'It's about a process of elimination. Police spies are necklaced. There is a cost for everything, especially in South Africa.'

Geers is an art student, one of 143 young men who made a public statement in August 1988 refusing to serve in the South African Defence Force.

A tablet next to a cross of lighted candles carries a newspaper story of a Soweto toddler burned to death in the room where he was sleeping – common in a society where small children must often be left unattended by working parents in homes without electricity. 'South Africa is a specific social context within which I as an artist feel responsible to my audience,' says Geers. 'I try to work outside traditional media, so that the spectator doesn't view my work as if it were "art."'

SANDRA KRIEL

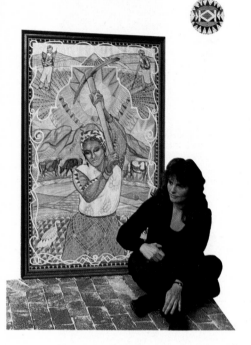

▲ SANDRA KRIEL, WITH HER GOUACHE PAINTING OF A FIELD WORKER

In 1980, fresh from art school in Europe, Sandra Kriel returned to her childhood home town, Stellenbosch, centre of the South African wine industry.

As a group, the labourers on the wine farms of the Western Cape are amongst the most exploited in the country, working as they do for slave wages often almost all used up in advance on small purchases from the farmer's shop and living in tumbledown cottages with no running water. Most of the men have a serious alcoholic dependence problem as a result of the iniquitous '*dop*' system, whereby a farmer will give each labourer five mugs of cheap wine each day starting at breakfast as part of his wage, whether he wants it or not. Every aspect of the people's lives is ordered from above, by the man they must call Boss. He has taken over the role of God, and he alone will decide, control and provide.

Kriel herself came from a working-class family. Her father was an electrician who sometimes worked on the wine farms. On her return in 1980, Kriel looked at her childhood surroundings with new eyes. 'I used to think these workers had unfortunate

▶ DAWIE BERRIES'S DRAWING OF HIMSELF AND HIS FAMILY

▲ DAWIE BERRIES, HIS WIFE KOBA AND THEIR DAUGHTER FRANSIENA

lives. Now I thought, let's find out how they really feel and think.'

Kriel didn't just want to ask questions, so she took paper and pencil and asked them 'to draw anything that was important to them and tell me what they'd drawn, then I'd tape that'. The workers had known Kriel for more than ten years, and they accepted her. 'After a while,' says Kriel, 'I realised the information they were giving me had to be shared.' Kriel started taking photos too. It was the beginning of the book.

The opening page reads: 'This book is dedicated to all farm labourers whose lives are ploughed into the ground without them ever seeing the fruits of their labour, to those who are exploited as private property without them ever having taken a decision about it, to those who cough and bleed without knowing that just being a human being gives every person certain rights.'

In his review of *Vir 'n Stukkie Brood* (For a Piece of Bread) Afrikaans writer André Brink hailed it as 'a bomb of a book. It is a cry which is even more compelling because it is so full of ordinary humanity,' he wrote. 'And it is part of the disturbing revelation of the monologues that the speakers do not know against whom or against what resistance can be made.'

Here is 28-year-old Dawie Berries talking: 'We have a hard time on one hand, but what can we do? The money is little. We get by. If we must eat *pap*

portant to them, the results can be extremely touching. Their often mundane, sometimes sad little drawings can shock more than expressions of naked anger.

Dawie Berries's drawing of himself and his family is quite a cheerful little image, giving us a very different impression from Kriel's photograph.

And then we have Anna Gouws, who years ago was brought to the farm and dumped by a boyfriend, Jan Burries. Says Anna, 'quick quick quick I owed the boss a R30 ($12),' so she stayed to work it off, and lived there until her death in 1982.

Jan Burries had left years before, but Anna had not forgotten him. Asked to draw, she described her drawing like

age of 12 with a strange Moslem family who had come to the farm selling clothes. The family asked Rousie if Sanna could go with them 'to look after their child for a while', but years went by, and Sanna did not return. Finally the family brought Sanna back, now 19 and changed for ever.

'My child Sanna and her case and her two bags. Her clothes are all in the case. She had a blue dress on, with a bag and earrings. Her hair was loose.'

When *Vir 'n Stukkie Brood* was published, the farmer whose workers Kriel had been interviewing was enraged and discomfited. The book had its effect, though. Water was laid on to the cottages, a community centre for the workers built.

Rousie, Dawie and the others were not all that interested in the book. The best part for them had been listening to the tapes and hearing their own voices tell about their world.

vir 'n stukkie brood

dokumentasie deur sandra kriel

minotaurus

one night . . . that's also all right. We know we must eat like that. The money is so little. Here on the farm we eat sheep's heads, sheep's trotters, offal. That's our life. And we are strong. And I say thank you to my boss that our boss pays us enough that our women can go to town. Thank you very much.'

When adults who have never had an art lesson in their lives are given pencil and paper and start drawing what is im-

this: 'This is Jan Burries. Here he stands. There lies Anna. He has a stick in the hand . . . Anna Gouws, he hits Anna. Old Anna did nothing, but when he's drunk, he hits poor Anna. Ooooh, I had a bad time with that man.'

Here is Rousie Karelse's picture of her daughter Sanna on the day she left the farm at the

ANGELA FERREIRA

democratic movement. The debate here is over what role art plays in politics, the gallery system, and whether artists should allow their work to be treated as a commodity to be marketed.

Angela Ferreira is one of a new generation of artists who has abandoned the art for art's sake approach. 'I started to look more deeply at politics and the society I was living in, and this has fed into my work.' One of the tenets of the

work to protest – but as a response to the fears, anxieties and sadness of our society'.

Mayday, a stylish painted wood piece with workerist imagery and tilting perspectives, was conceived after Ferreira attended a mass rally. 'In a sense, the stadium is outside society, but it is symbolic of society as a whole . . . the people, the banners, the speakers, the police presence . . . helicopters hover-

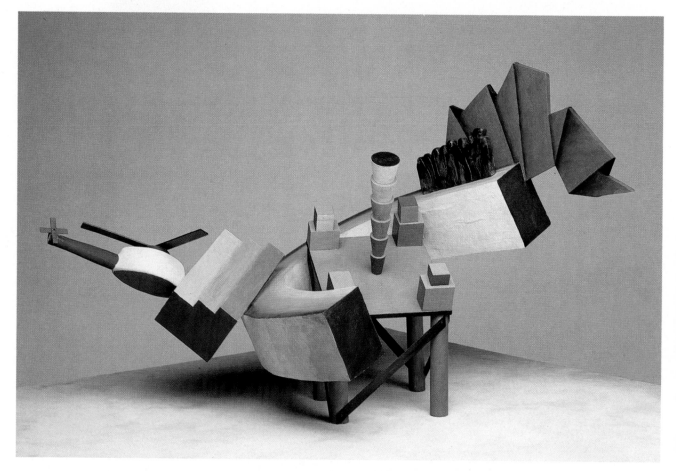

In the New York art world, the 1980s have seen the meteoric rise of a number of young artists who have been lauded by the critics, given major shows by museums, seen prices for their work go through the roof, and become stars of the media.

Vastly disparate circumstances in South Africa have given rise to a very different ethos: the artist as cultural worker, whose role is to use his or her skills in the service of the broad-based

new thinking of 'artist as cultural worker' is that he or she is accountable to the community, working on projects like banners and murals to carry the struggle forward.

'I did work with the media group at the Community Arts Project on T-shirts and posters,' says Ferreira. 'I felt it wasn't my best work though. I had to find a form which acknowledges my Western background, my roots in Africa and my political concerns. I don't

ing overhead.'

Questions about art and artists in society were explored in a recent series of drawings. 'I wanted to make two images in each picture, so that the different stances could be opposed. The box, the first form of a new sculpture, represents the art object. The people in blue refer to myself, the maker of this object.'

▲ MAYDAY 1988
WOOD, PAINT HT: 62 CM

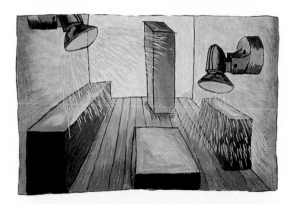

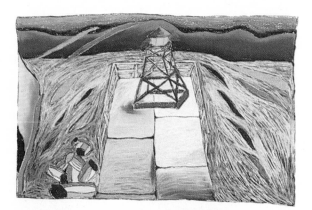

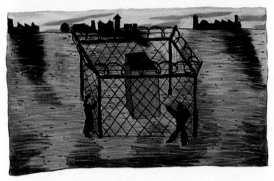

▲ "And what about galleries? Are these my boxes or vacant sculpture stands? Are these lights oppressive? Is the work lonely and surrounded by 'defences'? Is the city very far away on the horizon?"

▲ "Cape Town harbour West pier. Is the lighthouse warning? Or does the sculpture become the warning light?"

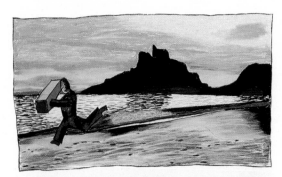

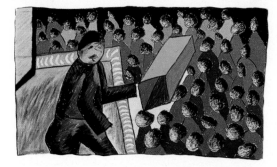

▲ "Does one run away from awesome 'truths', or does one present it as a strong 'stance'? What position to take?"

▲ "The images on the 'box' have become where they came from – the fence outside the houses of parliament. These are two clear separate areas. Am I stuck to the 'fence'?"

▲ UNTITLED SERIES OIL PASTEL ON PAPER APPROX. 25 × 36 CM

SUE WILLIAMSON

In August 1977, I spent seven days watching the total demolition by state employees in bulldozers backed up by police of the 2 000 houses of Modderdam, a settled squatter community just outside Cape Town.

Witnessing the cold brutality of this operation had a profound effect on my life. I became involved in community action, an involvement which spilled over into my work in the studio. Drawings made at Modderdam were used for a series of etchings I called *The Modderdam Postcards*. One was made into a real postcard as a media item in the struggle to save Crossroads, the next squatter camp under threat. That postcard was almost immediately banned for distribution by the state.

In 1981, bulldozers were knocking down the last houses in Cape Town's historic District Six, an overcrowded but dynamic coloured suburb, declared 'white' fifteen years previously.

Collecting the rubble left behind — bricks, chunks of wall with layers of wallpaper, broken plates, discarded school books, I piled it on the white tiled floor of a Cape Town gallery, and surrounded the pile with six chairs borrowed from Naz Ebrahim, one of the last residents of District Six. The chairs had been used in Naz's house for the last celebration of the Eid feast in District Six, and were now draped with white sheets in mourning for those who had left. The installation was called *The Last Supper*. A tape played throughout: a recording I had made of statements and memories of the people of District Six, their music, the calls from the Mosque and the scraping, crashing sounds of the bulldozer.

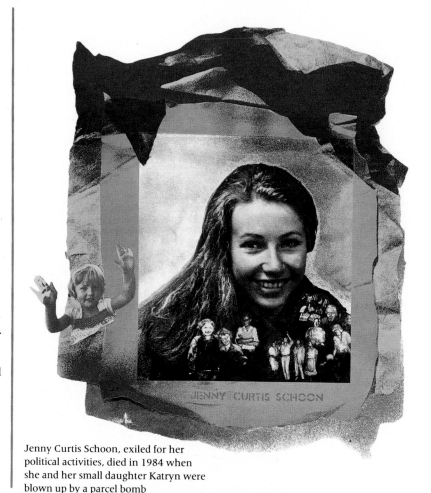

Jenny Curtis Schoon, exiled for her political activities, died in 1984 when she and her small daughter Katryn were blown up by a parcel bomb

▲ JENNY CURTIS SCHOON 1985
PHOTO ETCHING/SCREENPRINT
COLLAGE 70 × 64 CM
TATHAM ART GALLERY

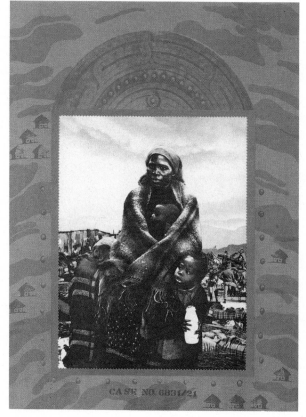

◀ CASE NO. 6831/21 1984
PHOTO ETCHING/SCREENPRINT
COLLAGE 69 × 52 CM
BRENTHURST LIBRARY

Case No. 6831/21 was the wife of a migrant labourer living in the Crossroads squatter camp, Cape Town. Illegally in the area, she was constantly harassed by the police.

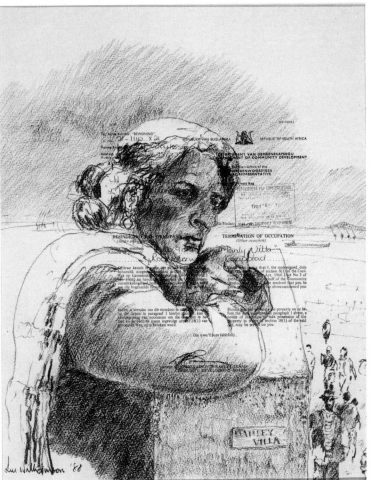

◀ NAZ EBRAHIM 1988
CHARCOAL, SCREENPRINTED
ACETATE 43 × 33 CM
DETAIL FROM 'LAST SUPPER
AT MANLEY VILLA', MIXED
MEDIA WORK

▲ The Ebrahim family
and friends celebrating
Eid for the last time
in Manley Villa

▲▶ A wall in the
entrance hall of
Manley Villa

▲ Manley Villa,
District Six

◀ THE LAST SUPPER
1981 INSTALLATION
RUBBLE, DRAPED CHAIRS,
TAPE RECORDING

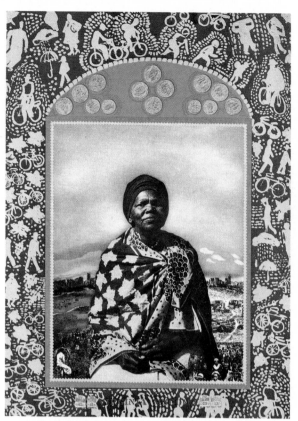

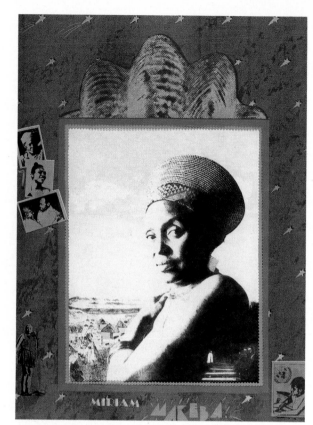

▲ Virginia Mngoma was an activist from Alexandra township, Johannesburg, and an organiser of the successful three-month bus boycott of 1957.

▼ Mamphela Ramphele, writer, doctor and Black Consciousness activist, named South African Woman of the Year in 1983 for her work in public health.

▲ Miriam Makeba, born in Johannesburg, who became an international singing star. Gave evidence against apartheid at the United Nations.

▼ Annie Silinga of Langa, Cape Town, veteran of the Defiance Campaign of the 1950s. All her life she refused to carry a pass.

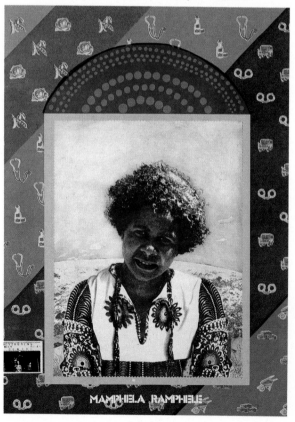

MAMPHELA RAMPHELE

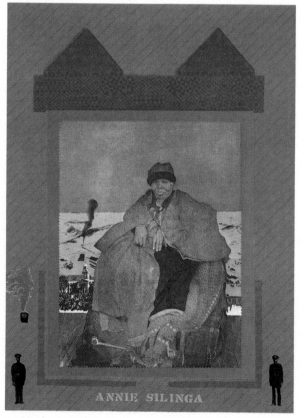

ANNIE SILINGA

'A FEW SOUTH AFRICANS' SERIES PHOTO ETCHING/SCREENPRINT COLLAGES 70 × 52 CM EACH

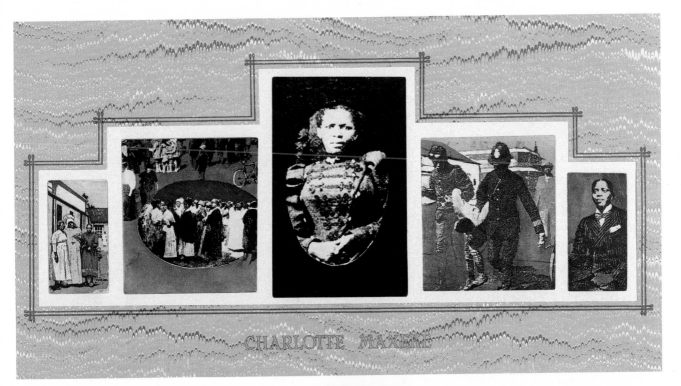

CHARLOTTE MAXEKE

Spending time in houses in Cross-roads, I noted that mainly what people hung on their walls were family photo-graphs, usually in colourful hand-made frames. One seen in many homes was of a Xhosa folk healer, Elizabeth Paul. She became the subject of the first print in a new series I started in 1982, fol-lowed by portraits honouring women who were heroines of the struggle.

Some of the women I knew, and I re-searched the history of others. That series was called *A Few South Africans*.

▲ Born in 1874, Charlotte Maxeke was the first black South African woman to obtain a university degree.

◄ A T-shirt printed for mourners at Annie Silinga's funeral.

▼ Maggie Magaba was a domestic worker honoured after her death by her employer's daughter who named a trust fund after her.

MAGGIE MAGABA

CAPE MURAL COLLECTIVE

The South African Domestic Workers' Union recommends a monthly wage of R350 (about $140) for a full time domestic worker, but most women earn far less. Unprotected by labour laws, and often having to abandon her own family for a 'sleep-in' job, the worker's life is one of alienation and struggle.

South Africa Will Never Be Free While the Women Are in Chains is the message spelt out in words and pictures on a series of ceramic plates made by the Cape Mural Collective.

Conceived specially for a Women's Festival in 1988, each plate was made by one of twelve women in the group.

MPOLOKENG RAMPHOMANE

One of the most powerful initiatives against the state has been the rent boycott, which began in Soweto and other townships in 1984, and by mid-1987 had spread to about 55 townships countrywide. Payments of rent for a sub-standard house which belonged to the government even if the tenant had lived there thirty years were deeply resented, but essentially the rent boycott was used as a political tool, hinging on three demands: that all township councillors (seen as government stooges) should resign and the councils be dissolved, that the state of emergency be lifted, and that all political detainees be released.

'The voteless people have only one power – the power to withdraw co-operation', said the South African Council of Churches in a statement endorsing the boycott. State attempts to break the boycott ranged from home-ownership offers to sending police, their heads covered in balaclavas, to evict or serve notice on residents late at night. The family of artist Mpolokeng Ramphomane received such a visitation, and the incident was the basis for his oil pastel drawing, *Eye Witness*.

'We were raided at 2 o' clock one morning. I was sleeping in a room in the back yard – the police came, they made a lot of noise. It woke me up. They were demanding the rent, pushing us out of their way, pointing their guns at the two small children in the house – but if you know your rights, you can defend yourself. My mother asked to see their court order and told them to stop harassing us. In the end, they left. But in other cases people were beaten up.'

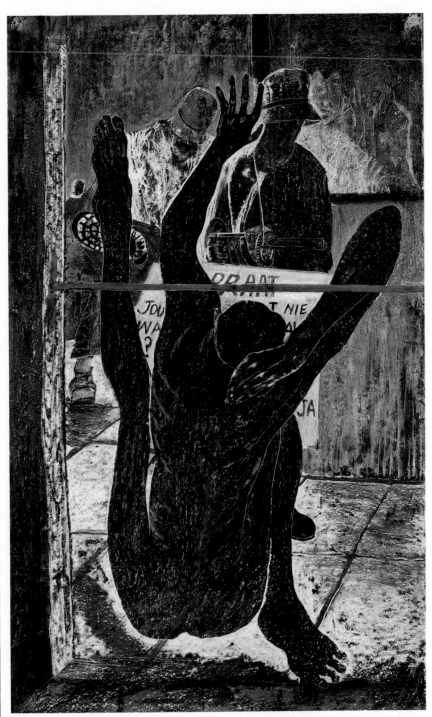

▲ EYE WITNESS 1988 OIL PASTEL ON PAPER 86 × 60 CM

Ramphomane is a young artist who did one year at the Rorke's Drift Art Centre in 1982, and has also studied with the Soweto Artists Association. In 1985 he took the decision to become a full-time artist. 'I like art. I get inspired by many things. I am very concerned about our present-day situation.'

MALCOLM PAYNE

'The country is changing . . . the voice of the worker is being heard. The government doesn't know what to do with mass culture – there are little schools and groups springing up all over the place making interesting work with no formal aesthetic background,' says Malcolm Payne. It is his belief that art should be accessible to all, utilising images and codes that relate to the experience of living in South Africa today.

His first exhibition was in Johannes-

COLOUR TEST 1974
SCREENPRINT
83 × 107 CM
UNIVERSITY OF THE
WITWATERSRAND

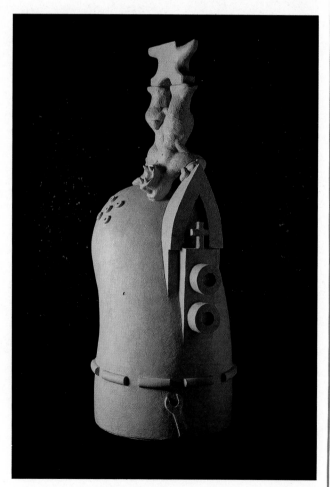

MAFIKENG HEAD NO. 6 1988
CLAY
HT: 82 CM

burg in 1973. Two people came to the opening. One piece was sold – a television screen stencilled with the words usually seen on the emergency exits of buses – *In geval van nood stamp die ruit uit* (In case of emergency, push the glass out). Anyone who has watched a few days of South Africa's propagandist pro-government television service would have understood that one.

Four other pieces on the show were of another integral part of the South African scene – the identity card (since replaced by the 'book of life') which, by the information on race it supplies to officials, controls every aspect of every citizen's life from birth to death – where he or she may live, go to school, even be buried. 'I consciously made no aesthetic decisions,' says Payne, who printed photographic silkscreens from blow-ups of the cards. He altered the images slightly, however. On one of the cards he substituted a test for colour blindness where the photo should have gone.

A series of sculptures utilised that tourist cliché, anathema to most professional artists, the wild animals of Africa. The problem was how to liberate the

image of the animals from all the traditional representations of animals made down the years.

Payne admires trade-union logos – 'the art content is so direct' – and his solution here was to draw on that kind formed part of the images. Payne followed the animal sculptures with black sprayed drawings in which the same small images – gorillas, chains, gravestones, eagles, flames – would be used again and again to produce an overall one knows who made those heads, but the idea of continuing a tradition that started that long ago intrigued Payne. 'It's got something to do with looking for an inherent vision outside the usual curio sense,' he says.

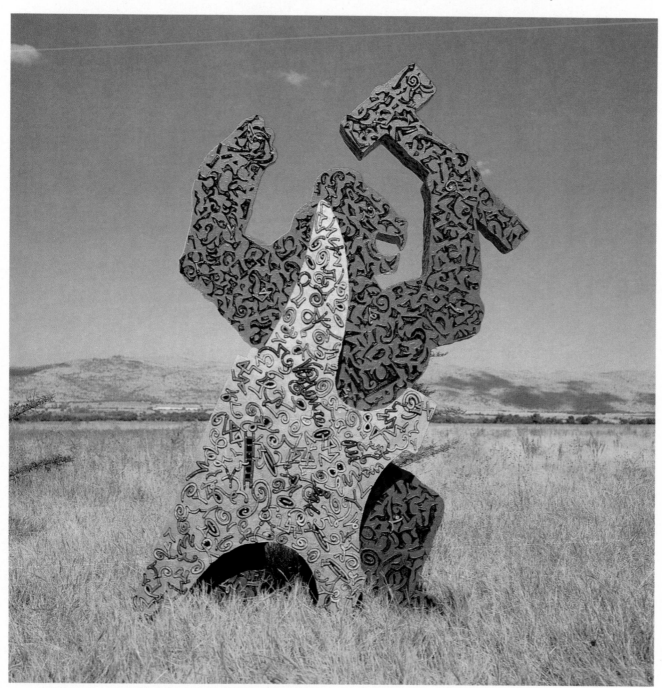

▲ GORILLA 1985 POLYSTYRENE, MARINE PLYWOOD, CANVAS, PAINT, FABRIC HT: 300 CM

of simplicity: the animals were presented as large-scale 3-D cutouts, identifiable by outline only. A further homage to workerist imagery came in the form of the tools – hammers, sickles – which pattern with no spatial depth.

Seven 1 500-year-old clay heads dug up in Lydenburg in the northern Transvaal in the early 1960s were the inspiration for Payne's most recent work. No His heads, also worked in clay but with the visual symbols of sinking ships, animals, tools added in, bridge the centuries and extend that vision.

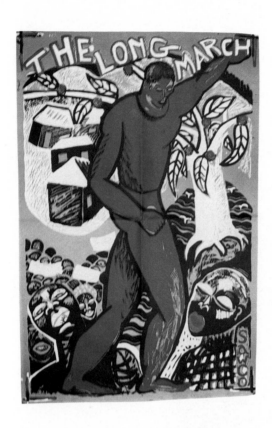

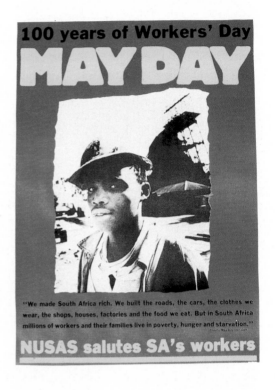

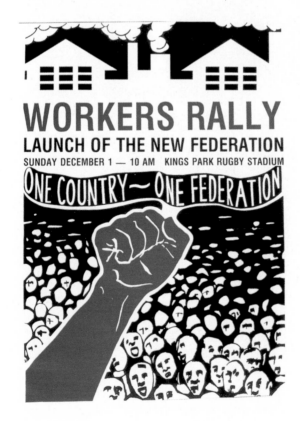

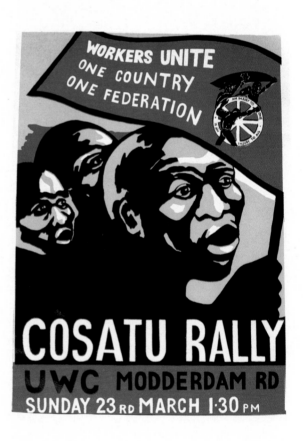

THURSDAY, JANUARY 30, 1986

Cape Times

BAN ON PROTEST T-SHIRTS, STICKERS

CT LTD

DRAWINGS ON THE WALL

THE MAN'S A FOOL

83

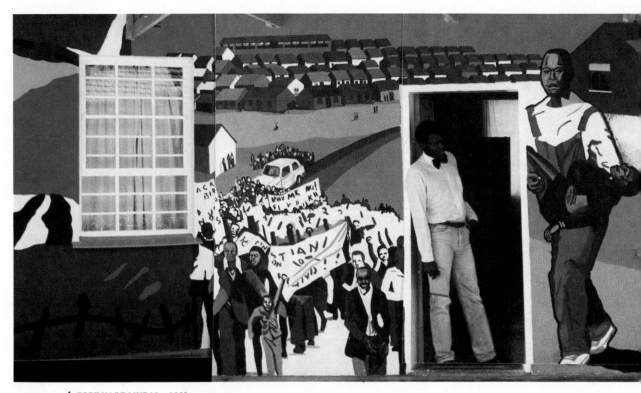

▲ FORT HARE MURAL 1982

MURALS

▼ MURAL BY THE CHILDREN OF
JOZA TOWNSHIP, GRAHAMSTOWN 1984

Grahamstown, in the Eastern Cape, is a university town showing its pride in an historic past by calling itself the 'Settler City'. The centre of a most impoverished area, it is also a traditional heartland of African resistance. In most South African cities, the black areas are well away from the white suburbs. In

Grahamstown, audiences entering the fine Monument Theatre on the hill can look across down to Joza township, searchlit during the unrest of the mid-1980s, and see the Casspirs thundering along the streets.

In April 1984, a media group at Rhodes University, looking at ways in

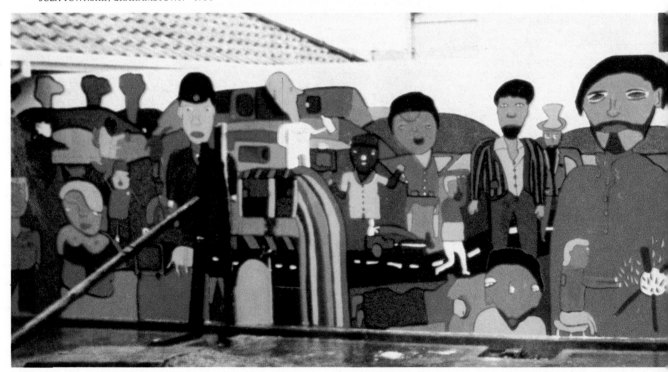

which wall art had been used in political struggles in Mexico, Chile and Mozambique, decided to try to initiate one in Joza township. One of the group, Michael Markovitz, set up a mural workshop for children in the township. The theme was 'What I see on Raglan Road [the main thoroughfare].'

Housing and public buildings in the township are state-owned, so could not be considered for wall space, but the owner of a Joza café gave the go-ahead for the mural. First, however, approval had to be obtained from the City Council. It was not possible, Markovitz was told, because the mural would conflict

with the settler aesthetics of a white housing development built behind the café!

By now it was September, and thousands of students marching in Raglan Road were attacked by the police with rubber bullets and teargas. After one workshop session, Markovitz was

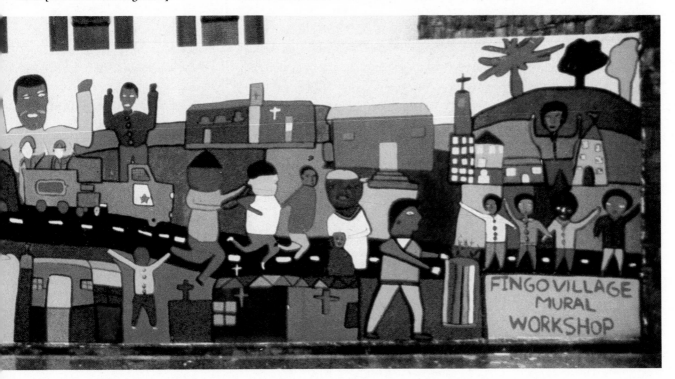

stopped by police who found drawings depicting their colleagues. 'I was taken to the police station, where members of the riot squad gleefully identified themselves in some of the children's

of cops and people and cars on Raglan Road and a picture appeared on the front page of the *Eastern Province Herald*, the group could not quite believe what it had achieved, in spite of everything.

A small echo of what once was is recorded in a mural on the side of the Holy Trinity Church, standing alone now, with most of its parishioners departed. The artist was Peggy Delport, a

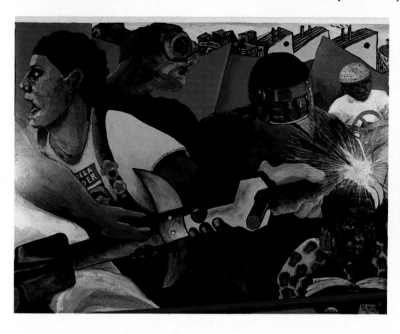

drawings,' says Markovitz. 'I was told to stay out of the township for good.'

In the next three weeks, Joza came under full army occupation, and it was impossible for Markovitz to enter without being subject to police surveillance.

In the end, he was forced to accept the offer of a university wall for the mural. The children chose fifty of their best drawings and painted them onto the wall. When the mural was complete and made an impressive pageant

A POSTER WHICH APPEARED NEAR A CAPE TOWN FREEWAY IN FEBRUARY 1989. REFERS TO A DEADLINE GIVEN TO THE STATE BY POLITICAL DETAINEES ON HUNGER STRIKE FOR THEIR DEMANDS TO BE MET.

Another university wall – in the art department at Fort Hare University – was the site for a striking mural by three art students in 1982, Zamani Mekanya, Sipho Mdanda and Phillip Phungula. Given the project by their lecturer, Annette Loubser, the students started work one Friday afternoon, and by late Sunday, their mural, on the theme of destruction, formulation and creation, was complete. Strong patterning contrasts with scenes of protest marchers and workers on the shopfloor. Regrettably, this mural was destroyed in 1987.

One of the most shameful episodes in the history of Cape Town is the destruction of District Six, a vibrant coloured community on the lower slopes of Table Mountain close to the heart of the city. In 1966 the area was declared white in terms of the Group Areas Act, and by mid-1983, in the face of bitter and sustained protests by residents and support groups, bulldozers had demolished every house.

lecturer in painting at the Michaelis School of Fine Art.

'As things went down,' says Delport, 'so the web was left. I'd pass it every day – the bulldozers, a flight of steps leading to nowhere. I started drawing. People would come and talk to me. What emerged from those conversations is what the nature of community is – the webbing . . . the interrelationships.'

The family at the centre of the panel was one of the last to leave District Six – carpenter Amien Hendricks, his wife Latiefa and their family. 'I liked the discipline of putting up something absolutely factual – an oral history,' says Delport. 'People would say, "You must have this." It was the process that was important. Later, comments were quite vengeful, like "the redness in the wall is like blood – it looks as if the earth is bleeding," and "God will not forget."'

▼ DETAILS FROM A MURAL IN THE FOYER OF
COMMUNITY HOUSE, SALT RIVER, CAPE TOWN,
DEPICTING ASPECTS OF THE STRUGGLE. PAINTED
BY ARTISTS ASSOCIATED WITH THE COMMUNITY
ARTS PROJECT.

THE PEOPLE OF
DISTRICT SIX:
A COMMEMORATIVE
MURAL PAINTED BY
PEGGY DELPORT
ON THE WALL OF
HOLY TRINITY
PARISH CHURCH

PEACE PARKS

Existing now only in photographs and memories, the peace parks which burst into being in the last months of 1985 were not only a direct response to repression but a triumphant reappearance of the tradition of beautifying the community which has always been part of Africa.

'They can kill us and detain us, but they can never remove from us the pride of caring for our environment,' said Luckyboy Zulu, a 15-year-old peace park worker.

Following the declaration of the first state of emergency in July 1985, essential services like removal of refuse had broken down and residents were dumping their rubbish on street corners and in open spaces.

Writing in the *Weekly Mail* (24 January 1986), Sefako Nyako described the way the peace parks came into being: 'Groups of youths organised themselves to do something about it [the rubbish]. Using tools "borrowed" from the family's toolbox, they went about cleaning debris from the streets and open spaces. It soon became a mammoth task, with grader and tipper-truck drivers "requested" to shift mounds of dirt and move loads of soil. Motorists were asked to put coins in empty cans held by those whose hands are too weak to handle a spade. The money was used for paint.

'This action caught the eyes of environmentalists, who donated trees and other shrubbery. What were once foul-smelling dumping grounds soon blossomed into well-constructed and laid-out parks.

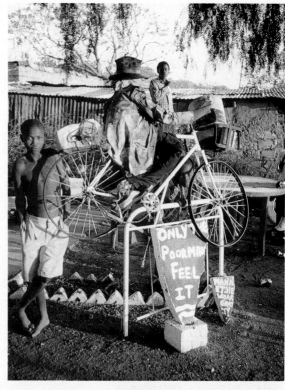

► 'ONLY POORMAN FEEL IT'
OUKASIE TOWNSHIP
BRITS 1985

▼ STREET CORNER MURAL
MAMELODI TOWNSHIP
PRETORIA 1985

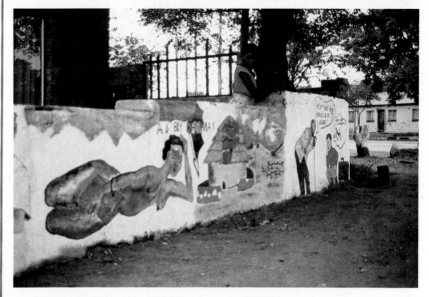

'In Orlando East, Lovers' Park is undoubtedly the best of the lot. Balanced on bricks in the centre of the park is the burnt-out shell of a car, repainted neatly in contrasting shades of black and white. Clearly marked footpaths skirt trees and flowers. To keep out the vandals, there is knee-high fencing.

'There is also Oliver Tambo Park in White City, Sisulu Park in Orlando West, Nelson Mandela Park and Steve Biko Park in Mohlakeng.'

One of most affirmative and heart-warming aspects of the peace park activities was the sheer scale on which the project gripped the imagination of the township residents. Younger children created little 'Gardens of Eden'. In some streets in Mamelodi and Alexandra, the outside of house after house was decorated with painted rocks or a colourful sign. Assembled sculptures appeared on pavements.

The joyous art works and the loving-

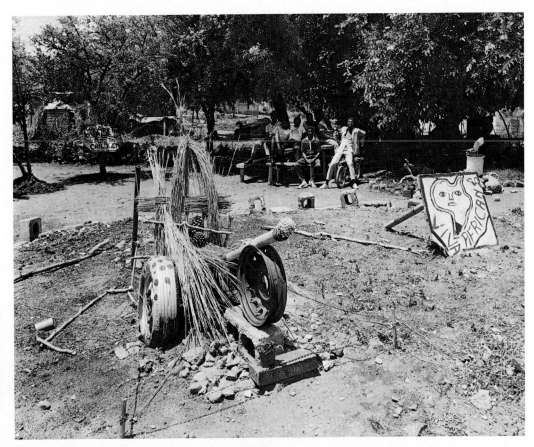

▲ CROSSROADS PEOPLE'S PARK, OUKASIE TOWNSHIP, BRITS

▼ THE GARDEN OF PEACE, ALEXANDRA TOWNSHIP, JOHANNESBURG

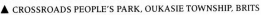

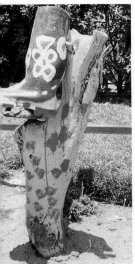

▲ TREE SCULPTURE
MAMELODI TOWNSHIP
PRETORIA 1985

ly made peace parks were not to last long. It was clear to the state that the youth groups, in making the parks and calling them after leaders like Nelson Mandela, were reaffirming their cultural and political beliefs. On the pretext that the parks were being used as places to hide arms, the security forces systematically destroyed them.

BENZ KOTZEN

Advertising sells, the admen tell us, and a strong poster campaign will promote a high degree of product recognition amongst consumers.

In 1981, a satirical poster campaign for what might be considered South Africa's best-known product, apartheid, hit the streets of Johannesburg. The posters were the work of art student Benz Kotzen, poking fun at the system. For each item in his apartheid range, Kotzen made a special pack. The names he gave his products, wonderful puns in both official languages, were both witty and derisive.

There was *Apartheid Twak*, in a little cloth pouch. 'Twak' is the word not only for tobacco but also for bullshit. *Apartheid se Moer Koffie* meant not only filter coffee, but was extremely derogatory towards the apartheid system, as was Kotzen's line of matches: *Apartheid Doos*.

Often choosing early Sunday mornings, Kotzen pasted up his posters in the streets, using other poster sites. Sometimes the police would tear them down minutes after they had been put up. Or passersby would start to deface them. On other occasions, people came up to Kotzen with comments and criticisms – 'or to tell me what I should be

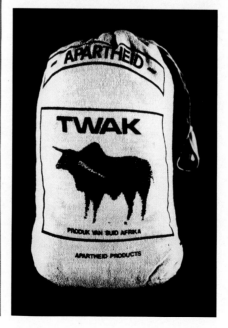

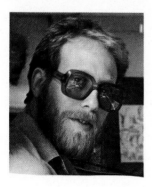

producing next!'

Kotzen knew his posters would not effect change in South Africa, but, he says, 'it was a means of heightening awareness amongst white middle-class South Africans.'

▲ APARTHEID BEER POSTER SHOWS CAN PHOTOGRAPHED AGAINST THE CURB OF LAAGER ROAD; APARTHEID FILTER CIGARETTES PROTRUDE FROM BACK POCKET OF JEANS; 'WHITE ELEPHANT' MATCH BOX

◄ BAG OF APARTHEID TWAK

POSTERS ANONYMOUS

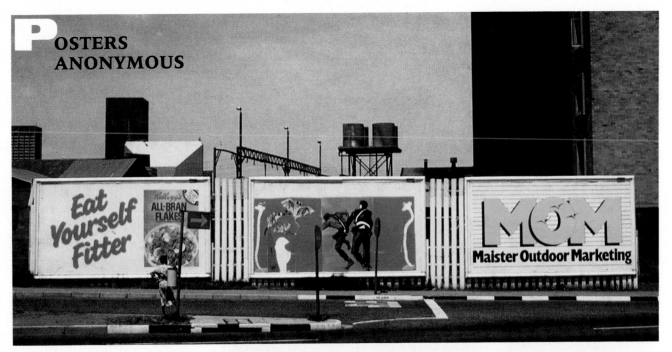

It became a kind of game: put the posters up as prominently as possible, and see how much attention they can attract before they're ripped down.

The first, on a wall passed daily by thousands of commuters in cars, showed a blindfolded businessman blundering forward amidst a shower of falling golden coins. For its audience it was right on target: it was August 1985 and the state of emergency had caused the rand to collapse, sending the business community into a panic.

That poster stayed up for some time, long enough to receive considerable media attention, much longer than one of Batwoman on a pedestal – rumoured to represent the complicity of the malignant forces of society.

One particularly large-scale effort filled a whole billboard on a ramp in Braamfontein – splendidly and subversively incongruous between its con-

sumer-orientated neighbours.

The artists/sticker-uppers were never publicly identified.

▲
▲ POSTER ON BRAAMFONTEIN HOARDING

▲ POSTER IN OXFORD ROAD, ROSEBANK, JOHANNESBURG, ON THEME OF FORCED REMOVALS WAS RIPPED DOWN AND STUFFED INTO LITTER BIN WITHIN HOURS

◄ 'RACE RIOTS' POSTER ALSO REFERS TO AN INTERNATIONAL CALL TO BOYCOTT KYALAMI (JOHANNESBURG) GRAND PRIX

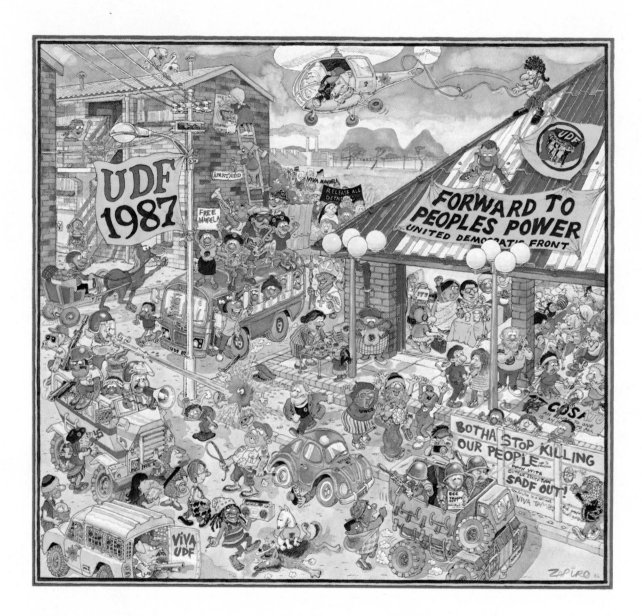

JONATHAN SHAPIRO

The 'in' Christmas present for lefties in 1986 was a cartoon calendar of jolly and recognisable activists being grimly surveyed by a police force of the porcine kind. The signature of the artist had clearly been painted out. Six weeks after publication, by which time it had virtually sold out anyway, the calendar was

banned for distribution.

'I was away when it was banned and got this frantic message, Don't come

back . . .,' says Jonathan Shapiro. 'So I came back really carefully and dyed my hair.' Shapiro was an architectural student, an activist who fell into cartooning to communicate ideas. Over the past few years, his initially crude drawings have matured into searing images of vitriolic refinement, appearing for a time in the newspaper *South*. 'I enjoy the immediacy of the work,' says Shapiro. 'The news happens, and the response comes.'

T-SHIRTS

'We Are Here to Stay! Stop Killing Us!'
'Troops Out of the Townships'
'Liberation Before Education'

In a country where almost all forms of protest are banned – an outdoor gathering of more than three people can be declared illegal, effectively preventing all rallies and marches – the humble T-shirt has become a potent way of making a personal political statement.

Every trade union, every progressive organisation has its own, and it's an indispensable media item in campaigns launched to raise public awareness on particular issues: *Free the Children! Save the Press! End Conscription Now!* And then there are the funerals. Because ordinary meetings are banned, an important political funeral might be attended by 20 000 people, brought by bus from all over the country. Such a funeral can go on for most of a day, with speeches by prominent figures talking on liberation issues alternating with freedom songs and haunting and powerful hymn-singing. A special T-shirt is a way of paying homage to the fallen comrade, and, by continuing to wear the shirt afterwards, one helps to keep his or her memory alive. Under the picture of the face there will often be a parting message, like *We Remember*, or *Hamba Kahle* (Go well).

Through the Publications Control Board, the state scrutinises protest T-shirts, banning some and charging and even jailing those who wear them. To pull on a T-shirt can be an act of courage.

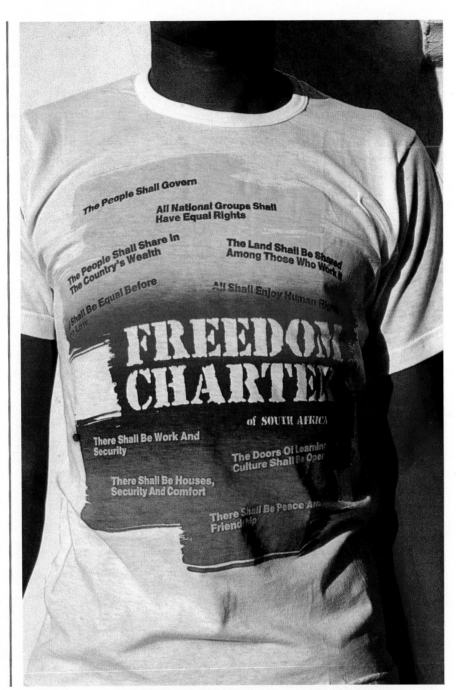

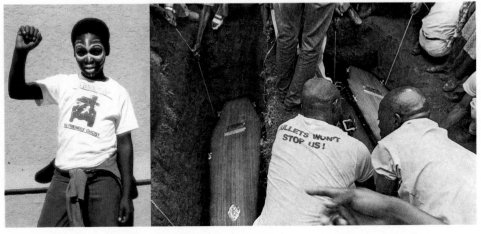

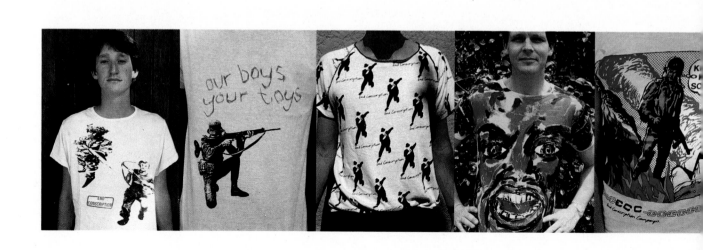

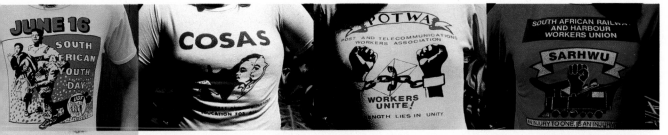

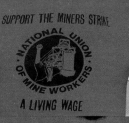

WHO'S LEFT? by Stent

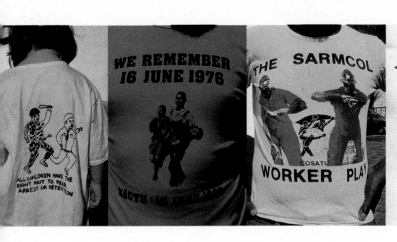

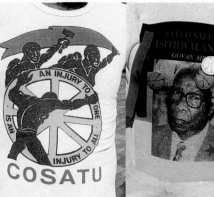

GRAFFITI

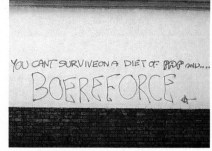

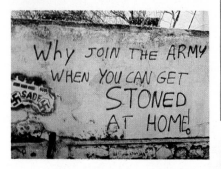

Unlike the spraycan kids who turned the New York subways into galleries – but it was all illegible – the agenda of the graffiti artists of South Africa is to pass the message on. The walls of the cities have become the noticeboards of

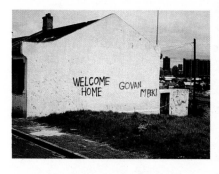

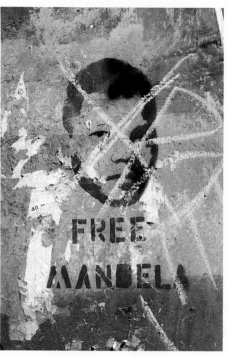

the people. They are read for trenchant, sometimes subversive comments on the news of the day, or to gain knowledge of popular demands. *Free Mandela* is the classic, probably written more ways in more places than any other. A comment on the role of the South African Defence Force in quelling township unrest was *Why Join the Army When You*

Can Get Stoned at Home. A hero of the people is greeted on his release from jail: *Welcome Home, Govan Mbeki.* State President P. W. Botha is often invoked. *PW, the Sky is Falling on Your Head,* and

PW Must Go to Robben Island.

Some walls seem to be particularly inviting. Late in 1986 the Cape Town City Council decided to paint out prominent graffiti if the owner of the property affected had painted his or her

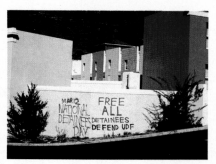

wall in the past 12 months. 'Sometimes we paint over, and three days later it's back again,' said a Council spokesman, noting that ten years ago the only graffiti one found was the four-letter kind; 'but in the past two years, graffiti has really taken off. The left-wing graffiti started earlier, and the right-wing graffiti seems in many cases to be done in

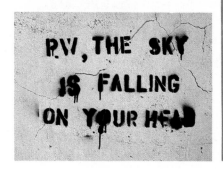

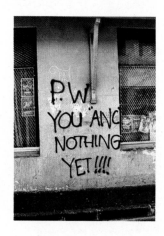

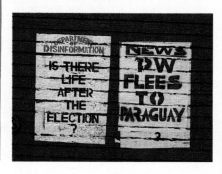

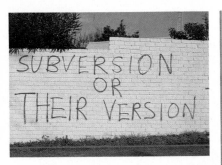

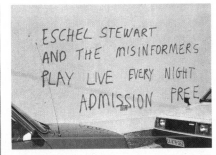

retaliation, like a backlash,' he said, adding that it was difficult to tell when the spraycanners' enthusiasm would burn itself out. 'Both lots might eventually find they make such a mess that they abandon the practice. It's an expensive business for us.' In

spots, reinforcing the message. The left say you can always tell a right-wing message quite apart from the sentiment: because the right-wingers aren't afraid of being spotted by the police, their graffiti take up more space. The left write their messages

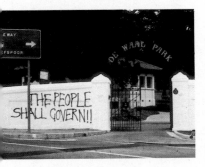

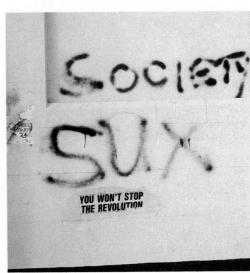

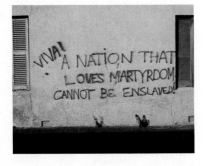

the meantime, whole dialogues go on. *Free All Detainees* got changed to *Freeze All Detainees*. *ANC for Peace* became *WANK for Peace*. A comment on the economy read *Rotten Ruler, Ruined Rand*. Some weeks later, *Rather Rands*

heart in mouth. Being caught in the act could mean two years in jail. The appeal of graffiti is its directness. It is a message sent at personal risk. Here is a cry from the heart or a

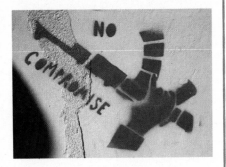

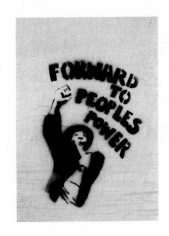

Than Roubles appeared, to be followed by the quick riposte *Rather Roubles Than Rubble*. Some of the most attractive graffiti around are the ones sprayed through a cardboard stencil. This variety blooms overnight, and the same image will appear in a number of different

call from the organisations that has not had to pass through the sieve of media restrictions. As press censorship increases, the writing on the wall has become required reading.

GARTH ERASMUS

▼ STATE OF EMERGENCY SERIES
ENAMEL SPRAY PAINT ON BOARD
60 × 50 CM EACH

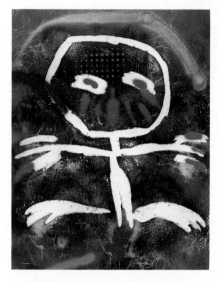

Garth Erasmus's *State of Emergency* paintings look like what they are – graf-

form a backdrop to the classic graffiti everyman. The spraying technique solved a problem for Erasmus. 'There I was, supposedly a black artist, doing pictures that had a very volatile content, like riot scenes. Painting them conventionally, they weren't projecting. But with the spray! The spray

touched the nozzle, the paint seemed to flow right up my arm. You just had to

fiti he once sprayed on city walls, refined and put on paper. Images of entrapment – grids, smoke, wire mesh –

burned right into the cardboard, like a photograph – the very medium itself was volatile. When I held the can and

feel it and it came out. Before, when I'd paint a fire, I'd paint it, but when I sprayed, the fire just came by itself.'

CONFRONTATION
AND
RESISTANCE

MANFRED ZYLLA

In October 1985 there occurred a notorious event in Cape Town, covered extensively by overseas television teams (before they were prevented from filming unrest situations by the state) which came to be known as the 'Trojan Horse' incident. It took place in the coloured residential suburb of Athlone.

Police forays into black areas were being greeted by resistance from the people. Barricades of burning tyres, fusillades of stones, 'traps' dug into the road, backed up the people's demand: 'Troops out of the townships.'

To punish stone-throwers, policemen hid in packing crates and had themselves driven up and down a busy Athlone thoroughfare on the back of a truck. At last the bait was taken. As the first stones hit the truck, horrified onlookers saw the crates burst open and the police leap out and open fire.

Moments later, three boys lay dead by the side of the road. The youngest was Michael Miranda, an 11-year-old relative of artist Manfred Zylla's wife, Aziza. 'He was a gentle boy,' says Zylla. 'He and his friends were on their way to the shop when it all happened in front of them.'

Death Trap 1985, a pencil diptych, is Zylla's record of this event. The drawing of Michael in his coffin was done from photographs Zylla took at the funeral.

It is an irony that Zylla, whose work is amongst the most sharply cutting in South Africa, is German by birth and upbringing, born at a time when Nazism was at its most fervent. He arrived in South Africa in 1970, and sub-

sequently married a Muslim girl. Living for two years with her family in Athlone has given Zylla a view of the country often missed by other whites.

His 1985 painting *Games* sums up the whole South African scenario: the stakes are money and power, and those who have such privileges will stop at nothing to maintain them.

In the centre of the painting, behind the circular wire framing of a dart board, loll four black youths, relaxing on the sand dunes (a reference to the inferior land usually allocated to blacks for residential purposes). A scoreboard

on the left tells us the name of the game is 'Killer'. Darts have already been thrown by an unseen onlooker, and the innocent-looking four are surrounded by a circle of the military in every kind of uniform, all intent on shooting, bayoneting, spearing, or otherwise eliminating the boys.

Looking on at the left are the establishment – the parliamentarians and the military general, impassively regarding the scene for which they are largely responsible. Their desks are papered with ten rand notes, and it is clear that the artist sees the struggle in economically exploitative rather than racial terms.

To retain financial control, white capitalists must maintain that pool of cheap black labour which in quieter times built up the industrially strong South Africa – and here, still smiling broadly, are the past and present Ministers of Finance, their eyes blinkered with banknotes. Skyscrapers are composed of stacks of notes, and a large pair of hands pushes more of these under the army attacking the four boys.

At the right, like viewers at a drive-in cinema, onlookers observe the scene from cars. And behind, beneath a dreamy pink sky with cotton-wool clouds, we see the rows of matchbox houses of Khayelitsha – ironically, it means 'New Home' – a recent government housing project for Cape Town's blacks, situated some 30 kilometres from the city centre, well away from the lush white suburbs.

The theme of the effect on the young of living in the brutalised society of South Africa is a recurring one in Zylla's work. A loving and concerned father, he says: 'I am afraid for my two little girls. I am afraid because there is so much violence towards children here.'

A 1985 diptych, *Bullets and Sweets*, refers to the peculiar desire of the leaders of the South African Defence Force to be loved by the township children in spite of the army's usually monstrous behaviour towards them. This desire has led the SADF every now and then to send a Casspir or two full of soldiers into the townships not to hand out the usual retribution (shooting, beating up and arresting people, often seemingly at random) but to distribute leaflets to the people reading, 'We are your friends', or to play a game of soccer with the township kids, or to hand out

▶ DEATH TRAP 1985
DIPTYCH
PENCIL ON PAPER
60 × 86 CM EACH

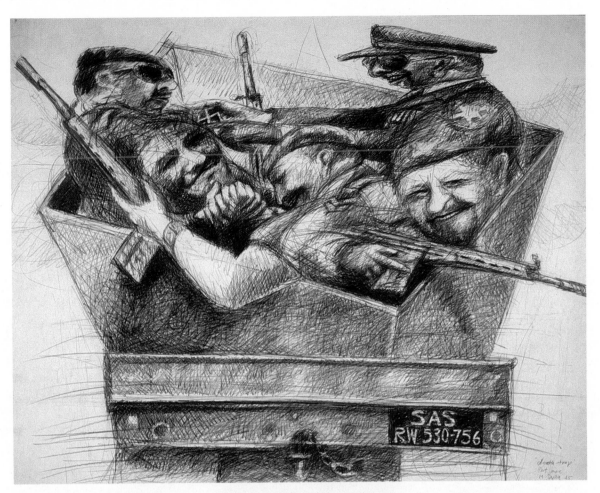

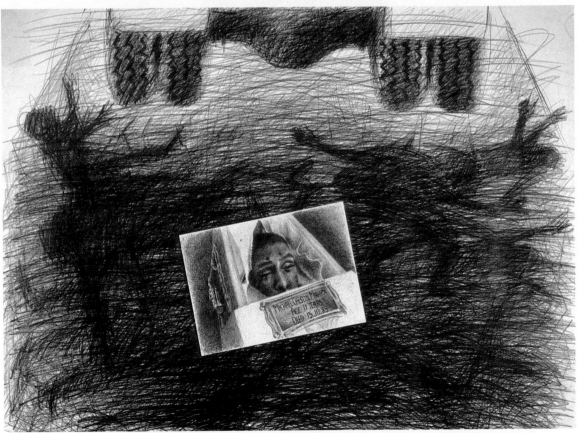

candy. Of course, on such occasions the press are welcomed – indeed, informed in advance – and the bizarre exercise in friendship is always reported in the next day's newspapers.

In Zylla's powerful drawing, a brawny soldier with a meaningless ship children. Terrified, bewildered, ignoring the sweets, the children watch the soldier intently, shielding themselves against anticipated blows, ready to run.

Some years ago, Zylla planned an event at which all those who came cooking pot, smug businessmen in the boardroom, military generals.

One Saturday in June 1982 he stuck his drawings onto the walls of the Community Arts Project hall in Woodstock, Cape Town, and invited people to add to them in any way they wished. More

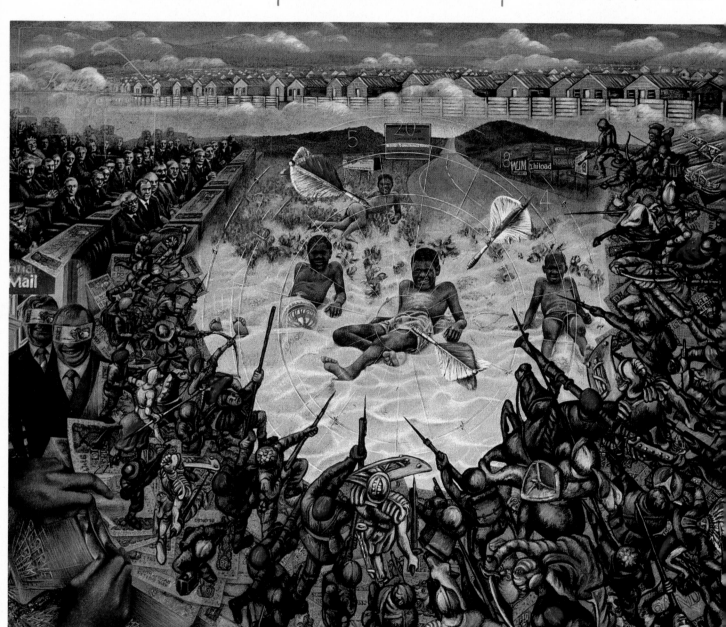

GAMES 1985 ACRYLIC ON HESSIAN 200 × 250 CM

half-smile on his face, gazes sightlessly down the barrel of his gun. In spite of the rows of bullets emitting virilely from between his thick thighs, his gun appears to be shooting candy, which lies at the feet of a small crowd of town-could express their feelings through drawing. For eight months he had worked on a series of large drawings done in pencil on brown paper. The images were of grossly fat whites at the barbecue, bombs and grenades in their than 200 people came.

This is University of Cape Town psychology professor Paul Taylor's account of the afternoon: 'The sight of Manfred's BOSS figures looming over you on all sides was thrilling as well as

disconcerting. The images ring true for us – hence that disconcerting sense of involvement, because they are also the reality we face, all of us. So the impact of these unambiguous images is much more than that of an ordinary Chamber of Horrors.

'Most art gives us the privilege of unrestrained scrutiny. Manfred's idea was to give us more: he gave us paint and brushes, the artist's weapons, and urged us to attack the monsters as we pleased. I saw one distinguished-looking man with a beard who, calmly ig-

perhaps, the procedure seemed to enhance rather than diminish the artist's responsibility for what was being communicated. The effect was both chilling and stimulating.'

On a different tack, painter Shelley Sacks summed it up like this: 'Manfred has had to sacrifice his images as "art work" to make way for the people. Not a masochistic sacrifice. There was too much warmth in the room for that. He showed us through his act that a real change in values means a deep change in attitude, and that we are all going to

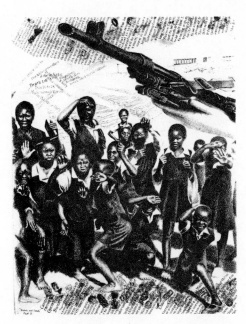 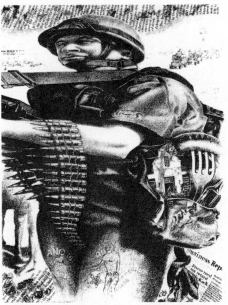

BULLETS AND SWEETS
1985 DIPTYCH
PENCIL AND WATERCOLOUR
ON PAPER
100 × 77 CM EACH

noring the rush for brushes and paint, left by a side door and came back with a ladder. He set it up next to one of the headless figures and carefully painted on the head of a pig. I think he'd waited a long time to do something like that.'

Not everyone felt quite as positive. Printmaker Jules van de Vijver commented: 'It was a shocking event. The first brushmarks on those complete and revealing monumental drawings overthrew the taboo that a finished drawing should not be touched. It was hard to accept that for the artist these drawings were not complete. I don't believe the drawings gained in authenticity by the communal contribution. Ironically,

have to give up a hell of a lot, to change our habits and values in uncountable ways if we want to create a truly democratic social order.'

After the event was over, Zylla had a book published with before-and-after pictures of the drawings and comments from participants. Before long, the book was banned.

That afternoon when art lost its image as an elitist activity and became a free expression of the people meant a lot to those who were there. Months afterwards, people still came up to Zylla on the street to thank him for it.

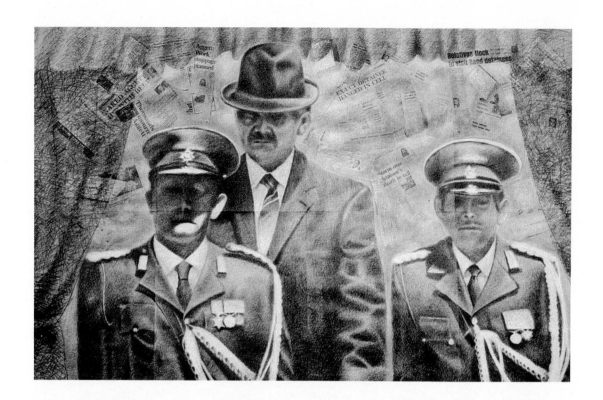

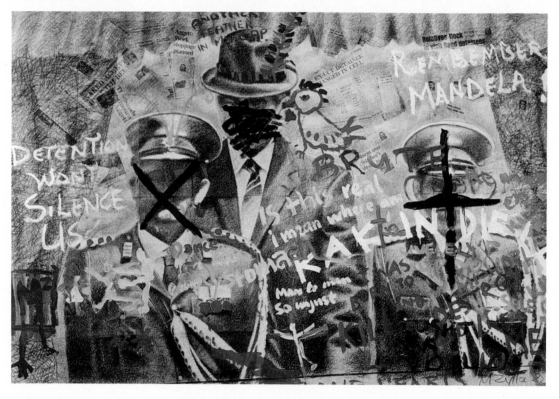

THE MILITARY GENERALS: BEFORE AND AFTER
BLACK AND WHITE CRAYON ON BROWN PAPER
200 × 300 CM

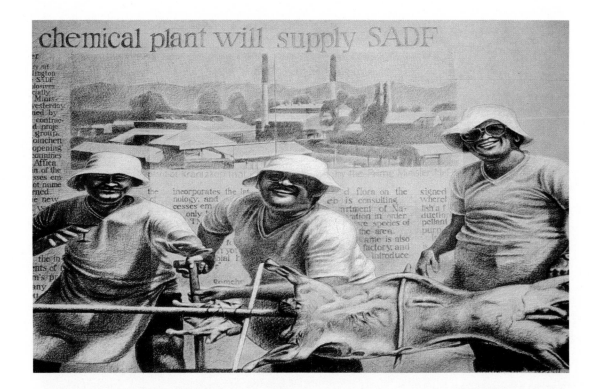

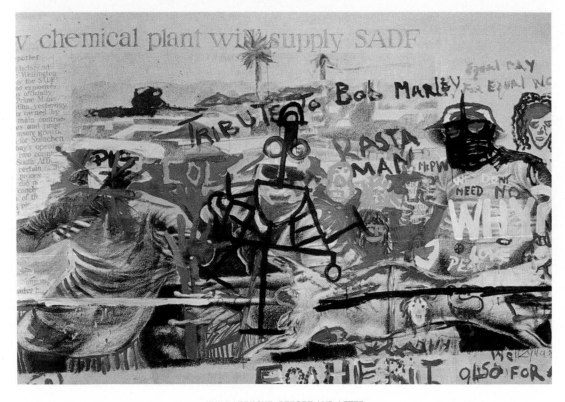

THE BARBECUE: BEFORE AND AFTER
BLACK AND WHITE CRAYON ON BROWN PAPER
200 × 300 CM

ALFRED THOBA

life in Johannesburg. Officially, under the Group Areas Act, blacks may live only in black areas, like Soweto. In practice, thousands are living illegally in central Johannesburg, but as exploited fugitives.

'I started the painting in a room in Yeoville. The owner said I couldn't use the room as a studio, so I had to carry

lot. Each time I looked at it I cried. The cops wanted to see it. Luckily the day they came in the picture was covered. I'm sure they were told about it. I had to take it to a certain businessman in High Point [apartment block] to keep it safe for me.'

1976 Riots, full blooded and poignant, was a high point of the 100 Artists Pro-

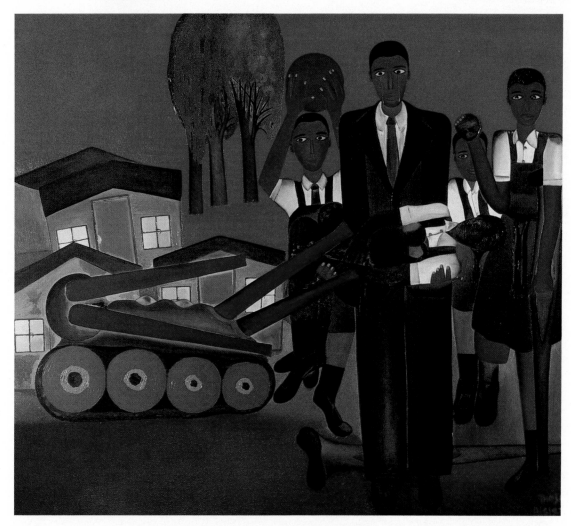

'I used to paint love stories all the time – I had no violence in my work – but one day I thought: let me paint the riots.'

Alfred Thoba's painting *1976 Riots* reminds us of the scores of news shots of that year when the schoolchildren of Soweto defied the authorities with such devastating results.

The story of the making of this paint-ing spotlights another aspect of black

the picture to Orange Grove and from there to Jeppe Street.' Thoba carried the large picture at night to avoid un-welcome attention.

'In Jeppe Street I could stay only a week, then I moved to Berea Boul-evard.' Thoba is talking about places many kilometres apart. 'I convinced the caretaker to give me a small room on the roof. . . . I worked very hard on the picture. When I finished it I cried a

test Detention Without Trial Exhibition at the Market Gallery in January 1988. The cops did see it after all. The exhibi-tion was organised by the Detainees' Parents Support Committee, and when the DPSC was restricted on 27 Feb-ruary, the police came to the gallery and photographed all the work.

▲ 1976 RIOTS 1977
OIL ON BOARD 147 × 151 CM

DAVID HLONGWANE

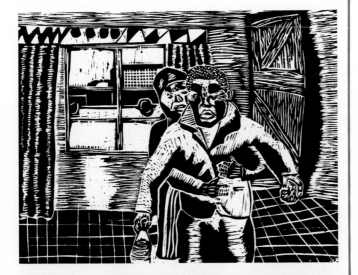

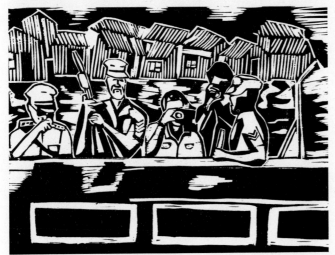

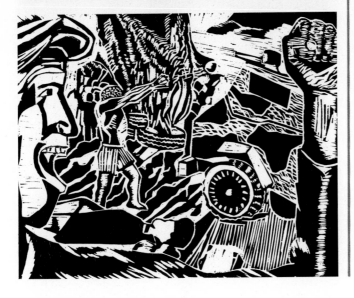

In their running battles with the police, the young lions in the townships have not only had to contend with the armed strength of the authorities, but often also with the disapproval of their parents, fearful for the safety of the family.

> Mama let me go
> to the battle
> on 21st March
> They've killed our heroes
> like animals
> in their land of Africa
> they have been killed by the boers
> Mama let me go
> to the battle
> on the 16th of June
> They have killed our students

David Hlongwane's own brother was killed in 1985 in a demonstration, allegedly by the police. Hlongwane wrote this poem as a narration for his series of three linocuts depicting just such a township battle. In the first, a distraught mother tries to prevent her son from leaving the house. His sideways glance leads us through the window to the police van passing by.

The static quality of the second panel, with the police surveying, and even photographing, the scene from the safety of their armoured vehicle, gives way to the intense action and dynamism of the third.

Hlongwane is a young artist, born in 1963 in the small Western Cape town of Worcester. In 1984 he began studying art at the Community Arts Project in Cape Town, and in 1988 won a bursary to study in Italy for a year.

◄ MAMA LET ME GO
TRIPTYCH LINOCUTS ON PAPER
20 × 24 CM EACH

SFISO KA MKAME

'I have been told my work is too political, but I say, my work is just what I see when I wake up in the morning,' says Ka Mkame.

Working in oil crayon, building up layer on layer of colour, then scraping back in a sgraffito technique to reveal the surfaces beneath, Ka Mkame presents the daily scenes and terrors of township life in a series of brilliant snapshots. Here are the shanties and the gangs, the police vans and the protesters, the mothers and the jails.

The 26-year-old Ka Mkame received a sporadic art education over the years – 'when we were growing up we made pictures in the sand, and cows out of clay. At school we did maps and I used to draw for other students, but I didn't realise it was *art*.'

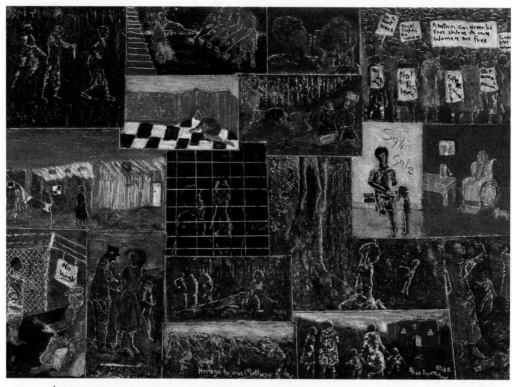

▲ HOMAGE TO THE MOTHERS 1988 OIL PASTEL ON PAPER 64 × 91 CM

▼ SCHOOLGIRLS COLLAGE AND MIXED MEDIA 36 × 48 CM

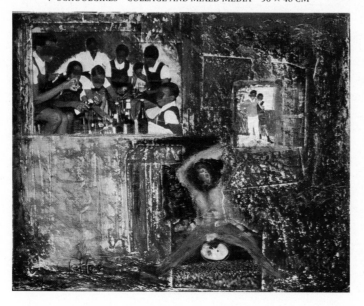

He was born in Durban, an area where violence in the townships has become endemic, and the police are notoriously repressive. Outspoken activists are liable to meet sudden deaths in violent and unexplained ways, as happened with the husband and wife lawyers Griffiths and Victoria Mxenge.

On *Homage to the Mothers* Ka Mkame says: 'Everyone is aware of the soldiers and the policemen – the child who is born into the world and the mother who is talking to herself imagining how she can bring up this child at this time.'

And on *Letters to God*: 'You write letters to someone telling them something has happened.'

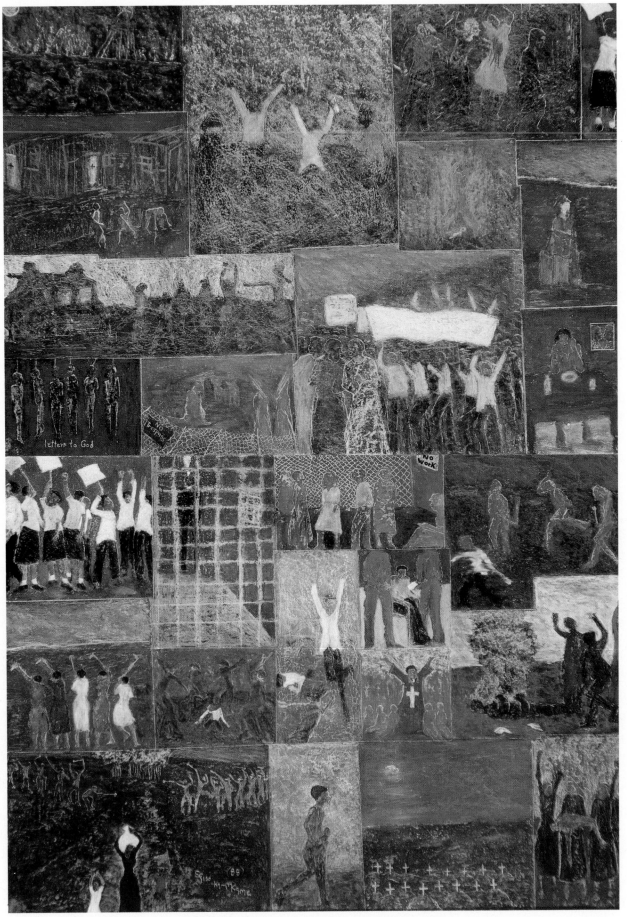

LETTERS TO GOD 1988 OIL PASTEL ON PAPER 128 × 91 CM

ILONA ANDERSON

There is a poem in Afrikaans by Ingrid Jonker called 'Die Kind' (The Child) which pays tribute to the unquenchable desire for freedom of the township children, who are determined to fight for liberty no matter how many comrades fall. Calling to memory scenes of confrontation between the kids and the heavily armed police, one verse reads in translation:

> The child is not dead
> Not at Langa, not at Nyanga
> Not at Orlando, not at Sharpeville
> Not at the police station in Philippi
> Where he lies with a bullet through
> his head

And continues:

> The child is the shadow of the
> soldiers
> In wait with armed Saracens and
> batons
> The child is present at all meetings
> and decisions on legislation
> The child peers through the windows
> of houses and into the hearts
> of mothers
> The child who just wanted to play in
> the sun at Nyanga is everywhere
> The child who has become a man
> treks through the whole of Africa
> The child who has become a giant
> travels through the whole world
> Without a pass

Johannesburg painter Ilona Anderson

took the line 'Die kind is nie dood nie' from the poem as the title for a diptych.

'I did it very quickly in about two days in '86 and then reworked it a bit in '87. I work and then passion builds up, and I'll do a very intense painting like that one, and then perhaps one or two others around it and then nothing for a while.

'My concerns have always been about living in this society, and as things have got worse that feeling has increased and I've begun to focus on that. Sometimes I can't stand the pressure, the knowledge of what's going on.

'In that painting I used Picasso's weeping woman and the wounded bull and I had in my head a Lucas Sithole statue of a wounded buffalo outside a mine compound, and I suppose the rage I felt and the rage I imagine will be unleashed were linked . . . all the deception and usurping of power . . . everything.'

▼ DIE KIND IS NIE DOOD NIE 1987 DIPTYCH ACRYLIC ON CANVAS 180 × 150 CM EACH UNIVERSITY OF THE WITWATERSRAND

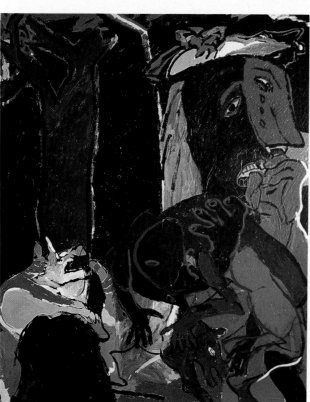
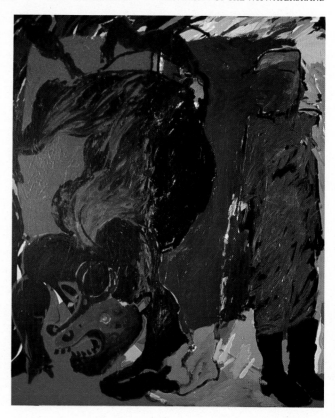

CECIL SKOTNES

One of the crucibles of black art in the 1950s and 1960s was the Polly Street Art Centre in downtown Johannesburg. Art facilities in the townships were virtually non-existent at this time, so Polly Street provided those basic essentials for every artist: materials, equipment, a space to work.

smash hit – it was a sellout,' says Skotnes – the first time a black artist had ever been so sought after.

The professionalism he tried to encourage in the artists who came to the centre has always been a hallmark of Skotnes's own work, represented as he is in almost every major collection in

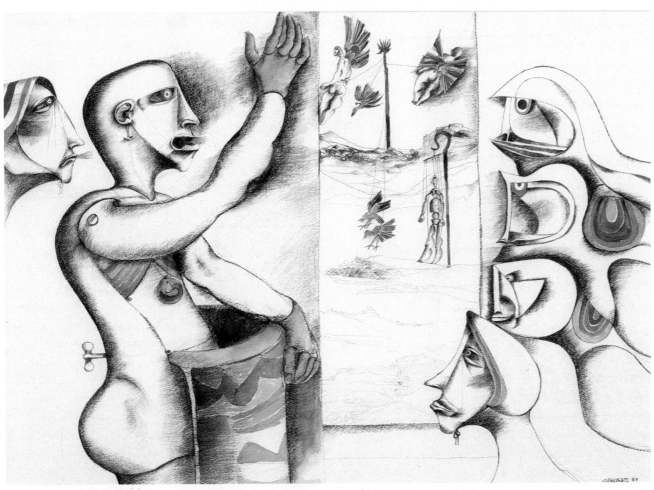

▲ THE ORATION 1987 PENCIL AND WASH ON PAPER 79 × 97 CM

But the Art Centre, under the direction of Cecil Skotnes, gave much more than that. Like apprentices in the studio of a master, those who came to Polly Street learned not only the techniques but the attitudes and ethos of being an artist.

The first exhibition of the Polly Street artists was opened by Father Trevor Huddleston in 1955. 'When money could be seen to be made, it propelled creative interest,' says Skotnes. Five years later, the first exhibition by Sydney Kumalo, a sculptor, 'was such a

the country. The teacher influences the students and in turn is influenced by them. Stylistically, Skotnes's work has always been clearly rooted in Africa.

Commenting on his beautiful pencil and watercolour drawing *The Oration*, Skotnes says, 'No one can ignore the situation in the country. There is no doubt about the end result and I look foward to the stage when the only colour of any value will be the stuff that comes out of paint pots. I just hope it happens in my time, that's all.'

PAUL STOPFORTH

'It is part of the contradiction of this country that at a time when the treatment of detainees is arousing acute anxiety, it should be possible for an artist to hold an exhibition depicting torture during interrogation,' wrote art critic Anne Pogrund in the *Rand Daily Mail* on 9 September 1978.

'It is astonishing that such a public protest should pass without much response, positive or negative, from anyone.'

The work under discussion was Paul Stopforth's series of sculptures in wire, plaster and gauze of naked figures in tortured poses of suffering: cringing, waiting to be assaulted, hooded, trussed, handcuffed and strung from a pole – or, like George Botha, having fallen down stairs.

'I want to make and spread an image as real as possible for the time now,' Stopforth said then. 'I want to bring the facts home to those willing to look. My figures parallel something that we can't be witness to. We can't refuse to accept that these things happen.'

It was the year after Black Consciousness leader Steve Biko died of injuries inflicted in detention, and along with Gavin Younge, Michael Goldberg and one or two others, Stopforth was one of the few artists attempting to come to grips with the situation through his work.

The triptych *The Interrogators* is a triple portrait of the security policemen who 'interrogated' (Stopforth's quotation marks) his friend Steve Biko.

Worked in graphite and floor wax, the piece is chilling, with a grey, steely coldness that seems eminently suitable for the subject. Form and content are perfectly matched. The portraits hang one above the other like a trio of over-sized Orwellian television screens. From whichever angle one tries to study these faces, they stare back, registering everything. There is no escaping these three.

Surprising, then, that Stopforth should say: 'My purpose was to show how terribly ordinary these

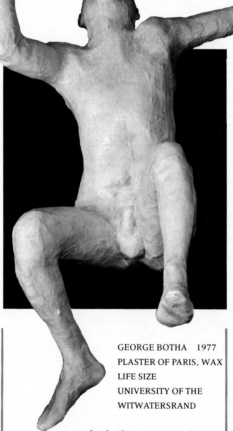

GEORGE BOTHA 1977
PLASTER OF PARIS, WAX
LIFE SIZE
UNIVERSITY OF THE
WITWATERSRAND

men looked – except perhaps the one with dark glasses [Snyman]. Hannah Arendt's phrase "the banality of evil" was, I felt, a perfect description of the men concerned.

'The shadow of the chair is a reference to the "struggle" that was supposed to have taken place while Steve was in their custody. The most mundane objects can take on frightening connotations in prisons and interrogation spaces.'

Elegy is Stopforth's homage to Biko and 'an attempt to place this image in the context of Western art history – a South African "saint", martyr and hero.'

In 1981, Stopforth was one of six artists chosen to represent South Africa at the Valparaiso Biennial International Exhibition. The work chosen to go by a panel of experts appointed by the South African Association of Arts was two small graphite drawings of damaged hands and feet entitled *Steve Biko* and *We Do It*.

Government intervention caused the drawings to be withdrawn. A letter received from the External Education and Cultural Relations Division of the Department of National Education read in part: 'The works chosen made political statements. While the department did not want to interfere with the autonomy of the artists, it decided, after discusssion with interested parties, that it was not the way of the department to promote and finance such works overseas.'

Three artists had refused the invitation to send work in the first place, not wanting to let the South African government appear as if supported by the art community, particularly in a repressive country like Chile. Stopforth had taken the confrontational route, and failed.

Extracts from a security police manual which surfaced in the alternative press recently listed a whole gamut of psychological techniques ranging from the friendly 'we know everything, anyway' approach, to the terrifyingly threatening, all designed to elicit information from detainees. Stopforth's *In-*

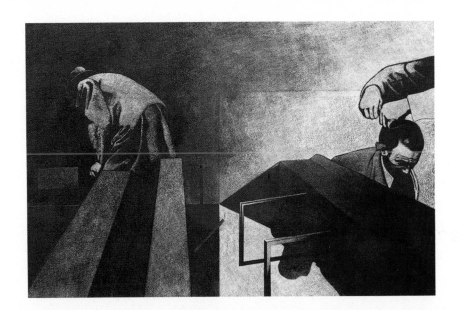

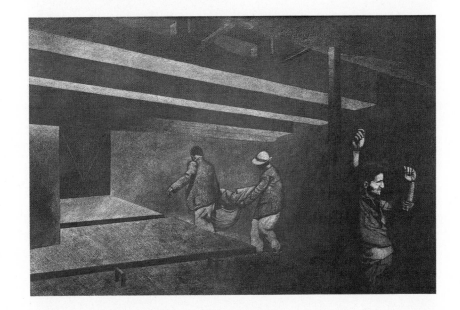

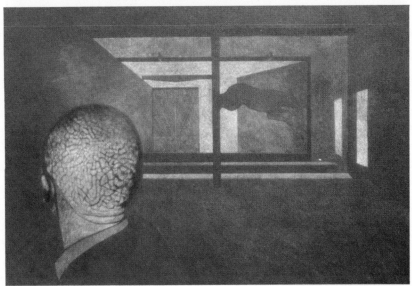

INTERROGATION SPACES II, III & IV 1983 GRAPHITE ON LAMINATED HARDBOARD

60 × 90 CM EACH

terrogation Spaces continued his illumination of the dark and murky corners where such sessions take place. 'The springboard for this series of drawings was a memorandum handed to the Minister of Justice and Police by the Detainees' Parents Support Committee asking whether prisoners were being interrogated in isolated areas, such as mine dumps, beaches and the bush-

this jump from the muted to the dazzling, the effect of the colour on the viewer is quite similar: somehow we know that all that brightness is only a smokescreen for what lies behind.

The same is true of the new drawing style. Since 1986 Stopforth's works have focussed on 'researching the human head for the face that exists inside of it, scanning for marks that give

meaning to brutality and greed, establishing visually the presence of another through a series of metamorphoses by which first marks develop into possible forms that are grasped, pushed, re-formed and deformed until given a specific identity.'

Titles like *True Detective* are a nod to Stopforth's interest in aspects of American mythology as presented in comic

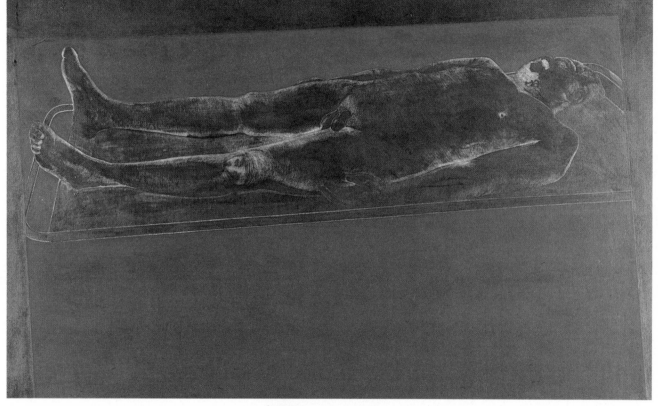

▲ ELEGY
MIXED MEDIA 149 × 240 CM
DURBAN ART MUSEUM

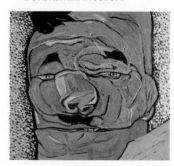

▲ THE LITTLE FASCIST
OIL ON BOARD
51 × 61 CM

veld.

'In my drawings, the interiors are bleak and sinister, their original function no longer visible. They are now torture chambers – spaces thick with fear.'

A sojourn in Europe with a spell at the Royal College of Art brought a change of direction for Stopforth. The grim bureaucratic greyness and carefully observed drawing were replaced by crisp black and white or brilliant comic-book colours.

It is interesting to note that despite

books, novels and films. The theme, though, is universal: the coarsening effect of a violent society on its members. These characters have been badly beaten up early in life. In this milieu, the bottom line is thuggery.

Says Stopforth: 'What the arts can do in South Africa is to construct images by whatever means possible to expose the nature of that tyranny, to support the struggle for freedom, and to give dignity and respect to the lives living and the lives lost.'

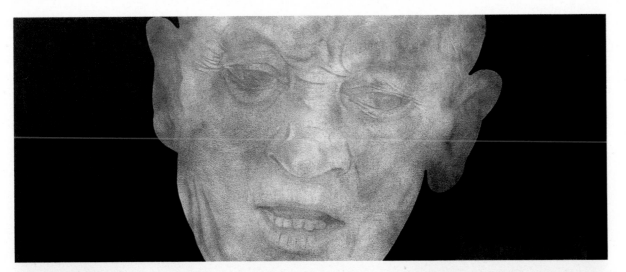

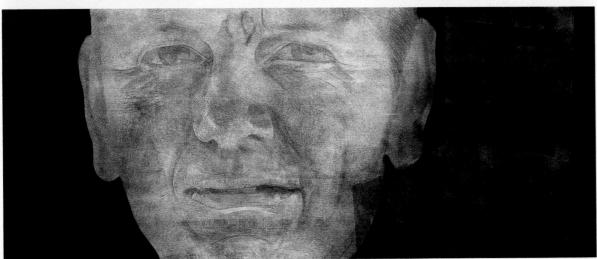

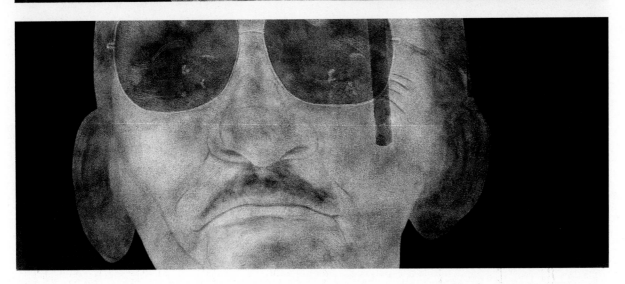

THE INTERROGATORS 1979
TRIPTYCH
GRAPHITE/FLOOR WAX
100 × 180 CM
S A NATIONAL GALLERY

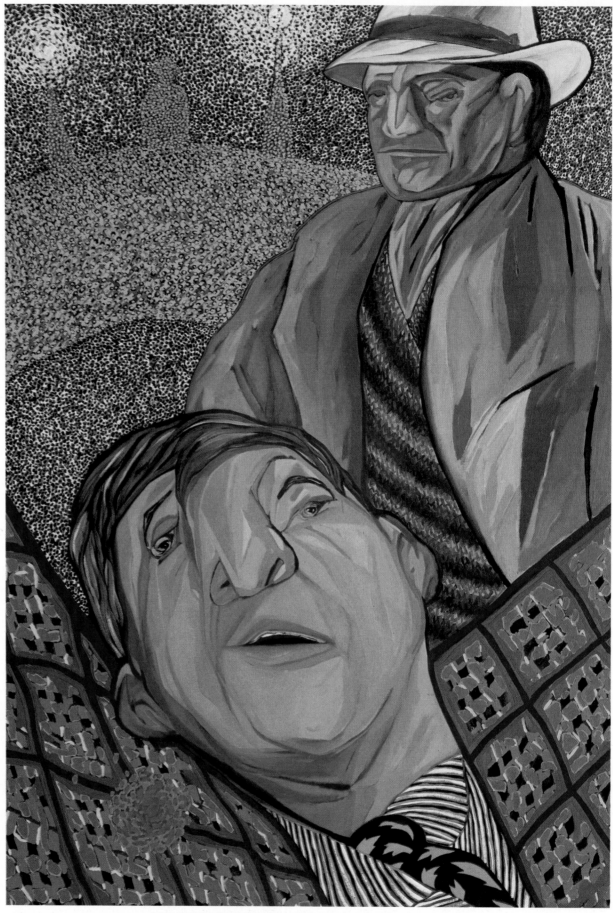

WHO KILLED DUTCH SCHULTZ? 1987 OIL ON CANVAS 160 × 112 CM

GARY VAN WYK

On 21 July 1985 the first state of emergency came into effect following months of unrest in the townships. Thousands were immediately detained and press reporting was strictly censored.

Wyk's new paintings were the freedom fighters and the soldiers, the cops and the comrades South Africans could no longer hear about. The background was a solid red. 'I wanted the images to leap out.'

Scale was important. The paintings were large enough to detach and hang as banners at meetings and events. They were not for sale, but an anti-apartheid organisation made postcards. In Germany, the city of Mainz featured the red paintings in a documentary ex-

hibition on the issue of academic contact with South Africa.

Some time later newspaper photographs and news footage of unrest situations were banned too. The state and Van Wyk did have something in common after all. They both recognised the power of images offered up for public consumption.

STATE OF EMERGENCY SERIES 1985
OIL ON CANVAS 150 × 200 CM EACH

In July 1985 Gary van Wyk was a final-year fine arts student at the University of the Witwatersrand, chafing under an academic program he felt was elitist. His idea about art was that it should be accessible to the community. He embarked upon a street-art project but could not get it recognised as his final-year submission.

Enraged by the state of emergency, Van Wyk started to paint pictures based on press and television images. Although the newspapers could no longer report freely on unrest situations, pictures were still coming out of the townships. And the pictures were saying a lot more than the words.

In newspaper black on unprimed white canvas, the subjects of Van

BONGIWE DHLOMO

While a trio of Casspirs patrols in the background, township residents in cars have to stop for a police search in Bongiwe Dhlomo's *The State of the 80's – Roadblock*. At the time of the unrest, roadblocks made every trip in and out of the townships a journey of fear. 'I had the idea of doing a series on roadblocks, their side effects and everything,' says Dhlomo. 'Now they're gone it's hard to remember.'

The hours wasted at the harsh roadblocks were not the only barriers in

Dhlomo's life at the time. In 1985 Dhlomo, her husband, graphic artist Kagiso Mautloa, and their two children had been living in the garage of Mautloa's family's house in Soweto for several years while waiting for an Alexandra house to become available. Facilities inside the house were shared with six other family members. Under those cramped circumstances, making art seems an indulgent and mess-creating activity.

Although she reserves the right to take any artistic direction she pleases – 'political expression is a form of release, but it is inhibiting to concentrate on that' – Dhlomo's work has always commented strongly on the South African situation. *Removals* was a series of seven linocuts which dealt directly with the forced resettlement of black com-

munities. The series on *Women and Work* examined the invidious position of black women in the labour market.

A recent triptych was made after a bomb explosion in a Krugersdorp shopping centre in March 1988. The title of the third panel, *All I Could Think of Was My Car*, refers to a remark made in a radio interview by a woman whose car was parked in the vicinity when the

bomb went off. Says Dhlomo: 'She didn't say anything about being sorry for all the dead people.'

Dhlomo has played an important role as an educator and spokesperson, running the FUBA (Federation of Black Artists) Gallery in Johannesburg, directing the Alexandra Art Centre, delivering a paper at the Culture in Another South Africa Conference in Amsterdam in December 1987.

'People must realise', says Dhlomo, 'that art is more than Michael Jackson

and Black is Beautiful and Tretchikoff posters from the furniture shops on their walls. It is the duty of artists and cultural workers to create an awareness of the importance of art in the life of the community.'

And answering calls from workers for artists to concentrate on group projects to further the struggle, Dhlomo says: 'It's undeniable that the power of

the workers will determine the future of this country, but they should be taking into consideration that artists must work as individuals. The whole problem is that the lack of education and the lack of understanding of aesthetics and what it means to be an artist are not understood by people who are not in this profession. I think artists have the right to determine their way of working, taking into consideration the needs of society.'

▼ THE STATE OF THE 80'S – ROADBLOCK 1988
LINOCUT ON PAPER
30 × 50 CM

▶ THE STATE OF THE 80'S
CAR BOMB TRIPTYCH 1988–9
PANEL I: CAR BOMB
PANEL II: EXPLOSION
PANEL III: ALL I COULD THINK OF WAS MY CAR
LINOCUTS ON PAPER
23 × 27 CM EACH

MANDLA EMMANUEL SIBANDA

▲ LIFE IN FLAMES 1986 PASTEL ON PAPER 58 × 76 CM

'I am using the brush to be part of the struggle,' says Mandla Emmanuel Sibanda. 'My other brothers are using AK47s.'

Sibanda was born in Soweto, and started drawing on his school slate at the age of 5. He was an 11-year-old at the time of the uprisings in 1976, a period that remains deeply imprinted on his mind. His evocative and vigorous paintings depict the news images the world associates with Soweto of that year, the year the township children took on the might of the heavily armed South African state, and Soweto caught fire.

Talking about his images of violent action, Sibanda says: 'After the uprisings of 1976 until now we are still struggling for our freedom – so these determined young men are fighting no matter how hard it is – running through burning flames, boiling soil. It is tough, but nothing will stop us from fighting.'

To drive on the streets of Soweto in times of unrest is to court danger. Heavy-duty wire-mesh grilles on the windows of buses and delivery trucks designed to protect the driver from flung stones and petrol bombs are not always sufficient. Roadblocks of burning tyres erected to obstruct the passage of police and army vehicles trap other vehicles too, and reports of burnt-out vehicles appear frequently.

This is My Life is the title of a painting of figures clustered round a burning car, and a group of urgent running figures is entitled *Zabalaza*, 'to struggle'. Like Goya, Hogarth and Daumier, Sibanda is a diarist recording the events and upheavals of his times. His work has all the authority and immediacy of a first-hand witness.

'My aim is not to be famous or a globe-trotter artist or something like that. Art is like a religion to me. I simply capture the turmoil of my people for historical posterity. I am part and parcel of the struggle.

'I am happy as an artist . . . it makes you feel free, cleansed.'

▼ THIS IS MY LIFE 1988 OIL ON BOARD 60 × 80 CM

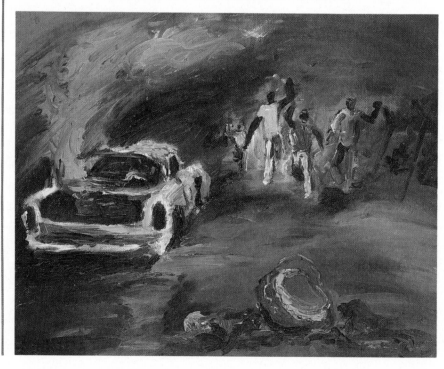

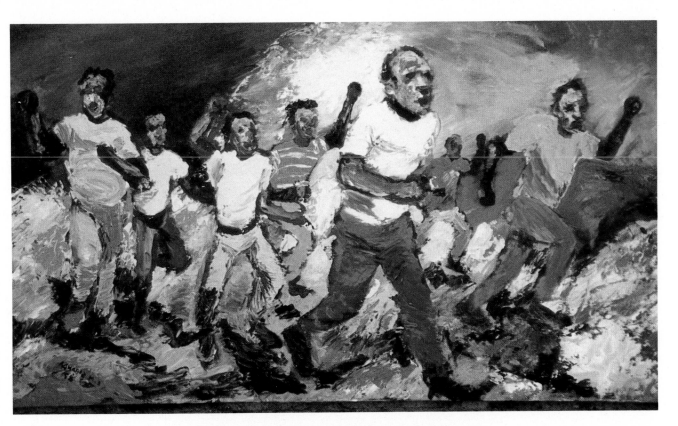

▲ ZABALAZA 1987 OIL ON BOARD 5O × 100 CM

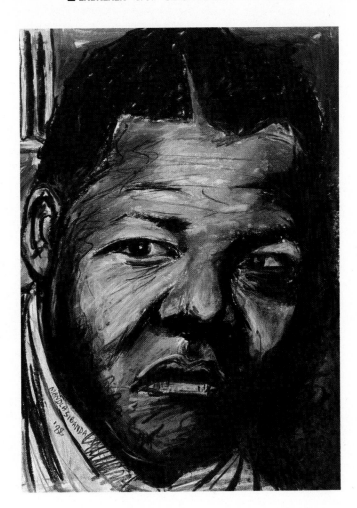

◀ UNTITLED
CHARCOAL ON PAPER
26 × 19 CM

THE EYES OF THE CHILDREN

▲ Rhoda, a three-year-old coloured child, explained her drawing like this: 'Casspir driving – mess it's made.'

▲ 'They shot the son dead in the house and the mommy is running to him' was the description of this one.

▲ The erasure and re-drawing of details on this armoured vehicle show with what attention the young artist studied it.

▼ Confrontations – with a pile of stones behind him, a schoolchild peers over the fence at a burning truck and an arrest.

▼ An expressive detail from the previous picture shows an activist, slumped forward in despair, being led away by police.

▼ An eight-year-old shows the progress of a Casspir along the road, helicopters overhead and bloody bodies in its wake.

◄ A drawing by an eleven-year-old of a policeman in a riot helmet.

▼ Houses burn in a township scene by a white high-school student.

▼ This picture and the previous one were exhibited on a show by white students expressing solidarity with black students in Cape Town in June 1986.

'The man from the Casspir who wants to shoot the lady. The lady is shouting "no."' 'This is a machine gun. The army boy is going to start shooting.'

These explanations of their paintings were made by 5-year-olds living in a coloured suburb in Cape Town. The year was 1985, the streets on which they lived had become battlefields, and the explicitness of the details left little doubt that these were indeed recent personal experiences. Feelings of deep insecurity, of persecution and of fear were clearly reflected. The cost of the effect on young children of living in a violent society has yet to be counted.

In 1986, a book called *Two Dogs and Freedom,* a collection of the drawings and writings of the children of Soweto, was published. Reviewing it in the *Weekly Mail*, a Johannesburg psychiatrist wrote: 'Young children often

emotional response is to move forward to more reality-based and creative avenues. But when these too are blocked (symbolically and actually by Hippos and Casspirs), then a regression occurs to earlier defensive structures,

▲ DRAWING BY A PRE-SCHOOL CHILD IN HOUT BAY OF A RIOT-CONTROL MACHINE

▼ PAINTED CLAY FIGURE MADE BY A NINE-YEAR-OLD BLACK CHILD IN AN ART WORKSHOP IN DURBAN. THE CHILDREN WERE ASKED TO MAKE 'SOMETHING SEEN RECENTLY'.

rises menacingly from this book.'

Black children experience violence directly. Young white children read and overhear enough to know that disturbances are taking place in other parts of their city. All might seem peaceful in their lives, but for how long? At the same time as the 5-year-olds were making their Casspir drawings, on the other side of Cape Town in Hout Bay, an upper middle-class white suburb, a teacher was also giving her class a drawing project related to recent events. Previous themes had included My Mummy and Sports Day. This one attempted to deal with their fears.

'Design a machine to be used in riots to control people', she told her class, adding, 'but it mustn't hurt anybody.' Ideas included a machine with a powerful beam to dazzle people.

'The greatest crime that society com-

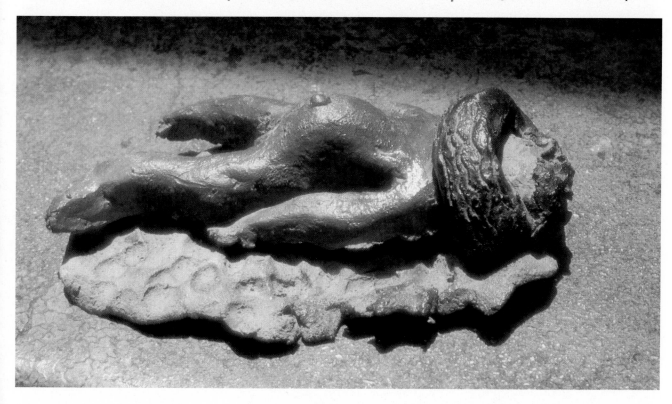

create internal fantasised solutions to insurmountable external problems . . . [but] magical solutions have currency only insofar as they are seen to produce results. When this does not happen, the

such as . . . hostile attacks on that which persecutes.

'The spectre of children's armies with their sadistic and immature destructiveness (viz Cambodia's killing fields)

mits', said educationist Maria Montessori, 'is that of wasting the money which it should use for children on things that will destroy them and itself as well.'

KEVIN BRAND

On 21 March 1985 in the small town of Uitenhage in the Eastern Cape, what started out as a funeral procession of a few thousand mourners turned into a shameful massacre which sent shock waves through the world. The funerals had earlier been banned by the police in terms of the Internal Security Act, and when the people decided to march anyway, the police opened fire, killing 20 people and injuring another 27.

In the report by the commission appointed by the state to investigate the shootings, it was found: 'Had the hold-

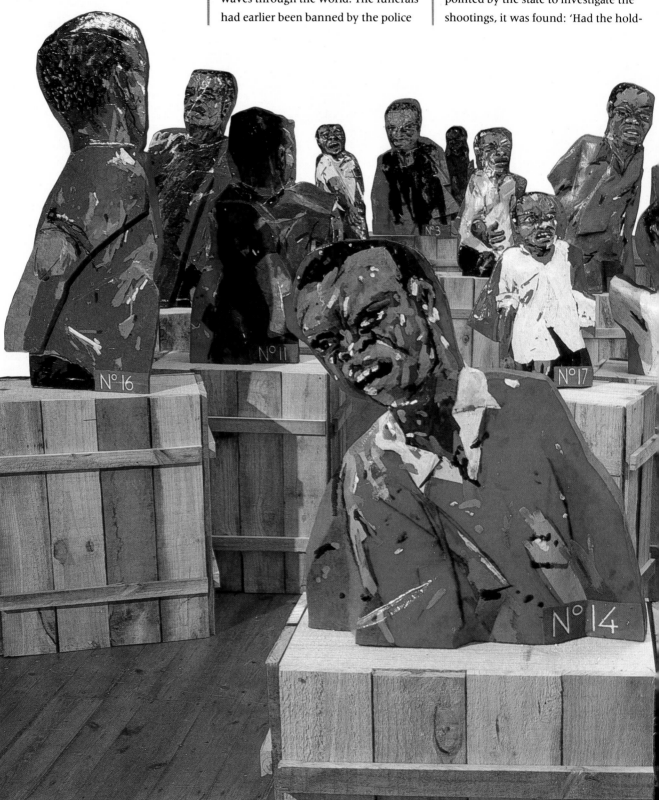

ing of the funerals not unnecessarily been prohibited on doubtful grounds, there can be little doubt that the procession would have passed through Uitenhage without incident along the normal road from Langa to Kwano-buhle, which happens to pass through the town.'

Equally, if the police had had proper equipment, the gathering might well have been dispersed with little or no harm to the people involved.

In his report Mr Justice Kannemeyer remarked that it was 'disquieting' that most of the people killed and wounded were shot from the rear. The majority of shots fired by the crews of the two Casspirs were made after the crowd had begun to disperse and run away.

In Kevin Brand's piece, *19 Boys Running*, we are confronted by a small crowd of anguished figures, faces contorted with the urgent need to escape. The irony is that, although they are said to be 'running', we find, as our eyes move downwards from the expressive faces, that these boys have no legs. Crude pine boxes replace the lower halves of their bodies. And, like a morgue specimen, each boy is numbered.

Brand worked his figures in very simple materials – they are cut out of polystyrene, sometimes shaped slightly to suggest movement, then covered with brown paper and painted. The figures are almost two-dimensional – from the side, little more than an edge is perceived. It's as if the boys are no more now than a front-page picture.

'The Langa shooting crystallised some of my thoughts – though the piece is not only about that incident,' says Brand. It's about the whole situation. 'The boys are in a state of pandemonium, but as a group they can also cause chaos to those around them. We don't know who is manipulating who.'

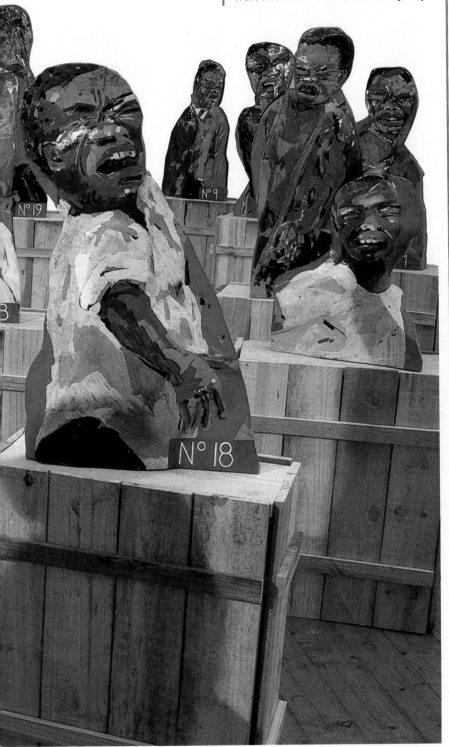

◀ 19 BOYS RUNNING 1988
SCULPTURE INSTALLATION
WOOD, POLYSTYRENE, PAPER, PAINT
AVERAGE HEIGHT: 160 CM

NORMAN CATHERINE

once ridiculously primitive – a fishing net? – and threatening. The central figure is trapped in an open coffin lined with spikes, smoking what is probably his last cigarette and gnawing on a bone. The piece is a compendium of

Catherine images: the clock of *House Arrest* indicates the agonising slowness of time passed in detention; an oversized rat-trap lies waiting to snap into action. We all carry baggage in some form or other, and inside the prisoner's

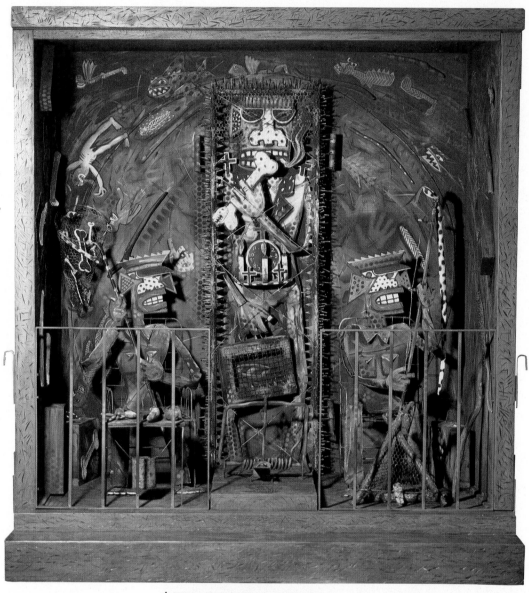

▲ THE LAST REMAINS OF ANOTHER MAN 1988
WOOD, METAL, PAINT
HT: 200 CM

'It's an entrance to hell,' says Norman Catherine, 'white man's witchcraft.' *The Last Remains of Another Man* is the largest construction Catherine has made, a life-sized chamber of horrors painted in a netherworldian palette of smouldering greys and blacks with ash white and flashes of fiery red. The entrance is guarded by two policemen in sawtoothed caps bearing weapons at

suitcase, the little doomed boat of *Blood River* is swept along in the current on its final journey. Hunting or fleeing, the Catherine menagerie of grimacing creatures flies frantically through the air.

The Last Remains has something of the feeling of the painted roadside shrines seen in other parts of Africa, and a link with the African tradition of art object as fetish. Catherine acts as shaman

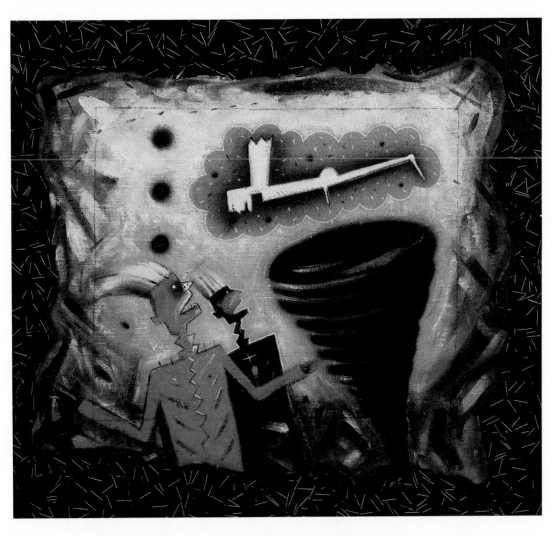

▲ ANGEL 1985–86 OIL ON CANVAS AND WOOD 25 × 25 CM

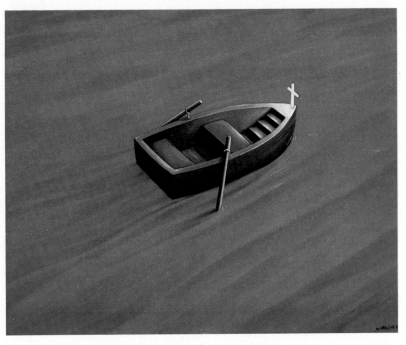

▲ BLOOD RIVER 1985 OIL ON CANVAS 60 × 45 CM

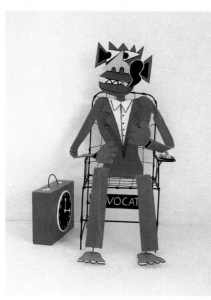

ADVOCATE

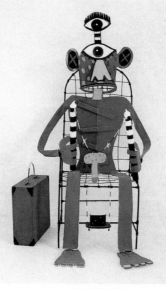

MANPOWER

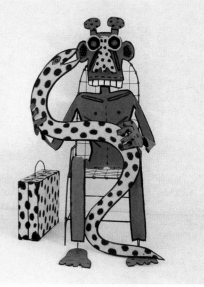

SNAKE CHARMER

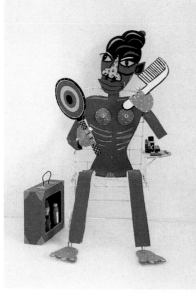

MIRROR, MIRROR

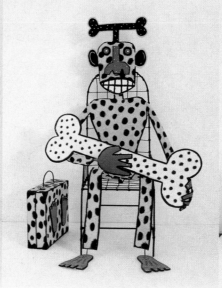

SANGOMA

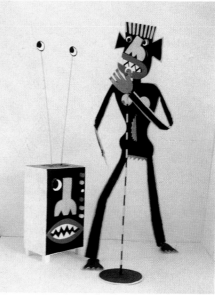

HI-FIDELITY

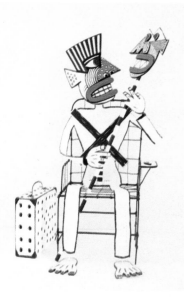

VENTRILOQUIST

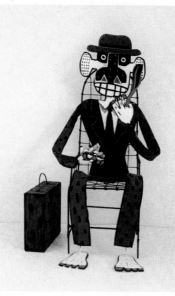

CHAIRMAN
ACRYLIC ON CANVAS, WOOD AND METAL 1987
SEATED FIGURES 99 CM HIGH, STANDING FIGURES 145 CM HIGH

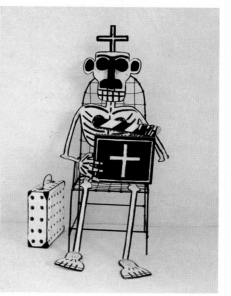

LAST RITES

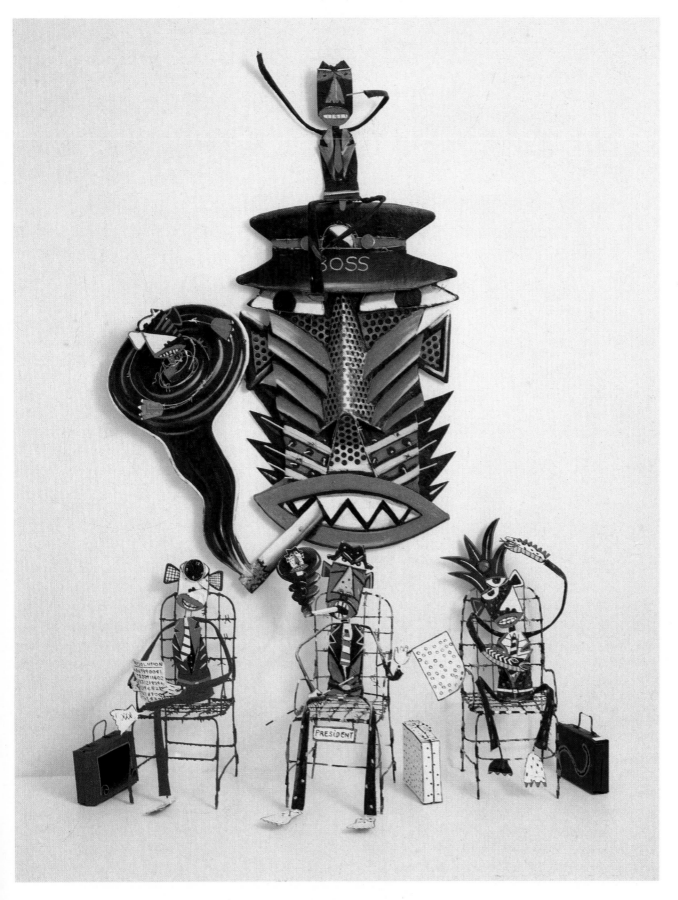

BOSS 1986 OIL ON FIBREGLASS AND METAL HT: 60 CM

129

here, the medium through which messages from the dead are passed to the living. 'It's almost voodoo,' says Catherine.

'When I was young in East London they had these glass cases in museums with animals or blacks in tribal dress. That's what this is. A museum piece. Maybe I should bury it and in a hundred years' time they'll dig it up and wonder what that was all about.'

On *Angel* Catherine says: 'The whirlwind is a premonition of disaster – the atomic bomb – the holocaust – people's heads on fire. The characters are whites – the instigators – with a sudden fear of what they've done.'

Catherine is one of the hardest working artists in the country, working from

INTENSIVE CARE 1986
OIL ON FIBREGLASS AND METAL
HT: 41 CM

9 a.m. to midnight daily in the studio of the house he built at Hartbeespoort Dam, near Johannesburg. Some years ago he was known for surrealistic images and the perfection of his airbrushed finishes, but the carefully modulated hues have largely given way to flat, often brilliant colour and strong patterning. 'My work still has surrealistic elements, but it has become more direct. The new stuff is far more textured.' Catherine now makes frequent use of the sort of found objects township kids collect to make their toy cars and bicycles: tin cans, wire, metal scraps. Welding was a skill Catherine learned when building his house, and the technique gave birth to a whole new tribe of comically recognisable

▲ DOG OF WAR 1988 DRYPOINT 25 × 31 CM

living-in-Africa characters – the san-goma with his bones, the kugel, and the BOSS figure, lackeys at his feet, who dominates and controls all the others.

Catherine's humour is often black, nourished by a fine sense of overkill. In the mixed media assemblage *Intensive Care*, a terminal patient, spotlit, tightly wired down in bed, mousetrap at his throat, gazes fearfully at the approaching wheel of a buzzsaw. One thinks of the April 1989 newspaper stories about the detainees under the state of emer-gency, on hunger strike after three years of incarceration, hospitalised because of their debilitated state but shackled to their beds to prevent escape. In Catherine's collage *State of Emergency* an X-ray view of leaping black cats shows they contain dismembered bodies.

The corrosive wit that amuses and shocks at the same time is equally apparent in two recent prints, masterfully handled drypoints, *Dog of War* and *Carnivores*. 'It's the animal in man that I'm portraying – his carnivorous aspects, his territorial instincts.' The subject matter is classic Catherine.

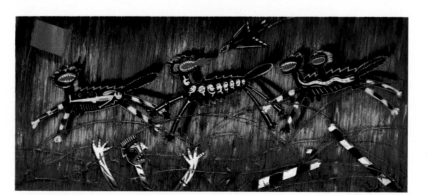

STATE OF EMERGENCY 1986
OIL ON STRAW, WIRE AND TIN
19 × 41 CM

PATRICK HOLO

The brothers Patrick and Sydney Holo are two of the founder members of the Nyanga Arts Centre, Cape Town.

Perennially distressed financially, the Centre appeals to the public periodically through the press. 'Nyanga Arts Centre Seeks Aid to Nurture Talent' ran a headline of a story in the *Argus* of 20 April 1989, which read: 'The revamping of the ailing 10-year-old Nyanga Arts Centre, one of the township's major venues for teaching art, is being held up by a shortage of funds.

'The centre, which is run by seven self-taught voluntary artists, was once a thriving "nursery" which unearthed some remarkably talented people. The arts centre is in an abandoned farmhouse. There are five workshops with dilapidated wooden floors and faded paintwork. Pottery and glass-blowing classes have been discontinued because of a lack of material. Only music and graphics courses are being run.'

However scarce the materials and sporadic the teaching, for the persistent student the Centre has been an invaluable place to go to learn, simply because it existed.

Patrick Holo himself cuts his linocuts at home, but uses the press at the Centre to make his prints. His themes are sometimes biblical, but most often reflect township life. He describes the thoughts of the man sitting at his kitchen table in *Untitled* (detail at right) like this: 'I can't get a job whether I'm inside or outside . . . it's better inside, at least they're feeding me. If I'm outside, I'm going to do something bad. I'm starving.'

THE NYANGA ARTS CENTRE

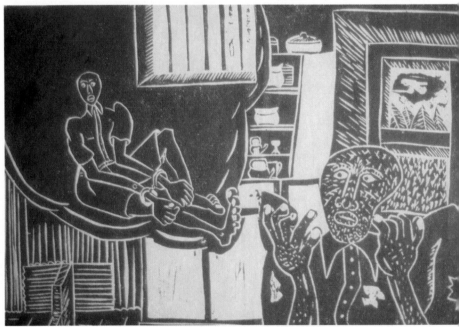

UNTITLED LINOCUT ON PAPER
21 × 30 CM (DETAIL)

PATRICK AND SYDNEY HOLO

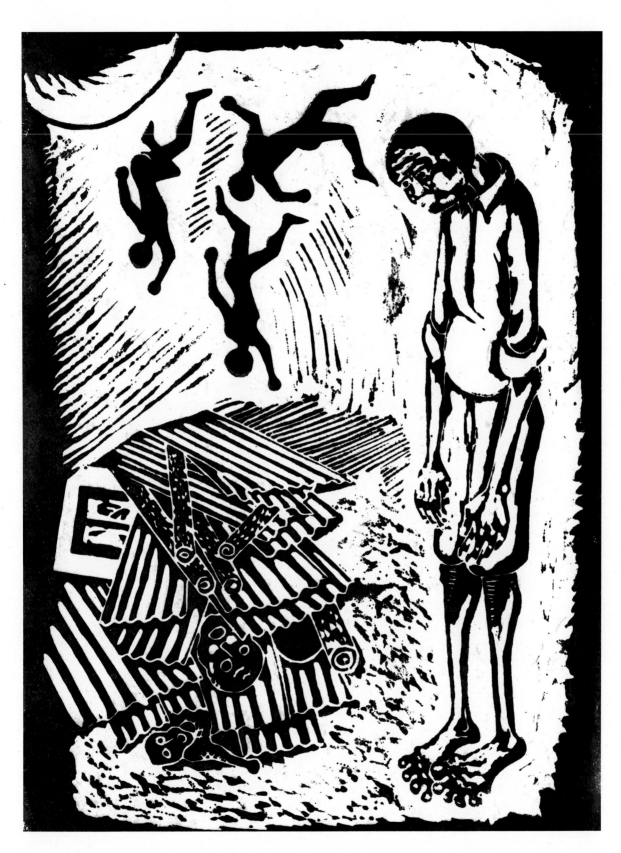

Desperate recalls the government demolitions of the squatter camps of Modderdam and Unibell, where 'even the children were bulldozed'.

▲ DESPERATE
LINOCUT ON PAPER
20 × 30 CM

SYDNEY HOLO

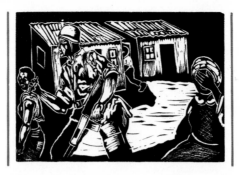

◄ CRYING PAIN
LINOCUT ON PAPER
21 × 30 CM

▼ NO LIFE
LINOCUT ON PAPER
29 × 34 CM

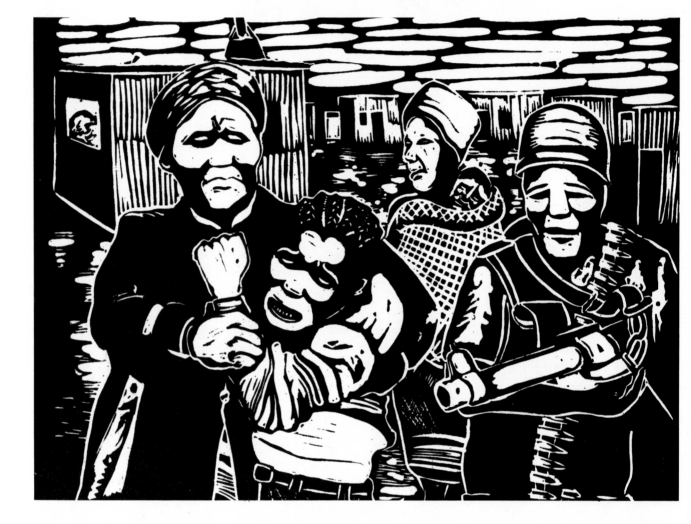

'The government has got no feeling about the people, no feeling about our fathers and mothers. They just take them like dogs,' says Sydney Holo, founder member of the Nyanga Arts Centre, and brother of Patrick. Holo speaks from experience: their own mother is an activist and has spent long periods sleeping away from home to avoid police harassment. 'I draw from the heart, I draw what I see happening in the townships,' says Holo. 'Drawing is not the same as taking a photograph: one can put feeling and expression into a work of art that cannot be shown in a photograph.' Holo demonstrates this with two moving linocuts, *No Life* and *Crying Pain*. In 1987, approximately 5 000 people were detained under the emergency regulations. The anguish of township families unable to prevent their young men being arrested is strikingly reflected in Holo's expressive prints.

BILLY MANDINDI

FIRE GAMES 1985
TIN, PAINT, WIRE, WOOD
HT: 32 CM
SOUTH AFRICAN NATIONAL GALLERY

and the assorted small-scale elements to impart a toy-like quality to his piece, but this is a gameboard of a deadly kind. 'It's the watchtowers and vans and a factory and some banks and a jail and AK47s and all those things. . . . '

Mandindi is a student at the Michaelis School of Fine Art in Cape Town, a young artist with a deep commitment to his work. 'I'll only do art in my life, nothing but art,' he says, 'work about people, and what's happening. At first, when I was thinking about art, I thought it was about drawing and all

'That story of Nongqawuse, the girl who told people they had to kill their cattle. That was a device told by Grey because the people did not need to work because they had cattle.' (Sir George Grey became Governor of the Cape of Good Hope in 1854.)

Asked if he thinks art can change the way people look at things, Mandindi replies: 'If people would try to understand what the artist is trying to say, they can be like kids who are trying to grow.'

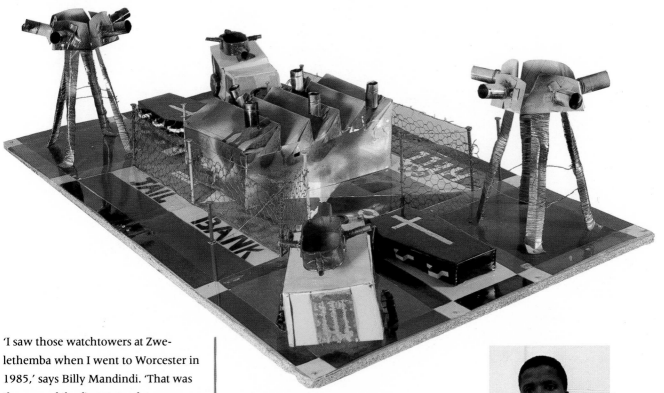

'I saw those watchtowers at Zwelethemba when I went to Worcester in 1985,' says Billy Mandindi. 'That was the year of the first state of emergency. They have those towers around the townships, and the lights were going across the township. Things were tight there. It was serious, but it was like a game . . . people running, being beaten up, mass funerals, somebody being buried every week and the number of armoured cars – every time you go outside you see an armoured car.

'I wanted to do work that reflected the whole of 1985,' he says, talking about his zinc sculpture, *Fire Games*. Mandindi has used the bright colours

those things . . . then I suddenly became aware of what was happening around me and I tried to capture that. In our art, I think there was something missing. It's still missing. Some of the things that happened years ago, the results are still coming now, so in my work, I am trying to go far back and mix it with what is happening now.' Mandindi not only depicts contemporary issues, but frequently makes work which gives a fresh perspective to an historical event.

NATHAN HONEY

The 'necklace'. Few words in South Africa today provoke such feelings of horror. The Afrikaans media in particular have seized upon necklace killings as a sign of the inherent savagery of blacks.

Nathan Honey's piece *Who Actually Designed the Necklace* points to the role of the army and the state in this form of killing – in almost every case the victim has been believed to be a police informer.

In a township where Casspirs full of soldiers rumble daily through the streets, where people are found mysteriously shot, where a whisper in the ear of the police can lead to the detention of a neighbour, it is hardly surprising that there should be a backlash against those seen as collaborators.

▲ WHO ACTUALLY DESIGNED THE NECKLACE
OXIDISED BRASS, RUBBER
HT: 6 CM

▲ ARMOURED OX
OXIDISED BRONZE
HT: 5.5 CM

Worn as a piece of jewellery, Honey's *Necklace* circles the throat like a choker or a noose. Honey is one of thousands of young white men bound by law to serve in the South African Defence Force for two years or else face six years' imprisonment. 'I am opposed to service in the SADF directly because of my opposition to the present system of government,' he says. 'As a jeweller, I communicate through my work.'

Armoured Ox, an object of power and destruction, refers to the increasing militarisation of life in South Africa, the relationship between farmers (landowners) and the army (government).

Trophies have been miniaturised so they can be worn as tie pins.

▲ TROPHIES
BRONZE, PERSPEX
HT: 5–6 CM

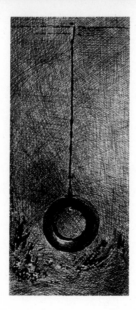

PROBING
THE
DARKNESS

WISEMAN MBAMBO – WOOD SCULPTURE LYN SMUTS – ETCHING

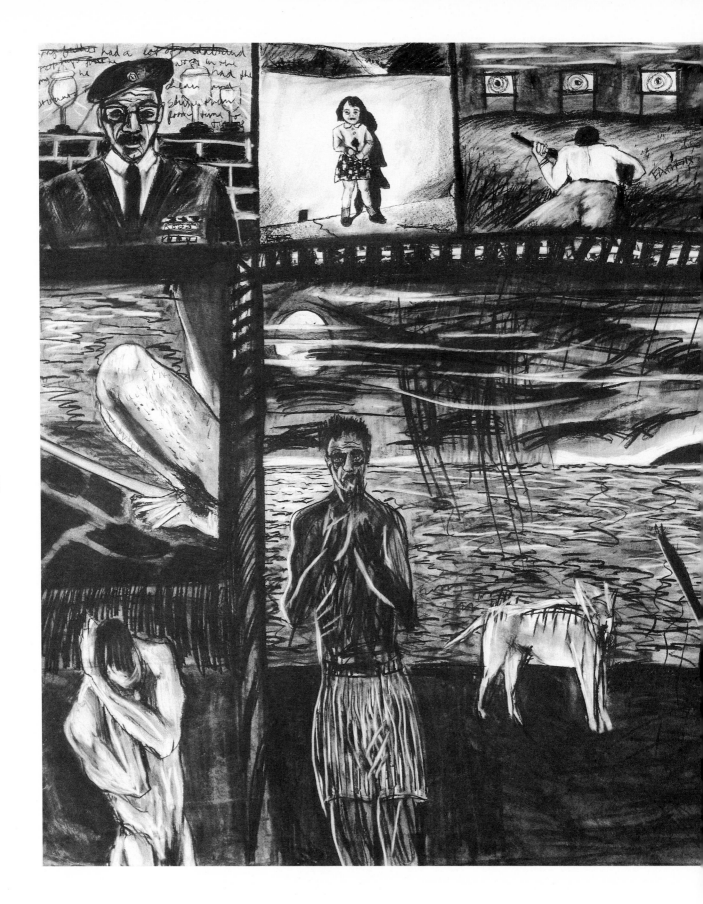

LEON VERMEULEN

'My father won all those silver cups for shooting, which always had to be kept shone. He wanted to teach my brother and I to shoot. I was never very good at it.'

Leon Vermeulen grew up in a small-town Afrikaner family. In that social group, a man's ability to hit the target first time and accurately reaffirmed his standing as a member of the *volk*, a man whose forebears had fed their wives and children by bringing down the fleet springbok, and protected them by keeping at bay hordes of attacking Zulus.

In a latter-day perversion of this gun mystique, a young Afrikaner called Barend Strydom gunned down black passersby on a Pretoria street in November 1988, leaving 6 dead and 14 wounded, because he believed the Nationalist government was giving the country away to the blacks. In another manifestation, there has been a horrifying rise in cases of family suicides, where a father has shot his wife and children before turning the gun on himself.

'My struggle was in not fitting into the society I was brought up in,' says Vermeulen. 'My work is always protest art – protesting against my own position – the restrictions, the fears, the guilt. . . . ' His searing black-and-white drawings function as a kind of diary intertwining personal experiences and anxieties with art historical references. 'I would like to use beautiful paint, but I'm painting something essentially ugly

BELOFTES 1988
CHARCOAL ON PAPER
92 × 122 CM

– that's probably why I have gone to charcoal – and then, too, I use cheaper materials because I don't want my work to have a precious quality.'

'I didn't have any art background as a child. My idea of what an artist is was formed with little formal information – I had a romantic notion of what an artist was. It was my brother who taught me how to draw. My father had beauti-

Vermeulen's father and the artist him-self, and broken promises and guns. Until 1985, with the repeal of the Immorality Act, love across the colour line was illegal. Its new legal status has done nothing to make it any more acceptable in Afrikaner circles. To love a person of another colour – and be found out – is to debase the entire *volk*, and the ulti-mate disgrace.

'I can't depict someone else's pain or anger. I can't divorce the social from the personal comment. My experience as an Afrikaner Calvinist is very differ-ent from an English middle-class per-son or someone brought up in a black township. In my work I'm saying to people, you don't feel fine, you can't feel fine, especially here.'

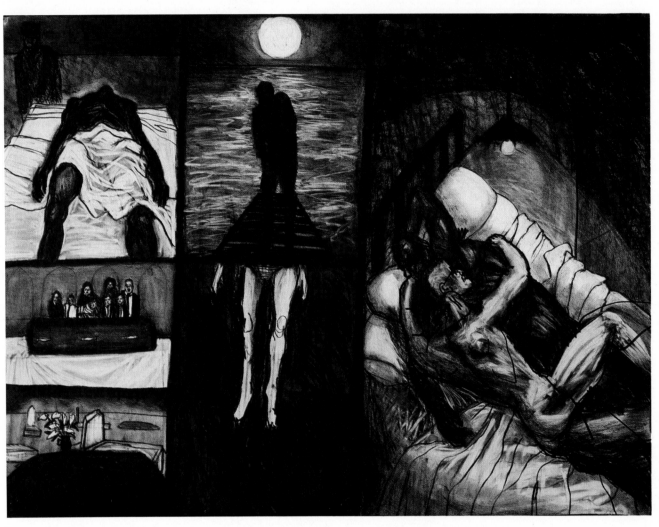

ful handwriting, but he never thought it was respectable to draw.'

In small-town cafés, the biggest-selling magazines are the cheaply print-ed photostories: tales of love, lust, vio-lence and betrayal told in a series of black-and-white photographs, like stills from a B-movie. The format and themes of Vermeulen's work remind us of these. *Beloftes* (Promises) is about

Die Skande (The Scandal) is about just such a forbidden liaison – Vermeulen uses it as a metaphor for the wider rela-tionship between the groups in South Africa. It is also about death. 'My broth-er was 16 when he died. His death had repercussions in the family long after-ward . . . the guilt. He's in a sense al-ways in my painting if there's an image of death.'

SKANDE 1988
CHARCOAL ON PAPER
60 × 86 CM

ANDREW VERSTER

Known for his painterly landscapes and interiors, and an exquisite sense of colour, Andrew Verster recently took a sharp turn with a new series sombrely examining man's fall from grace. Titles like *Garden, Plunge* and *Expulsion* suggest the myth of the Garden of Eden.

Verster produced this series after a re-examination of Rubens's paintings led to an urge to do some heroic work, but the movement of the figures away from the viewer and the tight, awkward cropping have more to do with the way the camera has educated the twentieth-century eye than Rubens has. Giant figures of men, naked and vulnerable, move through unidentifiable landscapes. In *Expulsion*, the figures are crouched , as if frighteningly aware of an unwanted scrutiny.

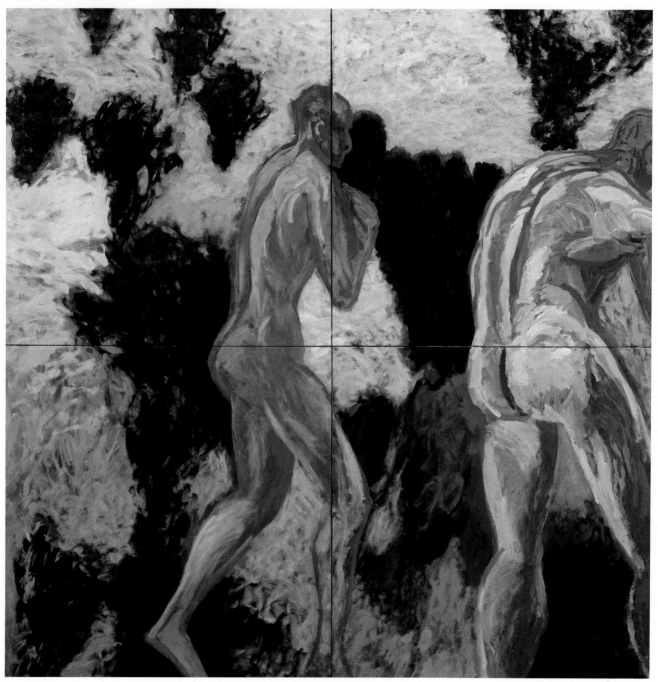

EXPULSION 1987
OIL ON CANVAS
240 × 240 CM

VUYILE CAMERON VOYIYA

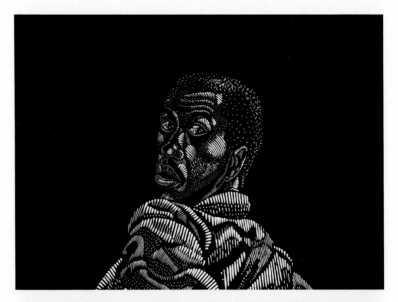

'This *Rhythm in 3/4 Time* series is based on one guy in Langa. He was on Robben Island [the jail for political prisoners] in the sixties. His mind has gone. He's always doing this dance like he's evading blows from the police. Preaching on the streets, but not preaching – telling about what happened to him and to others. People listen to him. Some think he's looking for trouble . . . if "they" hear him, "they" will take him, but he doesn't mind. He just talks. He's a bit insane.'

The artist, Vuyile Cameron Voyiya, though still a student at the Michaelis School of Fine Art in Cape Town, recently showed this series on an exhibition of 16 artists from Mozambique, Angola, Zimbabwe and South Africa at the Stockholm City Culture House in Sweden.

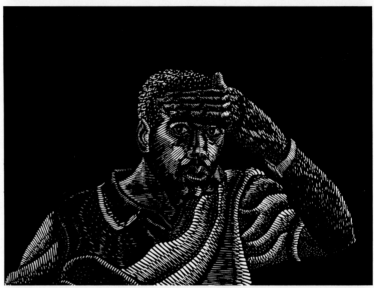

Acknowledging that the subject of *Rhythm in 3/4 Time* looks very much like himself, Voyiya comments: 'That experience could happen to anyone. You can say or do something not radically bad, and end up in prison. The fact of evading the blows, that had something to say about my interior fears.'

Michaelis is situated in a white suburb, near the exclusive Mount Nelson Hotel, and black men on the streets at night are likely to be picked up on suspicion. 'I was continually being harassed by the police when I went to Michaelis to work at night. "Where do you stay, what are you doing here at night?" Once they followed me, they stretched my arms against their car – they searched me. They had their guns out. They wouldn't believe I was a student, even though I showed them my

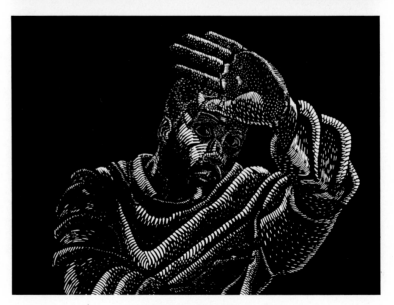

RHYTHM IN 3/4 TIME SERIES 1988
LINOCUTS ON PAPER
40 × 60 CM EACH

142

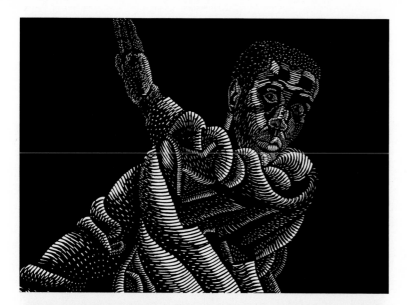

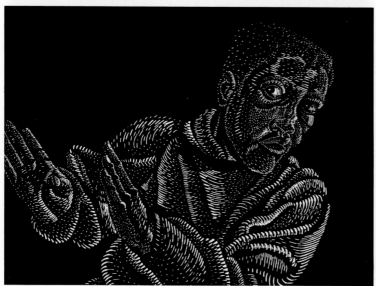

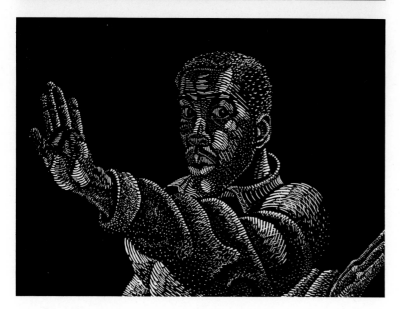

student card and my bag with paint brushes. I was really freaked out. I was preparing for a crit the next day.'

Fortunately for Voyiya, the incident happened near the Michaelis gates and eventually the police released him after checking his identity with the security guard.

'Things like that make you really paranoid. If you're walking on the streets at night, and you hear a car behind you, you think it could be the police and if it is, they're certainly going to stop you. An earlier print I made, *In the Coffin of My Skin*, really expresses that.'

In *Rhythm in 3/4 Time*, his powerful linocuts, in stark black and white, present themselves like stills from a police movie. Each frozen movement leads to the next. Ducking and diving, shielding himself, brilliantly highlighted as if caught in a powerful beam, the victim stares fearfully straight at us. His eyes engage ours. Unnervingly, it's as if we were holding that camera.

ANDRIES BOTHA

Andries Botha's career as a sculptor has been marked by his truly innovative use of traditional African materials and methods to make large-scale pieces which are at once very new-looking yet strike a deep cultural chord.

His breakthrough came in 1984. Driving in the foothills of the Drakensberg one day, he stopped to watch men making a Zulu beehive-shaped hut by

ANDRIES BOTHA AND TEACHERS

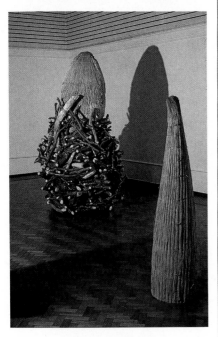

FAMILIAR MEMORIES
WOOD, ROPE
HT: 272 CM

knotting together bent branches and thatching over them. For the next six months Botha travelled regularly up to the Drakensberg to learn the old rhythmical skills of rope-making, weaving and knotting. His teachers were a master builder, Maviwa, and two women, Agnes and Myna Ntshalinshali. Botha started with very simple armatures and sculptural shapes. 'Initially my teachers

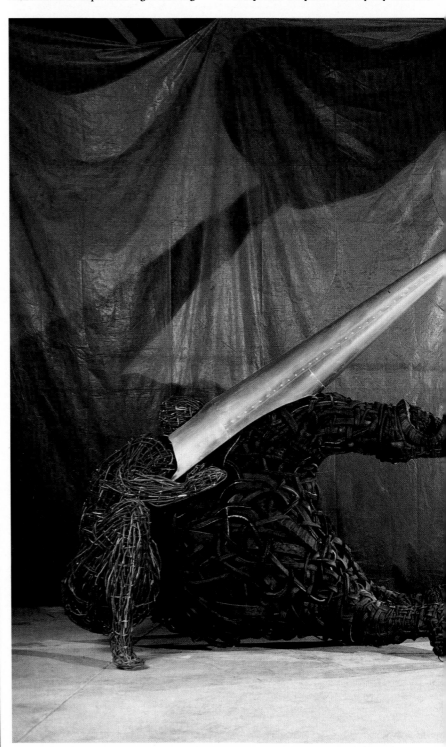

thought it was hysterical I was making these non-functional things,' he says. *Familiar Memories*, for a person living in Africa a warm and appropriately named piece, dated from this time.

Recently, urban materials have taken the place of wood and thatch. *Dromedaris Donder! – en Ander Dom Dinge* (Dromedaris Shit and Other Stupid Things) includes not only branches but

wire, aluminium and strips of black rubber tyres. The piece operates on a number of levels. The *Dromedaris* was the ship that brought the first white settlers to South Africa. 'That point in time had enduring repercussions,' says Botha, 'so it's about that beginning and the state of the nation today. It's almost catastrophic . . . but there is a spiritual dimension.'

In Botha's piece, the front half of a beast stumbles forward while being raped from behind. A lyrical, almost ethereal little figure strides ahead. Above this procession, a shiny flying object which could be a ship or a helicopter sends down a beam of light.

'It's the eye of God and also the

police helicopters that hover over the black townships,' says Botha. 'The figure in the front is masculine and feminine, and a memory of Bushman art.'

As the instigator of the Community Art Workshop in Durban, an alternative space in the old railway station where anyone may come and work, Botha says: 'I have an extraordinary hope and vision for South Africa . . . when people get in touch with their own creativity and start to use it. I believe this nation will be rebuilt from the bottom up.'

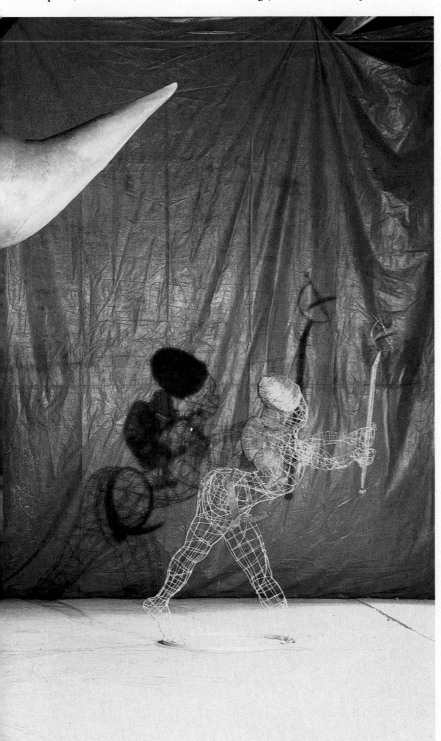

DROMEDARIS DONDER! . . . EN ANDER DOM DINGE 1987–8
WOOD, RUBBER TYRE, ALUMINIUM, WIRE
HT: 314 CM

145

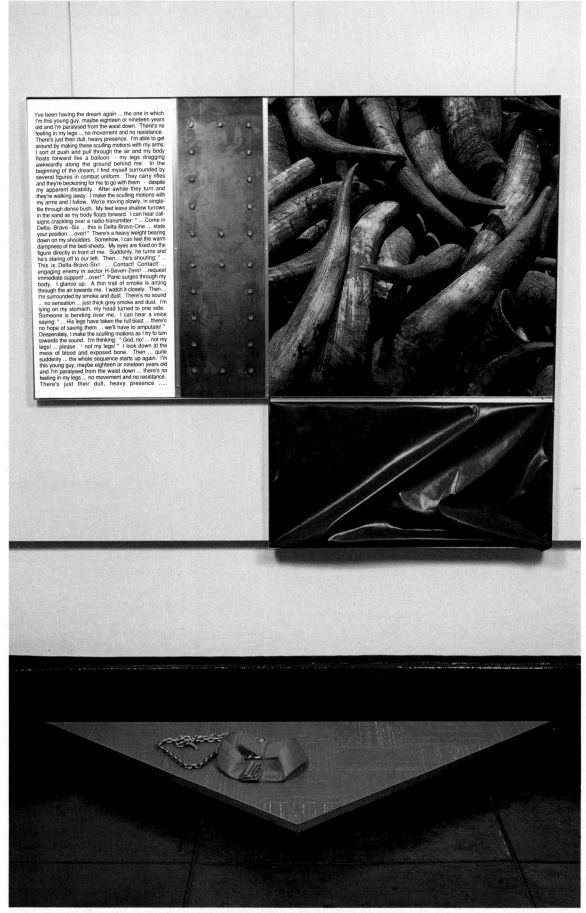

I've been having the dream again ... the one in which I'm this young guy, maybe eighteen or nineteen years old and I'm paralysed from the waist down. There's no feeling in my legs ... no movement and no resistance. There's just their dull, heavy presence. I'm able to get around by making these sculling motions with my arms. I sort of push and pull through the air and my body floats forward like a balloon - my legs dragging awkwardly along the ground behind me. In the beginning of the dream, I find myself surrounded by several figures in combat uniform. They carry rifles and they're beckoning for me to go with them - despite my apparent disability. After awhile they turn and they're walking away. I make the sculling motions with my arms and I follow. We're moving slowly, in single-file through dense bush. My feet leave shallow furrows in the sand as my body floats forward. I can hear call-signs crackling over a radio-transmitter: " ... Come in Delta- Bravo -Six ... this is Delta-Bravo-One ... state your position ... over! " There's a heavy weight bearing down on my shoulders. Somehow, I can feel the warm dampness of the bed-sheets. My eyes are fixed on the figure directly in front of me. Suddenly, he turns and he's staring off to our left. Then ... he's shouting: " ... This is Delta-Bravo-Six! ... Contact! Contact! ... engaging enemy in sector H-Seven-Zero! ...request immediate support! ...over! " Panic surges through my body. I glance up. A thin trail of smoke is arcing through the air towards me. I watch it closely. Then ... I'm surrounded by smoke and dust. There's no sound ... no sensation ... just thick grey smoke and dust. I'm lying on my stomach, my head turned to one side. Someone is bending over me. I can hear a voice saying: " ... His legs have taken the full blast ... there's no hope of saving them ... we'll have to amputate! " Desperately, I make the sculling motions as I try to turn towards the sound. I'm thinking: " God, no! ... not my legs! ... please - not my legs! " I look down at the mess of blood and exposed bone. Then ... quite suddenly ... the whole sequence starts up again. I'm this young guy, maybe eighteen or nineteen years old and I'm paralysed from the waist down ... there's no feeling in my legs ... no movement and no resistance. There's just their dull, heavy presence

DELTA BRAVO 1987 MIXED MEDIA & CIBACHROME HT: 150 CM

146

MICHAEL GOLDBERG

'I've been having the dream again . . . the one in which I'm this young guy maybe eighteen or nineteen years old and I'm paralysed from the waist down. . . . '

Set in type and blown up, this True Adventure-type story of a war night-mare is part of a 1987 piece by Michael Gold-berg called *Delta Bravo*. The heat and intensi-ty of the story are offset

all within the safety of a comfortable art gallery fortified with a glass or two of exhibition-opening wine,' he was to say in a 1978 speech.

'In South Africa . . . the impotency of the individual seems to relegate most [white] people's roles to those of voy-eurs who . . . transfer the burden of their inaction to the work of the Bondage- and Liberation-conscious artist, elevate him or her to the status of some potent god-like messenger, and then go home to a trouble-free sleep.'

In the eyes of many, Goldberg him-self was one of those 'potent, god-like messengers', although precisely what his message was, was not always clear to his audience, and when the penny did drop, the reaction was sometimes far from passive.

▲ MONUMENT TO THE NATIONALISTS 1978 MIXED MEDIA HT: 160 CM
▼

by the studied and formal ar-rangement of all the elements in the piece, which include a studded stain-less-steel panel, thick green plastic, a chain and harness, and a large Ciba-chrome of ox horns, traditionally used by the Boers as powder flasks.

If we couldn't read English, we might think this was an industrial display at a trade fair, but in fact it is that balance between blandness and high emotion that makes the piece so strong. The neutrality of the work is its essence. Goldberg has never been an artist to make things easy for his audience. He is wary of the quick fix engaged art can give the bleeding-heart liberal.

'The individual can experience the il-lusions of beauty and goodness, and even pain, suffering cruelty and death –

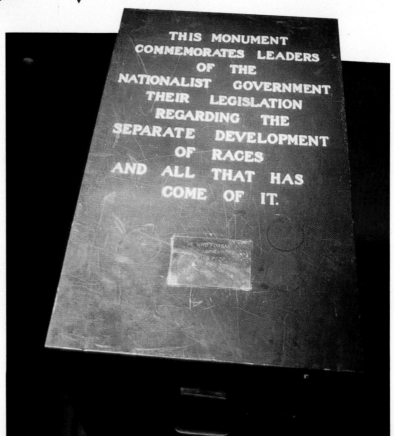

THIS MONUMENT COMMEMORATES LEADERS OF THE NATIONALIST GOVERNMENT THEIR LEGISLATION REGARDING THE SEPARATE DEVELOPMENT OF RACES AND ALL THAT HAS COME OF IT.

In a 1978 exhibition, his piece *Monument to the Nationalists* was a filing cabinet – one drawer for each of the four Nationalist Prime Ministers since 1948, holding the legislative acts which had most harshly and stringently enforced the policy of apartheid. The show was at the Market Theatre Gallery, and actor Marius Weyers was so incensed by the piece he told Goldberg he was going to bring his dog to piss on it. 'He changed his mind later, and apologised.'

Viewer reaction was to repeat itself some years later. 'The only creature that knows what to use this sculpture for is the gallery cat', said Francois Oberholzer, notoriously philistine chairman of the Johannesburg Management Committee. He was referring to the sandbox element of *Family Bath*, a Goldberg sculpture recently acquired by the Johannesburg Art Gallery. The Gallery asked Goldberg to write a sheet of paper for the public explaining his piece. 'I refused,' said Goldberg. 'Oberholzer said, "All I see is this Venetian blind, this zinc bath," so I asked him what each element reminded him of. He told me he thought of his mother washing their clothes in the backyard, so I said, "You see, you've started the process. . . . "'

▲ UNTITLED – THE FAMILY BATH 1981
MIXED MEDIA HT: 200 CM
JOHANNESBURG ART GALLERY

◀ NEXUS – OBJECTS THAT INTERVENE
BETWEEN CHURCH, FAMILY & STATE
1983
MIXED MEDIA
BASE: 200 CM × 300 CM

STEVEN SACK

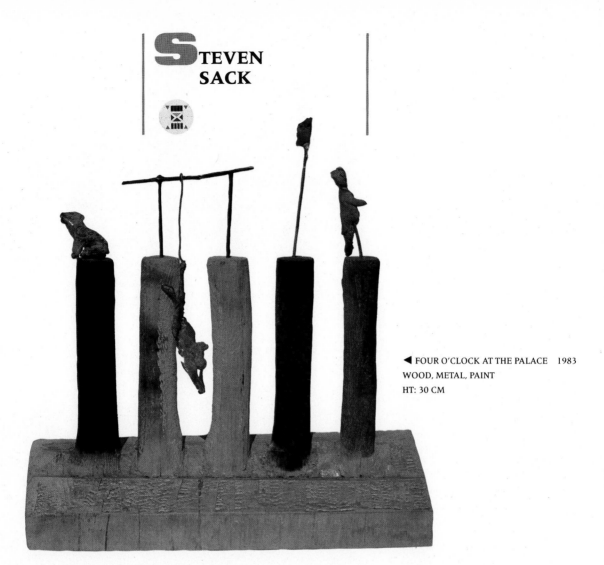

◀ FOUR O'CLOCK AT THE PALACE 1983
WOOD, METAL, PAINT
HT: 30 CM

Long overdue, the first retrospective of black art at a major gallery was held in the Johannesburg Art Gallery in November 1988. Entitled *The Neglected Tradition: Towards a New History of South African Art (1930–1988)*, and presenting fine work by almost a hundred black artists, only a few of whom were generally known. To most viewers, it was a revelation. The guest curator was Steven Sack, chosen, according to the catalogue notes, because his 'academic background and direct knowledge of community arts projects would be essential in formulating an exhibition . . . from a non-Eurocentric position.'

Sack's own history has always been one of involvement: in community and theatre groups, as teacher, lecturer and delegate to the CASA (Culture in An-

other South Africa) Conference in Amsterdam in 1987. For two years before that he taught art at the Funda Centre in Soweto – 'so rewarding for me be-

cause at that point in my life I thought it was necessary to work in the community and help others get culturally involved before allowing myself the privilege of making art,' says Sack.

He believes that to make political statements as an individual is problematical – 'one becomes fearful that a broader vision is needed.' Problemati-

cal or not, Sack's own work has always been influenced by his political experiences. In the late '70s a close friend was arrested. Sack and his wife Ruth were detained and interrogated for 24 hours because the friend had some of their books. The friend was jailed, and Sack started visiting him at the Pretoria Central Jail.

'I felt psychologically very trapped. I saw South Africa as a prison state. I saw images of prisons everywhere – the drains on the streets – I started taking photos and superimposing grids over them.' Jails have remained a recurring image in Sack's work. *Four o'Clock at the Palace*, a small but evocative piece, refers to deaths in detention.

LYN SMUTS

Lyn Smuts is a printmaker. 'I define printmaking as any mark left where two surfaces touch,' she tells her students. This wide definition embraces the tiniest animal tracks on the ground, or marks on the bark of trees; the stains left on streets by people eating, fighting, falling.

'When I say I work poetically, I mean I take various visual and verbal sources and bring them together in a way to make them work,' says Smuts.

The theme of Smuts's *Imprint* series of etchings is the vulnerability of each life. 'My interest lies with the individual, the complexity of each life,' she says. 'That life can be extinguished in one second . . . it's happening all the time. The etchings came about when I experimented with smoking cardboard sheets and imprinting various people and animals onto them. The soot is so sensitive that it records detail with photographic accuracy, but also shows the distortions of impact and the gesture to ward off violence – a flash-shot of a single, vulnerable individual.

'I also find the process formally satisfying as printmaking. The soot is so impermanent that I have to transpose the image onto a copperplate to retain it at all. To do a roomful of imprints of lives would interest me.'

The flat landscape sculptures on trolleys of earlier years have been abandoned. 'The situation forces you to respond,' says Smuts. 'In a sense you don't have a choice. The horror stories . . . I don't know how other women process it, but this is how I process it. I walk around with images of fire in my head.'

150

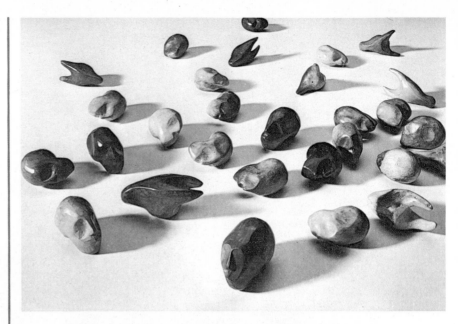

▲ UNTITLED 1987
ASHFIRED STONEWARE
HTS: 2–3,5 CM

▼ AMPHISCIAN 1987
CIMENT FONDUE, ASHFIRED STONEWARE, RUBBER, WIRE
BASE: 78 × 78 CM

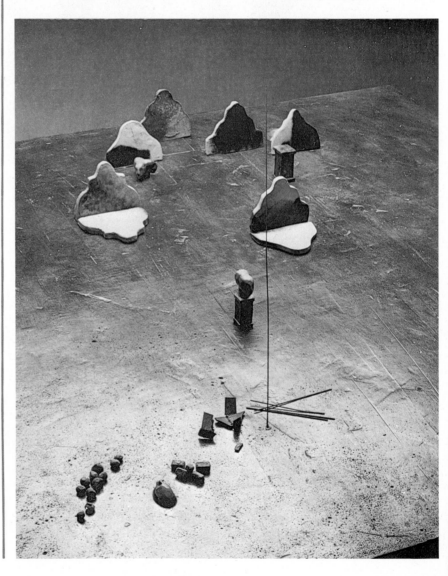

◄ As an expression of concern for the lives being wasted in South Africa, Smuts made over 100 of these tiny stoneware heads for the opening of an exhibition in August 1987. She scattered them over a bare table surface, and invited guests to take one home as an affirmation of the value of each life.

◄ By dictionary definition, amphiscian means: 'inhabitants whose shadows are thrown both ways, to the north one part of the year and to the south one part'. Smuts's table-top sculpture with its Dutch gables facing a tiny pile of stones and scraps of rubber, points up the unease and difficulties of a people trying to come to terms with its own culturally mixed inheritance.

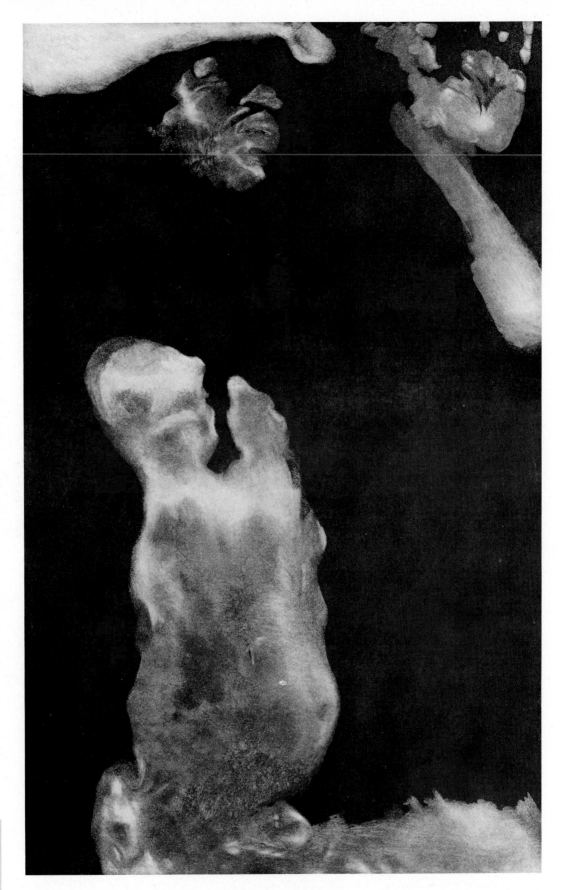

IMPRINT OF A MAN 1987
AQUATINT 44 × 28 CM

SARAH
TABANE

tion. 'That traditional mask – it's being pushed away by this white civilisation, and the new generation doesn't know anything about these things. But – the eye is a promise – it's beginning to see – we're going to fight for our rights. The

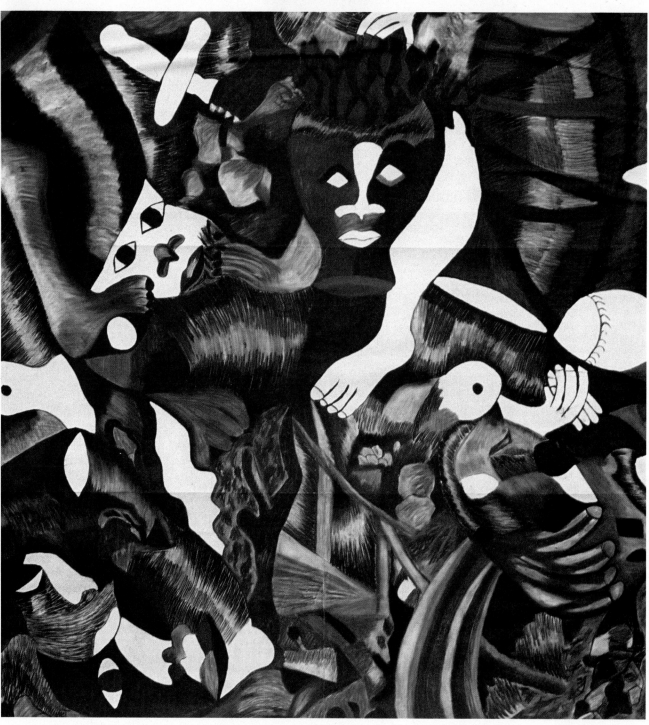

▲ UNTITLED 1987
CHARCOAL AND MIXED MEDIA
200 CM × 200 CM

'This is my best drawing for last year,' says Sarah Tabane, a model turned student at the Johannesburg Art Founda-

hands show we want peace. The breasts indicate Mother Africa – we will not move.'

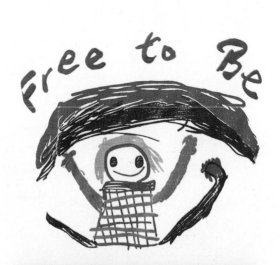

THE
ELUSIVE
VISION

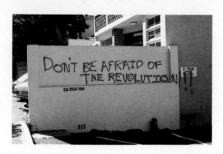

HARDY BOTHA

dents, academics, businessmen, and most recently fifty women have made the pilgrimage to meet the ANC.

But in 1987 the situation was very different. In July of that year, a party of 62 largely Afrikaans-speaking South Africans headed by the ex-leader of the

South African delegation would be allowed to leave the country in the first place on what was regarded by the state as a traitorous mission, and the scorn and vituperation heaped on their heads by the Afrikaans press on their return reached previously unimagined levels

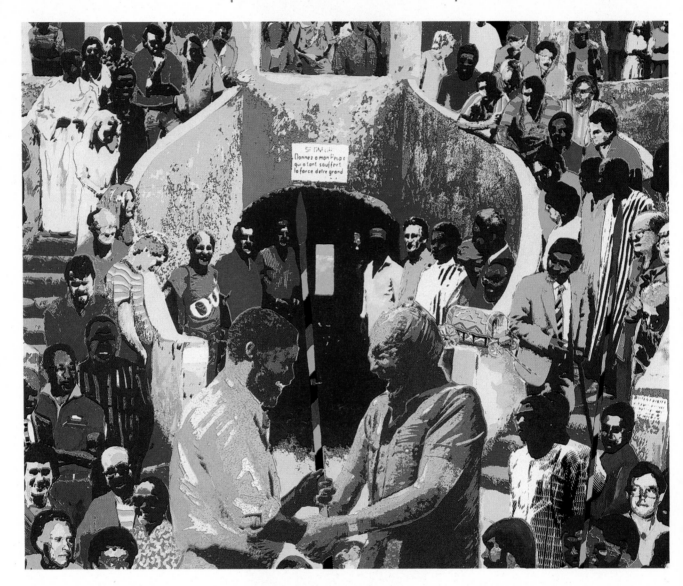

By mid-1989 'going to see the ANC' has become almost commonplace. Since the African National Congress has been banned since 1960, and operates in exile through its diplomatic and information offices, communication with the organisation has to take place beyond the borders of South Africa. To learn its views and its vision of the post-apartheid South Africa groups of stu-

opposition party in parliament, Van Zyl Slabbert, flew to Dakar to meet with leading members of the ANC.

After the talks, the two delegations issued a joint communiqué which supported a negotiated settlement for South Africa and included a call for the release of all political prisoners and the lifting of the ban on the ANC.

It had not been at all certain that the

of hysteria. Speaking in parliament, State President Botha said: 'The ANC is laughing up their sleeves at the naivety of "useful idiots" who, as Lenin puts it, can be used to further the aims of the first phase of the revolution.' Threats of passport withdrawals followed.

Artist Hardy Botha was one of the Dakar delegation, met at the airport by a hostile crowd on their return. 'We

were on such a high over there. The gloom hit us when we landed at Johannesburg. We were whisked off to the charge office – "for our own good." Later, we found out they were deciding what to do with us.

'For me, the Dakar trip was such a rich experience, a whole culture shock. I became very aware of our physical appearance – we were so white or pink – it definitely cut me down to size. Africa is a big island, yet down here we are totally isolated. I came out feeling very optimistic in a strange way. It suddenly solved a whole lot of things for me, and I realised I didn't have to wait for the revolution to start living in a post-apartheid way. It was an important attitude change for me.'

Botha is the son of a stationmaster, and as a boy lived in 'almost every little dorp in the Free State'. After his art student years, majoring in printmaking, he travelled around Europe for eight months, swopping little etchings for meals, and when he ran out of these, befriending local art students and printing more at art schools, slipping into classes and taking in some free education at the same time.

Back home, he worked for a theatrical company in Cape Town painting sets, clowned and tried trapeze – 'only my falls were spectacular'. South Africa has been referred to as 'the largest theatre of the absurd in the world' and Botha's work at this time portrayed it as such. His large canvases were rich and manic allegories of South Africa as a frenzied circus of the insane.

It was Botha who, fed up with the preciousness of an art gallery where he was to participate in a group show, had himself listed as Creatus van Anus on the invitation posters, and instead of hanging his own work, put out blank canvases with tins of paint below for viewers to paint what they wished. The gallery was not amused. 'Art isn't such

a big deal,' says Botha.

His screenprint *Dakar* commemorates the meeting with the ANC. In the Slave House on the Ile de Gorée, just off the coast of Dakar, all the participants are grouped. Behind the figures is the opening of the Gate of No Return. It leads out to the sea, and if a slave died or wanted to leave, the sharks waited on the other side. The traders used to live on the top of the house, with the slaves underneath. The two men in the centre of the picture, joyfully shaking

hands as they lay the foundations for an anti-apartheid memorial, are veteran human rights crusader and theologian Beyers Naudé, and publicity officer for the ANC Thabo Mbeki. In a radio interview a few weeks after the conference, Mbeki was to say: 'the Afrikaners who went to Dakar wanted to understand what the ANC would expect of them in terms of action to oppose the system of apartheid.'

Botha sees the Dakar trip in historic terms. 'All the farm houses used to have prints of the Battle of Blood River – very formal – so when I made this print, I thought "here we go again."'

BEEZY BAILEY

Beezy Bailey is something of a latter-day visionary, albeit of a post-colonial ethno-funk kind. His vision is of a tortured land, racked by war and disharmony, a land which will become whole only when people regain spiritual fulfilment through the healing process of

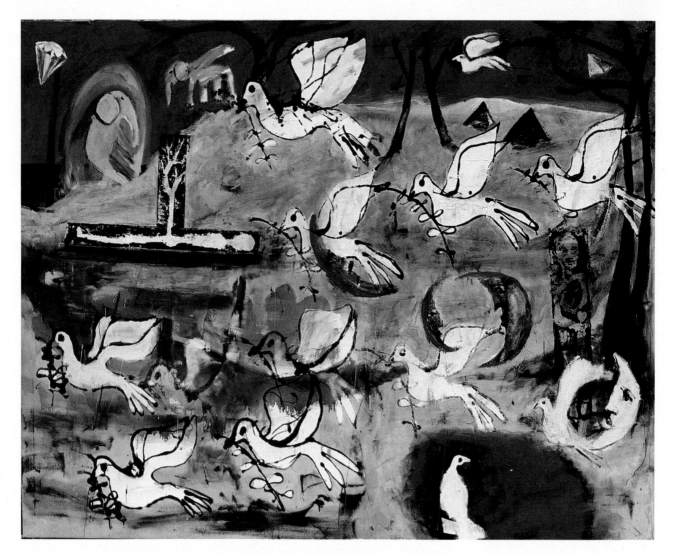

▲ THE NEW CLEAR AGE 1988
OIL ON CANVAS
100 CM × 140 CM

art. His painting, *The New Clear Age*, is accompanied by this poem:

> Elephant feet and plaster cast master blasters
> that couldn't sing because they were dead from the war
> yet there grew from its depths, its tortured soul, this
> spider ectoplasmic green stretched dream
> that swallowed us to the clean night silk choir moons
> and elephant heaven dome across its smooth skin and
> into its turquoise marine cloud earth, and all the time
> quiet doves of peace flew past.

TITO ZUNGU

On the white man in Africa, Steve Biko said: 'We wanted to remove him from our table, strip it of all trappings put on it by him, decorate it in true African style, settle down and then ask him to join us on our own terms if he liked.'

When at last the white man does sit

sell to fellow migrant workers for their letters home. Today, though galleries queue for his drawings, Zungu still chooses to be a worker – a hostel cook in a girls' hostel in Durban.

'If South Africa is to be a land where black and white live together in har-

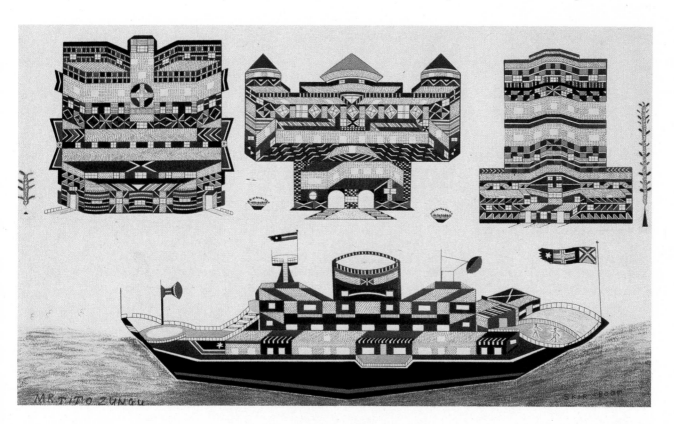

down at the black man's negotiating table, would it be fantasising too far to envision that meeting taking place inside a building created from a drawing by Tito Zungu? Imagine a city of such buildings, their shapes suggesting a futuristic blend of first and third world, every surface covered with Zungu's beautiful and intricate African patterning. What a cultural life that city might have.

Born in the country, Zungu never went to school, yet the first drawings he made as an adult were of the complex buildings, boats and aeroplanes which have remained his subject matter. His early artistic efforts were painstakingly decorated envelopes made to

mony, it is only when these two opposites have interplayed and produced a viable synthesis of ideas and modus vivendi,' said Biko. Is it not significant that it is the art of a worker, Tito Zungu, which points to an idea of quite how culturally dynamic such a synthesis could be?

▲ UNTITLED
PEN, COLOURED INKS ON PAPER
29.5 × 51 CM

INDEX OF ARTISTS AND ART INSTITUTIONS

AUTHOR'S ACKNOWLEDGEMENTS

To all the people and the organisations who have helped me put this book together, and to the artists and cultural workers who allowed their work to be included: thank you very much indeed. I hope the finished result will bring you pleasure in being part of this documentation of our new culture. My only regret is that time did not allow me to see every artist making committed work, and that shortage of space was a further limitation.

My heartfelt thanks to Roy Clucas, the designer of this book, whose brilliant and unerring eye gave form to every page.

In terms of help, I would especially like to mention Jo Thorpe and Terry-Anne Stevenson of the African Art Centre, Durban; Lorna Ferguson of the Tatham Art Gallery; Julia Meintjies at the Johannesburg Art Gallery; Jill Addleson of the Durban Art Museum; Julia Charlton of the University of South Africa Art Gallery; Fiona Stuart White of the University of the Witwatersrand; Bongiwe Dhlomo, then at the Alexandra Art Centre; David Koloane and Bill Ainslie at the Johannesburg Art Foundation; David Rousseau and Fiona Nicholson of the Ditike Art Centre in Venda; Lyn McLelland of the South African National Gallery; Linda Givon and Sheree Lisoos of the Goodman Gallery; Fernand Haenggi of Gallery 21; Lionel Davies at the Community Arts Project, Cape Town; Jenny Sorell and Jo Harvey at *ADA* magazine; and finally to Andries Oliphant of *Staffrider* magazine, who suggested a change of title to the present one.

I would also like to thank Cape Laboratory (Pty) Ltd who painstakingly copied photographically much of the material in this book.

The best moment of an exhibition is when the work is finally hung, up on the wall, and one can look at it all together for the first time, and see threads running through and interesting relationships that had not been apparent before. It's often a moment when one feels an urge to rush off and start something new. If this book could have that effect, I would be happy.

PHOTOGRAPHIC AND DESIGN CREDITS

Photographers

Bruce Attwood, 146
Andrew Bannister, 35 (*Soldier's Embrace*), 51, 106
Andries Botha, 144 (*Familiar Memories*)
Cape Laboratory, 11, 18, 19, 62, 74–7, 90, 101–3, 138–40, 151, 154–5
Jac de Villiers, 47 (*Page v Coetzee*), 124–5, 150
Gill de Vlieg, 89 (*The Garden of Peace*) by courtesy of *The Weekly Mail*
Flip du Toit, 48 (*Drunk Boer*)
Athol Franz, 27, 33 (*Woman in Bath*), 34, 36–9, 45, 46 (*Cross Madam*), 49, 52 (*A Beast Slouches*), 110–12, 114, 116, 120–1, back cover
David Goldblatt, 7 (*Archbishop Tutu*) by courtesy of *Leadership*, 89 (*Cross Roads People's Park*)
Kathleen Grundlingh, 16, 20, 21, 28, 58, 109, 135
David Hewitt, 59, 79, 108 (*Homage*), 113 (*Elegy*), 137 (wood sculpture), 141
Michael Hill, 144 (*Dromedaris*)
Stephen Hilton-Barber, 149 (Steven Sack)
Georgina Karvellos, 126
Jill King, 144–5 (Andries Botha)
Bob Knoops, 43 (collage), 44

Sandra Kriel, 70–1 (wine labourers)
Ronnie Levitan, 40, 41 (policeman and bed), 56–7, 98, 156
Trevor Matterson, 30, 31, 32, 33 (*Art* silkscreens)
Andrew Meintjes, 12, 13, 49, 72
Gideon Mendel, 93 (funeral), 88 (*Only Poorman Feel It*)
Malcolm Payne, 80–1
John Peacock, front cover, 10, 127–31
Larry Scully, 64–5 (Crown Mine hostel shots)
B. S. Shoba. 79 (Mpolokeng Ramphomane) by courtesy of *UmAfrika*
Cecil Sols, 88 (street corner mural), 89 (tree sculpture)
Mark van Dyk, 42, 43 (*Butcher Boys*)
Judith van Heerden, 96–7 (graffiti)
Gary van Wyk, 91 (posters), 117
Colleen Wafer, 41 (tennis players), 55
Gisèle Wulfsohn, 10 (Sue Williamson) by courtesy of *Leadership*
Amanda Williamson, 29, 78, 93 ('Freedom Charter' T-shirt)
Sue Williamson, *title page*, 15, 17, 47 (P.W.), 48 (Vorster), 50 (clay figure), 61, 94–5, 96–7 (graffiti), 108 (*Schoolgirls*), 149,

Gavin Younge, 48 (*Ballet Dancer*; Nelson Mukhuba), 66–8
Anna Zeminski, 147 (Michael Goldberg) by courtesy of *The Weekly Mail*

Designers

Louise Almon, 95 (Cosatu logo)
Patti Henderson, 82 (*The Long March* poster)
Bobby Marie, 94 (*MAWU: Workers Mobilise and Lead for a Democratic South Africa* T-shirt)
Dennis Purvis, 94 ('Angry face' T-shirt)
SAWCO, P.O. Box 156, Howick, 95 (*SARMCOL Workers' Play* T-shirt)
Stacey Stent, 95–6 ('Who's Left' cartoons, courtesy of *The Weekly Mail*)
Sue Williamson, 93 ('Freedom Charter' T-shirt)

The circular devices on most pages are Zulu earplugs, *iqaza*, and were lent to us for photographing by African Magic, Johannesburg.

Apologies are made for any omissions from the above list of credits. To be included in the next edition, please write to the publishers.